Nikon® D90
Digital Field Guide

Nikon® D90 Digital Field Guide

J. Dennis Thomas

Wiley Publishing, Inc.

Nikon® D90 Digital Field Guide

Published by
Wiley Publishing, Inc.
10475 Crosspoint Boulevard
Indianapolis, IN 46256
www.wiley.com

Published simultaneously in Canada

ISBN: 978-0-470-44992-9

Manufactured in the United States of America

10 9 8 7 6 5 4 3 2

For general information on our other products and services or to obtain technical support, please contact our Customer Care Department within the U.S. at (877) 762-2974, outside the U.S. at (317) 572-3993 or fax (317) 572-4002.

Wiley also publishes its books in a variety of electronic formats. Some content that appears in print may not be available in electronic books.

Cataloging-in-Publication Data is available from the Publisher.

WILEY

About the Author

J. Dennis Thomas is a freelance photographer based out of Austin, Texas. He's been using a camera for fun and profit for almost 25 years. Schooled in photography first in high school and then at Austin College, he has won numerous awards for both his film and digital photography. Denny has a passion for teaching others about photography and teaches black-and-white film photography to area middle school students as well as lighting and digital photography seminars in Austin. His photographic subjects are diverse, from shooting weddings and studio portraits to photographing concerts and extreme sports events for Red Bull. He has written six highly successful Digital Field Guides for Wiley Publishing and has another in the works. His photographs have been featured in magazines and newspapers in the central Texas area and beyond.

Credits

Acquisitions Editor
Courtney Allen

Senior Project Editor
Cricket Krengel

Project Editor
Christopher Stolle

Technical Editor
Ben Holland

Copy Editor
Kim Heusel

Editorial Manager
Robyn B. Siesky

Vice President and Group Executive Publisher
Richard Swadley

Vice President and Executive Publisher
Barry Pruett

Business Manager
Amy Knies

Senior Marketing Manager
Sandy Smith

Project Coordinator
Kristie Rees

Graphics and Production Specialists
Andrea Hornberger, Christin Swinford

Quality Control Technician
David Faust

Proofreading
Cindy Lee Ballew, Precisely Write

Indexing
Steve Rath

Acknowledgments

Thanks to everyone at Wiley: Courtney, Cricket, Laura, and Chris. You guys rock! Thanks to Robert and the rest of the staff at Precision Camera in Austin. Thanks to Shausta at Nikon.

Contents at a Glance

Contents

Part I: Using the Nikon D90 9

Chapter 1: Exploring the Nikon D90

Chapter 2: Nikon D90 Essentials 39

Chapter 3: Using the Nikon D90 Menus 71

Part II: Capturing Great Images with the Nikon D90 109

Chapter 4: Selecting and Using Lenses for the Nikon D90 111

Chapter 5: Essential Photography Concepts 131

Chapter 6: Working with Light 145

Chapter 7: D-Movie 181

Chapter 8: Advanced Shooting Techniques 189

Chapter 9: Viewing, Downloading, and In-Camera Editing 235

Part III: Appendixes 253

Appendix A: Accessories 255

Glossary 263

Index 269

Introduction

Welcome to the *Nikon D90 Digital Field Guide*. This book is a handy reference for you to get started learning about all the features and functions of your Nikon D90 dSLR camera.

This Digital Field Guide isn't meant to replace the user's manual but is an adjunct to the manual, explaining things in a simpler and more detailed manner than the manual. The guide is aimed at D90 owners that are just beginning in the world of dSLRs up to advanced users with more hands-on knowledge of photography.

The D90 Digital Field Guide not only covers the specifics of the D90 but also covers many other facets of digital photography, from the basics of exposure to lighting and composition. There's also a chapter to help you get started with Nikon's Creative Lighting System and all the possibilities that Nikon's Speedlights offer.

About This Book

The D90 will likely be used by a wide variety of users, from first-time dSLR owners to people who have owned other dSLRs and have plenty of experience with photography. This book contains information for D90 users of all levels. The first few chapters cover the basics of the camera: the buttons and switches, the menu options, and the different settings. These are all described in detail, including some tips on how to effectively use them.

Other chapters include information on lenses, how they work, and for what applications specific lenses are best used. There's a primer on working with different lighting types as well as a chapter that teaches you how to take on different photographic tasks.

To put it simply, there's a lot of information in this book. There's a good bit of information for everyone, from the new photographer to the advanced hobbyist.

About the D90

The D90 is the successor of Nikon's hugely successful D80 camera and isn't just a mild upgrade but almost a whole new camera. The D90 has inherited quite a few features from Nikon's high-end cameras — the D3, D700, and D300 — as well as offering some features that no other dSLR offers, such as the ability to record HD video clips.

The D90 is the first camera in Nikon's line of cameras to feature a CMOS sensor. The D90's DX-format 12.3-megapixel CMOS sensor gives the camera a high signal-to-noise ratio. Combining this sensor with EXPEED image processing inherited from the venerable D3, the D90 offers incredible images with low noise rivaling the D300 images, especially at high ISO settings.

Like the D300 and Nikon's FX-format cameras, the D90 has Live View. Live View allows you to view exactly what's coming through the lens right on the rear-panel LCD. This feature enables you to use the LCD monitor to compose your photographs in situations where it may be awkward to put your eye up to the viewfinder.

The Live View feature enables the camera to shoot live HD video straight from the image sensor. This feature has never been available on any dSLR previous to the D90. The built-in microphone allows you to record sound as you're recording video and has surprisingly good sound quality.

This new video ability allows you to record and share your memories like never before by using only one camera. Additionally, the D90 sensor is larger than that of most video cameras, allowing you to shoot higher-quality videos in low light. This larger sensor also allows you to get a much more shallow depth of field, giving your videos a more creative look.

Nikon has designed a brand-new lens to complement the D90: the AF-S Nikkor 18-105mm f/3.5-5.6G ED VR. This is a great all-around lens that covers the most-used focal lengths. From the moderately wide 18mm to use for architecture, interiors, and landscapes to 105mm, which is perfect for portraits and some sports, this lens covers most of your basic photography needs. The added bonus of Nikon's Vibration Reduction allows you to hand-hold the camera at slower shutter speeds without worrying about blurry pictures caused by camera shake. The Silent Wave motor in the lens allows for quick, nearly silent focusing.

Another great thing about the D90 is that like all other Nikon dSLRs, you can use almost all lenses manufactured by Nikon in the last 75 years. Nikon is known for having some of the highest-quality optics in the industry.

Your Nikon D90 is a well-built camera that will serve you for many years to come, and I hope this book helps you in all your photographic endeavors.

Quick Tour

This Quick Tour is designed to cover the basic functions you need to know to help you immediately start using your Nikon D90. It's by no means meant to be an in-depth look at the menus and modes, so if you're ready for that information, you can just give this section a quick once-over and move on to the later chapters, where everything is discussed in more detail.

If you already use a Nikon dSLR, a lot of this may be familiar to you. In fact, if you've used a D80, the setup for the D90 is very similar. If you're upgrading from a compact digital camera, you should probably read the entire Quick Tour to familiarize yourself with the camera's layout.

This Quick Tour assumes that you've already unpacked the camera, read the manual, charged the batteries, mounted a lens, and inserted the memory card. If you haven't done these things, please do them now.

Selecting a Shooting Mode

If you're anything like me, I'm sure you're ready to get out there and start taking pictures with your new camera. The great thing about the D90 is that you can start taking great photos right out of the box. The D90 has some automatic Shooting modes that choose the proper settings for you. All you really have to do is point the camera at something and shoot!

The first thing you need to do is turn the camera on. The On/Off switch is located right on top of the camera and surrounds the Shutter Release button.

On/Off switch

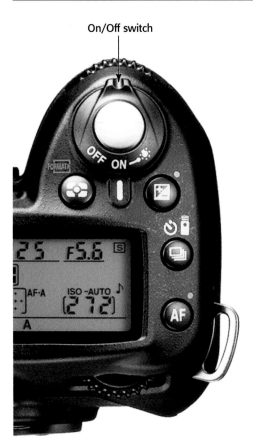

Image courtesy of Nikon
QT.1 The On/Off switch

Choosing a Shooting mode is simple: Rotate the Mode dial located on the top of the camera. The Shooting mode also appears in the top-left corner of the LCD, where the shooting information is displayed.

The D90 has four standard Shooting modes:

✦ **P.** Also known as Programmed Auto mode. This is a fully automatic Shooting mode in which the camera decides both the aperture setting and shutter speed. You can use the Main Command dial to adjust the aperture and shutter to better suit your needs. This is

known as Flexible Program, and it allows you to control the settings while maintaining the same exposure. Use this mode when taking snapshots or when controlling the shutter speed and the amount of the image that's in focus aren't as important as simply getting the photo.

Mode dial

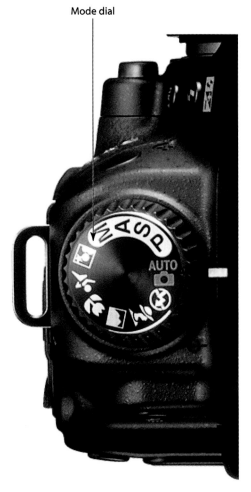

Image courtesy of Nikon
QT.2 Rotate the Mode dial to select a Shooting mode.

✦ **S.** Also known as Shutter Priority mode. This is a semiautomatic mode in which you decide the shutter speed to use and then the camera chooses the appropriate aperture. Use this mode when you need fast shutter speeds to freeze action or slow shutter speeds to show motion blur. Be sure not to use this mode when you need to control the amount of the image that's in focus.

✦ **A.** Also known as Aperture Priority mode. This is another semiauto-matic mode where you adjust the aperture to control how much of the image is in focus (the depth of field). Use this mode when you want to isolate a subject by focus-ing on it and letting the back-ground go soft or if you want to ensure that everything in the pic-ture is in sharp focus.

✦ **M.** Also known as Manual mode. With this mode, you decide the shutter speed and aperture. You can use this mode when you want to completely control the exposure in order to achieve a certain tonal-ity in your image by purposefully over- or underexposing the image. To help you when using this mode, you can check the D90 light meter in the viewfinder.

In addition to these modes, the D90 also employs what Nikon terms Scene modes. These are modes that apply settings that are optimized to the type of scene you're shoot-ing. The following Scene modes are available:

AUTO
📷
Auto. This is a point-and-shoot mode in which the camera con-trols all the settings, including shutter speed, aperture, and ISO.

If the camera deems it necessary, the built-in flash automatically activates.

 Auto (flash off). This setting is similar to the Auto mode; the camera controls all settings. However, in this mode, the flash is disabled. This is a good setting to use when natural lighting is preferred or the use of flash isn't allowed (such as in a museum).

 Portrait. This mode uses a wider aperture, allowing the back-ground to be soft while giving you sharp focus on your subject.

 Landscape. This mode chooses a smaller aperture to ensure that focus is achieved throughout the image. The camera also enhances blues and greens to accentuate the sky and foliage in the scene.

 Close-Up. This setting provides sharp details of the subject while allowing the background to soften to draw attention to the subject.

Sports. With this setting, the camera chooses a higher shutter speed to freeze the action.

Night Portrait. This setting uses flash to capture your subject while maintaining a longer shut-ter speed to capture the ambient light of the background, resulting in an evenly balanced and more natural-looking exposure.

The Scene modes take care of all the set-tings for you, including activating the flash. These modes are handy when starting out,

but you're limited in fine-tuning the settings. After you become more familiar with the camera settings, such as aperture and shutter speed, you may find yourself eschewing these Scene modes in favor of choosing the more flexible Shooting modes.

Focusing

Your Nikon D90 camera can automatically focus on a subject when using the lens that comes with the D90 kit or when using any of Nikon's many other autofocus lenses.

The lens that comes with the D90 kit is the AF-S DX Nikkor 18-105mm f/3.5-5.6G VR. This lens can be focused automatically or manually. To use the AF feature, you must first ensure that the switches on the lens and the camera body are set to AF.

Autofocusing the camera is done simply by pressing the Shutter Release button halfway down. The focus areas that are used to determine focus are shown in the viewfinder as tiny squares. One or more of these squares is momentarily lit up in red when the camera achieves focus. The active target is indicated by lit brackets.

By default, the camera automatically focuses on the closest subject in all modes except for the Close-Up mode, in which the camera uses the center focus point, or the Sports mode, in which the camera uses the center focus point by default and tracks the subject if it leaves the center of the frame.

After the camera locks the focus, a small green light in the bottom-left corner of the viewfinder lights up. If you want to lock focus and exposure settings, you can simply keep

Lens autofocus switch

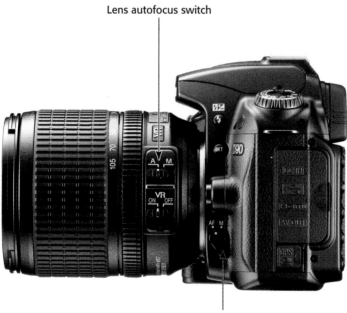

Camera autofocus switch

Image courtesy of Nikon

QT.3 The A/M switch on the kit lens and the AF/M switch on the camera body

the Shutter Release button half-pressed or you can press the AE-L/AF-L (Autoexposure/ Autofocus Lock) button that's found to the right of the viewfinder. This allows you to recompose your photo while maintaining the focus and exposure readings on your subject.

When the camera achieves focus, all you need to do is completely press down on the Shutter Release button to take your picture.

Using the Playback Mode

After you shoot some images with your D90, you can look at them on the big, bright, 3-inch LCD screen. To view your images, press the Play button on the back of the camera to the left of the LCD. The most recent photo taken is the first image displayed.

To scroll through the images that are stored on the memory card, press the Multi-selector left or right. Pressing the right button allows you to view the images in the sequence that they were taken. Pressing the left button displays the images in reverse order.

There are a few other options available to you when the camera is in Playback mode:

✦ **Press the Thumbnail/Zoom Out button to view thumbnails.** You can choose to view either four, nine, or 72 images at a time or a calendar view that shows images from a specific day. When in Thumbnail mode, use the Multi-selector buttons to navigate among the thumbnails to highlight one. You can then press the OK button to bring the selected image to a full-sized preview.

✦ **Press the Zoom In button to magnify the image.** This button allows you to check for sharpness or look for details. Pressing this button also takes you out of the thumbnail preview.

✦ **Press the Protect button to save images from being deleted.** The Protect button (denoted by a key) locks the image to prevent you from accidentally erasing it when editing your images in the camera.

 When a memory card is formatted, all images, including the protected ones, are erased.

✦ **Use the Multi-selector buttons to view image data.** To check to see what settings were used when the photograph was taken, press the Multi-selector up or down. This also allows you to check the histogram, which is a visual representation of the tonality of the image.

Cross-Reference For more information on histograms, see Chapter 5.

✦ **Press the OK button to do in-camera photo editing.** Pressing the OK button brings you to a menu that allows you to do some rudimentary in-camera editing, such as D-Lighting, fixing red-eye, and cropping.

Cross-Reference For more information on in-camera editing, see Chapter 8.

✦ **Press the Delete button to erase images.** The Delete button has an icon shaped like a trash can. Press this button to permanently erase the image from your memory card. When the Delete button is pressed, the camera asks for confirmation. Press the Delete button again to complete the deletion.

 For more information on settings, see Chapter 2 for modes and Chapter 3 for menus.

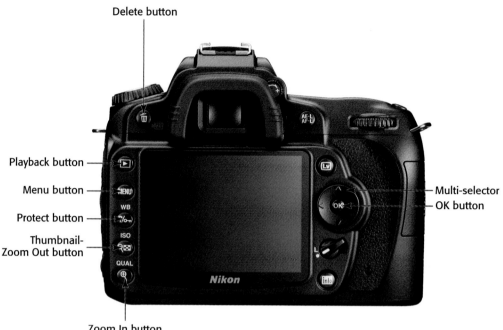

Delete button

Playback button

Menu button

Protect button

Thumbnail-Zoom Out button

Multi-selector

OK button

Zoom In button

Image courtesy of Nikon

QT.4 These buttons can be used in Playback mode for a variety of functions.

Downloading Images

When you fill a memory card or you're ready to do some post-processing of your images, you want to download them from your memory card to your computer for storage. You can either download the images straight from the camera to your computer or you can remove the memory card from the camera and then use a card reader to transfer the images.

To download images from your camera by using the USB cable, follow these steps:

1. **Turn off the camera.** Be sure that the camera is off when connecting it to the computer to ensure that the camera's or computer's electronics aren't damaged.

2. **Open the rubber cover that conceals the D90's output connections.** On the left side of the camera with the back facing you is a cover that has the camera's USB and video-out ports.

3. **Connect the camera to the USB cable.** Inside the box that your D90 came in is a USB cable. Plug the small end of the cable into the camera's USB port and then plug the other end into a USB slot on your computer.

4. **Turn on the camera.** Once the camera is turned on, your computer should recognize the camera as a mass storage device. You can then drag and drop your files or you can use a software program, such as Adobe Bridge or Nikon Transfer, to transfer your files.

USB port

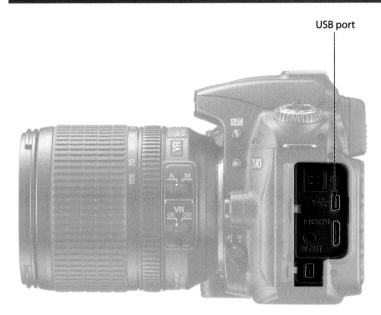

Image courtesy of Nikon
QT.5 The camera's USB port

The D90 comes with a free copy of Nikon Transfer inside the box. Nikon Transfer can help you to keep your images in order. Installing this software is optional, but if you're new to digital photography and file management, installing this software may be beneficial. To download your images by using a SecureDigital (SD) card reader, follow these steps:

1. **Turn off the camera.** Be sure that the camera is off to ensure that the camera's electronics aren't damaged.

2. **Remove the memory card.** Open the memory card door cover and then press the SD memory card in to eject it.

3. **Insert the memory card into the card reader.** Be sure that the reader is connected to your computer. Your computer should recognize the card as a mass storage device, and you can drag and drop the files or you can use a software program, such as Adobe Bridge or Nikon Transfer, to transfer your files.

Note *Depending on your software and how your computer is set up, your computer may offer to automatically transfer the files to a predetermined destination.*

Using the Nikon D90

Exploring the Nikon D90

This chapter covers the key components of the Nikon D90. These are the features that are most readily accessible because they're situated on the outside of the camera: the buttons, knobs, switches, and dials.

If you're upgrading from another Nikon dSLR, some of this may seem like review, but there are some new features that you may or may not be aware of, so a quick read-through is a good idea even if you're an experienced Nikon dSLR user.

For those of you who are new to the world of dSLRs, this chapter is a great way to become acquainted with some of the terms that are used in conjunction with your new camera.

So, let's explore the D90!

Key Components of the D90

If you've read the Quick Tour, you should be pretty familiar with the buttons and switches that you need for basic settings. In this section, you look at the camera from all sides and break down the layout so that you know what everything on the camera's surface does.

This section doesn't cover the menus (see Chapter 3), only the exterior controls. Although there are many features you can access with just the push of a button, you can usually change the same setting inside of a menu option. While the D90 doesn't have the same amount of buttons as some of its bigger siblings in the Nikon line, it does have quite a few of them. Knowing exactly what these buttons do can save you a lot of time and help you to not miss out on getting a shot.

Top of the camera

The top of the D90 is where you find some of the most important buttons and dials. This is where you can change the Shooting mode and press the Shutter Release to take your photo. Also included in this section is a brief description of some of the things you find on the top of the lens.

 Note *Although your lens may vary, most of the features are quite similar from lens to lens.*

✦ **Mode dial.** This is an important dial. Rotating this dial allows you to quickly change your Shooting mode. You can choose one of the Scene modes or one of the semiautomatic modes or you can choose to manually set the exposure.

Cross-Reference *For more on the Exposure modes, see Chapter 2.*

✦ **Focal plane mark.** The focal plane mark shows you where the plane of the image sensor is inside the camera. The sensor isn't exactly where the mark is; the sensor is directly behind the lens opening. When doing certain types of photography, particularly macro photography by using a bellows lens, you need to measure the length of the bellows from the front element of the lens to the focal plane. This is where the focal plane mark comes in handy.

✦ **Shutter Release button.** In my opinion, this is the most important button on the camera. Halfway pressing this button activates the camera's autofocusing and light meter. When you fully depress this button, the shutter is released and a photograph is taken. When the camera has been idle and has gone to sleep, lightly pressing the Shutter Release button wakes up the camera. When the image review is on, lightly pressing the Shutter Release button turns off the LCD and prepares the camera for another shot.

✦ **On/Off switch/LCD illuminator.** This switch, which surrounds the Shutter Release button, is used to turn the camera on and off. Push the switch all the way to the left to turn off the camera. Pull the switch to the right to turn your camera on. This button also has a spring-loaded switch that, when pulled all the way to the right, lights up the LCD control panel on the top of the camera for viewing in dim light. You can also set this momentary switch to light up the LCD control panel and show the Shooting Info Display on the rear LCD in the Custom Setting menu (CSM f1).

✦ **Metering mode button.** This button is used to choose the Metering mode. Press this button and then rotate the Main Command dial until the desired mode appears on the LCD control panel. You can choose Matrix, Center-weighted, or Spot metering. This button also doubles as one of the two-button format buttons.

Focal length indicators Metering mode button On/Off switch/LCD illuminator

Zoom ring Focus ring Shutter Release button

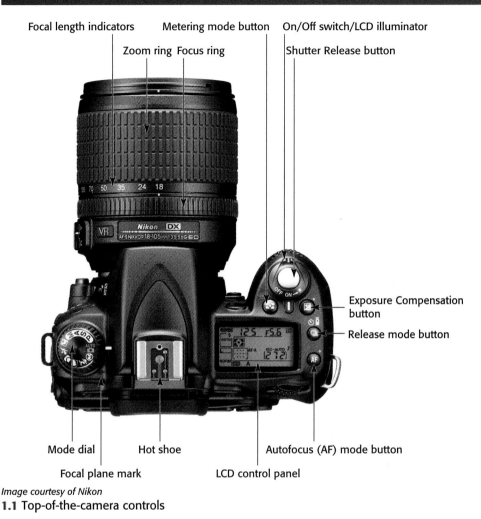

Exposure Compensation button

Release mode button

Mode dial Hot shoe Autofocus (AF) mode button

Focal plane mark LCD control panel

Image courtesy of Nikon
1.1 Top-of-the-camera controls

Cross-Reference *For more on Metering modes, see Chapter 2.*

✦ **Exposure Compensation button.**
Pressing this button in conjunction with rotating the Main Command dial allows you to modify the exposure that's set by the D90's light meter or the exposure you set in Manual mode. Turning the Main

Command dial to the right decreases the exposure, while turning the dial to the left increases the exposure.

Note *You can reset the camera to its default settings by pressing the Exposure Compensation button and the AF mode button at the same time and holding them down for about 2 seconds.*

✦ **Release mode button.** Pressing this button and then rotating the Main Command dial changes the Release mode of the camera. You can choose from Single Frame, Continuous Low Speed, Continuous High Speed, Self-timer, Delayed Remote, and Quick Remote. In order to use the remote function, you must purchase an ML-L3 wireless infrared remote.

✦ **AF (Autofocus) mode button.** Pressing this button and then rotating the Main Command dial allows you to choose the AF mode. Your choices are AF-A, AF-S, or AF-C.

 For more on the ML-L3 wireless infrared remote, see Appendix A. For more on AF modes, see Chapter 2.

✦ **LCD control panel.** This monochrome LCD panel displays camera settings. This feature is covered later in this chapter.

✦ **Hot shoe.** This is where an accessory flash is attached to the camera body. The hot shoe has an electronic contact that tells the flash to fire when the shutter is released. There are also a number of other electronic contacts that allow the camera to communicate with the flash to enable the automated features of a dedicated flash unit, such as Nikon's brand-new SB-900 Speedlight.

✦ **Focus ring.** Rotating the focus ring enables you to manually focus the camera. With some lenses, such as

the high-end Nikkor AF-S lenses that have M/A–A switches, you can manually adjust the focus at any time. On other lenses — typically older, low-end AF-S lenses that have an A-M switch, such as the Nikkor 18-55mm f/3.5-5.6 and non-Nikon lenses — you must switch the lens to Manual mode or disable the focusing mechanism by using the AF/M switch on the camera body. With the kit lens, you must switch to Manual mode.

 Rotating the focus ring while the lens is set to Autofocus can damage your lens and/or camera.

✦ **Zoom ring.** Rotating the zoom ring allows you to change the focal length of the lens. Prime lenses don't have a zoom ring.

✦ **Focal length indicators.** These numbers indicate to which focal length in millimeters your lens is zoomed.

Cross-Reference *For more on lenses, see Chapter 4.*

Back of the camera

The back of the camera is where you find the buttons that mainly control playback and menu options, although there are a few buttons that control some of the shooting functions.

Most of the buttons have more than one function — a lot of them are used in conjunction with the Main Command dial or

the Multi-selector. You also find several key features on the back of the camera, including the all-important viewfinder and LCD:

✦ **LCD.** This is the most obvious feature on the back of the camera. This 3-inch, 920,000-dot liquid crystal display (LCD) screen is a very bright, high-resolution screen that's the same as the higher-end D3, D700, and D300 Nikon cameras. The LCD is where you review your images after shooting. The Shooting Info Display also appears here, and this is where you view all the menus.

✦ **Viewfinder.** This is what you look through to compose your photographs. Light coming through the lens is reflected through a pentaprism, which enables you to see exactly what you're shooting (as opposed to a rangefinder camera, which gives you an approximate view). Around the viewfinder is a rubber eyepiece that serves to give you a softer place to rest your eye and to block any extra light from entering the viewfinder as you compose and shoot your images.

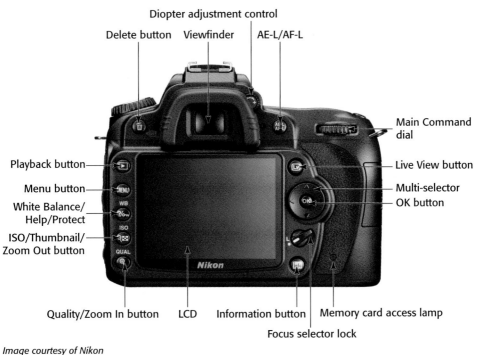

Diopter adjustment control

Delete button Viewfinder AE-L/AF-L

Main Command dial

Playback button

Menu button

White Balance/ Help/Protect

ISO/Thumbnail/ Zoom Out button

Live View button

Multi-selector

OK button

Quality/Zoom In button LCD Information button Memory card access lamp

Focus selector lock

Image courtesy of Nikon
1.2 Back-of-the-camera controls

✦ **Diopter adjustment control.** Just to the right of the viewfinder is the diopter adjustment control. Use this control to adjust the viewfinder lens to suit your individual vision differences (not everyone's eyesight is the same). To adjust this, look through the viewfinder and then rotate the diopter control until the viewfinder information is sharp. You can also press the Shutter Release button halfway to focus on something. If what you see in the viewfinder isn't quite sharp, rotate the diopter control up or down until everything appears in focus.

✦ **AE-L/AF-L.** The Autoexposure/ Autofocus Lock button is used to lock the Autoexposure (AE) and Autofocus (AF). You can also customize the button to lock only the AE or only the AF. It can also be set to lock the exposure with a single press and reset with a second press (AE Lock (hold)). You can set the button to initiate AF (AF-On) and to lock the flash exposure value (FV Lock). This can be set using CSM f4.

> **Cross-Reference** *For more on customizing the AE-L/ AF-L button, see Chapter 3.*

✦ **Main Command dial.** This dial is used to change a variety of settings depending on which button you press in conjunction with it. By default, it's used to change the shutter speed when in Shutter Priority and Manual modes. It's also used to adjust exposure compensation as well as change the Release, AF, and Flash modes.

> **Tip** *Setting the AE-L/AF-L button to AE Lock (hold) when shooting video allows you to lock the exposure so that the video doesn't fluctuate between light and dark when filming in a setting with areas that have high contrast between the highlights and shadows, such as with spotlights at a performance or under dappled sunlight.*

✦ **Live View (Lv) button.** Pressing this button activates the Live View function. Pressing the button a second time disables Live View and returns the camera to the standard Shooting mode.

✦ **Multi-selector.** The Multi-selector also serves a few different purposes. In Playback mode, the Multi-selector is used to scroll through the photographs you've taken, and it can also be used to view image information, such as histograms and shooting settings. When in certain Shooting modes, the Multi-selector can be used to change the active focus point when in Single Point or Dynamic Area AF mode. You also use the Multi-selector to navigate the camera's menus.

✦ **OK button.** When in Menu mode, press this button to select the menu item that's highlighted. When Live View is activated, pressing this button starts recording video by using D-Movie mode.

> **Cross-Reference** *For more on D-Movie mode, see Chapter 7.*

✦ **Focus selector lock.** This switch allows you to lock the selected focus area so that it can't be accidentally changed.

✦ **Information (info) button.** Pressing this button causes the Shooting Info Display to appear. This shows some camera settings, such as aperture, shutter speed, and others. Pressing the Shutter Release button lightly returns you to the default Shooting mode. Press this button again while viewing the Shooting Info Display to enter the Quick Settings Display, which allows you to quickly access some commonly used features. The Shooting Info Display and Quick Settings Display are discussed later in this chapter.

✦ **Memory card access lamp.** When this light is blinking, the camera is transferring data to the memory card. Under no circumstances should the memory card be removed when this is lit. This can damage your camera or the card and will almost certainly result in a loss of images.

✦ **Delete button.** When reviewing your pictures, if you find some that you don't want to keep, you can delete them by pressing the button marked with a trash can icon. To prevent accidental deletion of images, the camera displays a dialog box asking you to confirm that you want to erase the picture. Press the Delete button a second time to permanently erase the image.

Note *You can format the SD card by pressing the Metering mode button and the Delete button at the same time and holding them down for about 2 seconds then release the buttons and press them again.*

✦ **Playback button.** Pressing this button displays the most recently taken photograph. You can also view other pictures by pressing the Multi-selector left or right.

✦ **Menu button.** Press this button to access the D90 menu options. There are a number of different menus, including Playback, Shooting, Custom Setting, Setup, Retouch, and Recent Settings/My Menu. Use the Multi-selector to choose the menu you want to view.

✦ **White Balance/Help/Protect.** This button has the icon of a key and question mark on it. Above it is WB. This button actually has a few different uses. When in Shooting mode, press this button and then rotate the Main Command dial to change the white balance (WB) setting. Rotating the Sub-command dial allows you to fine-tune the current WB setting, making it warmer or cooler. The WB setting can only be changed when using the M, A, S, and P settings. When in Playback mode, this button is used to lock an image to prevent it from accidentally being erased. When viewing the image you want to protect, simply press this button. A small key icon is displayed in the upper right-hand corner of images that are protected. When viewing the menu options or when the camera is set to a Scene mode, pressing this button displays a help screen that explains the functions of that particular menu option or Scene mode.

✦ **ISO/Thumbnail/Zoom Out button.** When the camera is in Shooting mode, pressing this button allows you to manually adjust the ISO sensitivity. When using a Scene mode in which the Auto ISO function is set, using this option allows you to override the Auto ISO setting. In Playback mode, pressing this button allows you to go from full-frame playback (or viewing the whole image) to viewing thumbnails. You can view either four, nine, or 72 thumbnails on a page. Pressing this button a fourth time shows a calendar view that displays images taken on a specific day. When you're zoomed into an image during playback or Live View, this button allows you to zoom out.

✦ **Quality (QUAL)/Zoom In button.** When in Shooting mode, press this button and then rotate the Main Command dial to change the image quality and JPEG compression. You can choose from RAW, fine, normal, or basic JPEG or RAW + fine, normal, or basic JPEG. Rotating the Sub-command dial allows you to choose the size of your JPEG files: Large, Medium, or Small. When reviewing your images, you can press the Zoom In button to get a closer look at the details of your image. This is a handy feature for checking the sharpness and focus of your shot. When zoomed in, use the Multi-selector to navigate around within the image. To view your other images at the same zoom ratio, you can rotate the Main Command dial. To return to full-frame playback, press the Zoom Out button.

Depending on how much you've zoomed in, you may have to press the Zoom Out button multiple times.

Front of the camera

The front of the D90 (lens facing you) is where you find the buttons to quickly adjust the flash settings, bracketing, and some focusing options, and with certain lenses, you find some buttons that control focusing and Vibration Reduction (VR).

Right front

✦ **Flash pop-up button/Flash mode button/Flash Exposure Compensation button.** Press this button to open and activate the built-in Speedlight when in M, A, S, or P mode. Rotate the Main Command dial to change the Flash mode, and rotate the Sub-command dial to adjust the Flash Exposure Compensation (FEC) button. When using Scene modes, this button functions differently for different modes.

Cross-Reference *For more on Scene modes, see Chapter 2.*

✦ **Bracketing (BKT) button.** This button allows you to activate exposure bracketing. Pressing this button and then rotating the Main Command dial, you can set the number of bracketed exposures. You can bracket up to three frames. The choices are 3 frames (metered, over, under), −2 (metered, under), and +2 (metered, over). Pressing this button and then rotating the Sub-command dial allows you to

choose the exposure value increment (EV). These are adjusted in 1/3-stop increments from 0.3 EV to 2.0 EV.

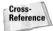 *For more information on bracketing, see Chapter 5.*

✦ **Microphone.** This built-in condenser microphone allows you to record sound when shooting video.

✦ **Infrared receiver.** This allows you to wirelessly control the Shutter Release by using the optional ML-L3 wireless infrared remote.

✦ **Lens Release button.** This button disengages the locking mechanism of the lens, allowing you to rotate and remove the lens from the lens mount.

✦ **Lens Focus mode selector.** This switch is used to quickly choose between using the lens in Auto or Manual mode. Not all lenses are equipped with these switches.

Flash pop-up button/Flash mode button/ Flash Exposure Compensation button

Microphone

Infrared receiver

Bracketing button

Lens Release button

Lens Focus mode selector

Focus mode selector

Vibration Reduction switch

Image courtesy of Nikon

1.3 Front-right camera controls

✦ **VR switch.** This allows you to turn the Vibration Reduction (VR) on or off (if your lens is VR-equipped). When shooting in bright light with fast shutter speeds or using a tripod, it's best to turn the VR off to reduce battery consumption.

✦ **Focus mode selector.** This switch is used to choose between using the lens in Auto or Manual mode. You also use this switch if a lens doesn't have its own switch, such as a non-AF-S lens.

Left front

✦ **Built-in flash.** This is a handy feature that allows you to take sharp pictures in low-light situations. Although not as versatile as one of the external Nikon Speedlights, such as the SB-900, SB-800, or SB-600, the built-in flash can be used very effectively and is great for snapshots. You can also use the built-in flash as the commander for wireless remote flash.

 For more on using flash, see Chapter 6.

✦ **AF-assist illuminator.** This is an LED (light-emitting diode) that shines on the subject to help the camera focus when the lighting is

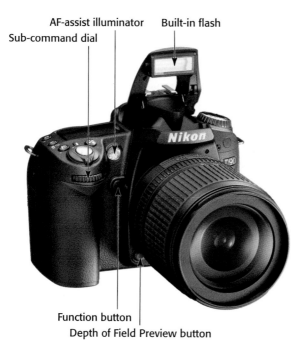

Sub-command dial
AF-assist illuminator Built-in flash

Function button
Depth of Field Preview button

Image courtesy of Nikon
1.4 Left-front camera controls

dim. The AF-assist illuminator only lights when in Single Focus mode (AF-S) or Autofocus mode (AF-A) when using the center AF point. When using M, A, S, or P, the AF-assist illuminator can be switched on or off in CSM a3. When using a Scene mode, this is set automatically.

✦ **Function (Fn) button.** This button can be assigned to provide different functions. You can set the button to display a framing grid in the viewfinder, change the AF Area mode, move the focus point to the center, lock the flash exposure value (FV Lock), switch the flash off, change Metering modes, access the top My Menu item, or shoot a RAW file in conjunction with the current JPEG setting. The Function (Fn) button can be assigned to a specific function in CSM f3.

✦ **Depth of Field Preview button.** Also known simply as the Preview button, pressing this button stops down the aperture of the lens so you can preview how much of the subject is in focus. The image in the viewfinder gets darker as the aperture decreases.

✦ **Sub-command dial.** By default, this dial is used to change the aperture setting. Pressing the WB button and then rotating this dial fine-tunes the current WB setting. When set to PRE WB, rotating this dial allows you to select from one of the five available custom presets that you can save.

Sides and bottom of camera

The sides and bottom of the camera have places for connecting and inserting things, such as cables, batteries, and memory cards.

Right side

On the camera's right side (lens facing you) are the D90's output terminals. These are used to connect your camera to a computer or to an external source for viewing your images directly from the camera.

These terminals are hidden under a plastic cover that helps keep out dust and moisture:

✦ **DC in.** This AC adapter input connection allows you to plug the D90 into a standard electrical outlet by using the Nikon EH-5 or EH-5a AC-to-DC adapter. This allows you to operate the camera without draining your batteries. The AC adapter is available separately from Nikon.

✦ **USB port.** This is where the USB cable plugs in to attach the camera to your computer to transfer or print images straight from the camera. The USB cable is also used to connect the camera to the computer when using Nikon's optional Camera Control Pro 2 software.

✦ **HDMI out.** The high-definition video output terminal is used to connect the camera to a high-definition TV (HDTV). The camera is connected with an optional Type C mini-pin HDMI cable that can be purchased at an electronics store.

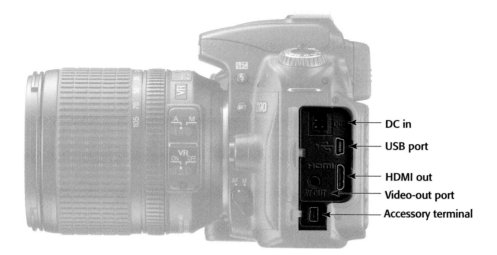

Image courtesy of Nikon
1.5 The D90's output terminals

DC in
USB port
HDMI out
Video-out port
Accessory terminal

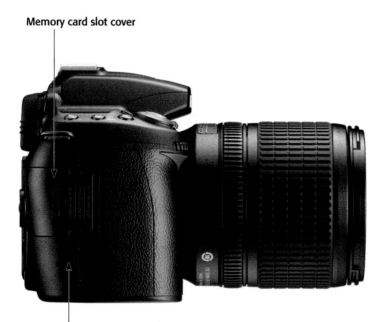

Memory card slot cover

Built-in speaker

Image courtesy of Nikon
1.6 Memory card slot cover and speaker

✦ **Video out.** This connection, officially called standard video output, is used to connect the camera to a standard TV or VCR for viewing your images on-screen. The D90 is connected with the EG-D100 video cable that's supplied with the camera.

✦ **Accessory terminal.** This port is used to connect the optional Nikon GP-1 GPS unit or the remote MC-DC2 cord.

Cross-Reference *For more on optional accessories, see Appendix A.*

Left side

On the left side of the camera (lens facing you) is the memory card slot cover. Sliding this door toward the back of the camera opens it so you can insert or remove your memory card. Also located here is the speaker that's used when playing back D-Movie videos.

Bottom

The bottom of the camera has a couple of features that are quite important:

✦ **Battery chamber cover.** This covers the chamber that holds the EN-EL3e battery that's supplied with your D90.

✦ **Tripod socket.** This is where you attach a tripod or monopod to help steady your camera.

Battery chamber cover

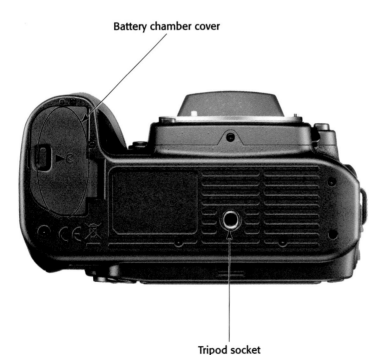

Tripod socket

Image courtesy of Nikon
1.7 The bottom of the D90

The D90 CMOS Sensor

The imaging sensor is one of the most important parts of the camera and unfortunately also one of the most misunderstood. Not many people understand how these sensors work and what the differences are between the two most common types of sensors — CMOS and CCD — so this section sheds some light (no pun intended) on exactly what's going on when the sensor is exposed.

The Nikon D90 has a 12.3-megapixel CMOS sensor with an integrated dust reduction system. The D90 sensor is an APS-C-sized sensor. APS (Advanced Photo System) is a film format that was designed by Kodak to make photography easier for amateurs by allowing the photographer to control the image aspect ratio in the camera. The negatives were smaller than standard 35mm negatives. There were three image sizes that you could choose from: APS-H (30.2mm × 16.7mm) 16:9; APS-C (25.1mm × 16.7mm) 3:2; and APS-P (30.2mm × 9.5mm) 3:1. The D90 sensor is actually a bit smaller than the standard APS-C film, being 23.6mm × 15.8mm, but still has the 3:2 aspect ratio. Nikon refers to this sensor size in its proprietary term of DX, so from here on out, I refer to the sensor size as DX.

The reason for these smaller DX sensors is that manufacturing these sensors made from silicon was (and still is to an extent) very expensive, and reducing the size of the format from 36mm × 24mm (35mm film size) to APS-C allowed camera manufacturers to produce dSLRs at more affordable prices.

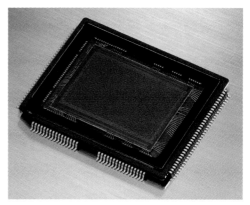

Image courtesy of Nikon
1.8 The D90 12.3-MGP DX-format CMOS sensor

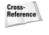 *For more on DX sensor and crop factor, see Chapter 4.*

From analog to digital

Believe it or not, digital image sensors are actually analog devices that capture light just like emulsion on a piece of film. When the shutter opens, light from the scene that you're photographing, whether sunlight or flash, travels through the lens and projects (hopefully in focus) onto the sensor. Each sensor has millions of pixels, which act as a receptacle that collects individual *photons* of light. A photon is a quantum particle of light, which is a form of electromagnetic radiation. The more photons the pixel collects, the brighter the area is; conversely, if the pixel doesn't collect a lot of photons, the area is dark.

Each pixel has a photodiode that converts these photons into minute electrical charges that the Analog/Digital (A/D) converter reads. The A/D converter renders this analog data into digital data that can be utilized by Nikon's EXPEED imaging processor.

CMOS versus CCD

About half of Nikon's dSLRs use Charge Coupled Device (CCD) sensors, although Nikon appears to be moving away from this technology by putting a CMOS sensor in the D90. Although CMOS and CCD sensors do the same job, they do it differently, and each type of sensor has its own strengths and weaknesses.

CCD

The name Charge Coupled Device refers to how the sensor moves the electrical charges created by the photons that the pixels have collected. The CCD sensor moves these electrical charges from the first row of pixels to a shift register (a digital circuit that allows the charges to be shifted down the line). From there, the signal is amplified so the A/D converter can read it. The sensor then repeats the processes with each row of pixels until every row of pixels on the sensor has been processed. This is a pretty precise method of transfer, but in digital terms, it's quite slow. It requires a large amount of power, relatively speaking, so it uses more of the camera's battery, which equals fewer shots per charge. CCD sensors have a higher signal-to-noise ratio, which makes them less prone to high ISO noise than CMOS sensors and enables them to provide a higher image quality.

CMOS

Just like a CCD sensor, a CMOS (Complementary Metal-Oxide Semiconductor) sensor has millions of pixels and photodiodes. With the CMOS sensor, each pixel has its own amplifier, and each pixel converts the charge to voltage on the spot. It's much more efficient to transfer voltage than it is to transfer a charge; therefore, CMOS sensors use less power than CCD sensors. Multiple channels of sensor data can also be sent out at the same time, so the CMOS sensor can send the data to the A/D converter much faster. CMOS chips are also cheaper to manufacture than CCD chips.

Pixels

The more pixels the sensor has, the higher the resolution of the sensor. However, packing more pixels onto a sensor means that although the resolution is higher, each pixel becomes less effective at gathering light because it's much smaller. A larger pixel is more effective at gathering photons; therefore, you get a wider dynamic range and a better signal-to-noise ratio, which means less inherent noise and the ability to achieve a higher ISO sensitivity.

Micro-lenses

In addition to having larger pixels to gather more light, camera manufacturers place micro-lenses over the pixels. These micro-lenses collect the light and focus them onto the photodiode much the same way the camera lens focuses the image onto the sensor. By making the micro-lenses larger, Nikon has decreased the gaps between the pixels, which increases the effective light gathering ability of each one, allowing the camera to produce less noise in the image.

Interpreting color

The light-sensitive pixels on the sensor only measure the brightness in relation to how many photons it has gathered, so the basic image captured is, in effect, black and white. To determine color information, the pixels are covered with red-, green-, or blue-colored filters. These filters are arranged in a Bayer

pattern. (Dr. Bryce Bayer was a scientist at Kodak who developed this pattern.) The Bayer pattern lays the filters out in an array that consists of 50% green, 25% blue, and 25% red. The green filters are luminance-sensitive (brightness) elements, and the red and blue filters are chrominance-sensitive (color) elements. Twice as many green filters are used to simulate human eyesight, given that our eyes are more sensitive to green than to red or blue.

The camera determines the colors in the image by a process called *demosaicing*. In demosaicing, the camera *interpolates* the red, green, and blue data for each pixel by using information from adjacent pixels. Interpolation is a mathematical process in which sets of known data are used to determine new data points. (I like to call it an educated guess.)

 Note *When shooting NEF files, the RAW converter handles the demosaicing.*

Viewfinder Display

When looking through the viewfinder, you see a lot of useful information about the photo you're composing. Most of the information is also displayed in the LCD screen on the top of the camera, but it's less handy on top when you're composing a shot.

Here's a complete list of all the information you get from the viewfinder display:

✦ **Focus points.** The first thing you're likely to notice when looking through the viewfinder is a small bracket near the center of the frame. This is your active focus point. Note

that the focus point is only shown full-time when in the Single or Dynamic AF setting. When the camera is set to Auto Area AF, the focus point isn't shown until the Shutter Release button is half-pressed and focus is achieved.

✦ **Framing grid.** When this option is turned on in the Custom Setting menu (CSM d2), you see a grid displayed in the viewing area. This is to help with composition. Use the grid to help line up elements of your composition to ensure that things are straight (or not).

✦ **8mm [center-weighted] reference circle.** These curves located at the top and bottom of the AF Area brackets give you an idea of how much of an area of the frame is used for Center-weighted metering. The curves show you an area of 8mm, which is the default circle size for Center-weighted metering. Note that although you can change the size of the area for Center-weighted metering (CSM b3), this display doesn't change.

✦ **Black and White indicator.** This icon appears when the Picture Control is set to monochrome (MC).

Cross-Reference *For more on Picture Controls, see Chapter 2.*

✦ **Battery indicator.** This icon appears when the battery charge is getting low. When this icon is blinking, the battery has been depleted and you can't take any more pictures until the battery has been charged and replaced or a charged backup battery is installed.

Framing grid 8mm [center-weighted] reference circle

No memory card warning Focus points

Battery indicator

Black and White indicator

Battery indicator

WB bracketing indicator

FV lock indicator

Focus indicator

AE Lock indicator

Shutter speed display

Aperture/f-stop display

Light meter

FEC indicator

Auto ISO sensitivity indicator

ISO sensitivity compensation indicator

Bracketing indicator

Thousands indicator

Flash-ready indicator

Exposure compensation indicator

Remaining exposures

1.9 The viewfinder display. Note that this figure displays all possible focus points. Only the active focus points are visible in actual shooting conditions.

✦ **No memory card warning.** This icon flashes when there's no memory card inserted in the camera.

Note *The Black and White indicator, low battery indicator, and memory card warning can be turned off by using CSM d4.*

Below the actual image portion of the viewfinder display is a black bar with LCD readouts on it. Not only do you find your shooting information here, but depending on your chosen settings, other useful indicators also appear here. From left to right, these items are:

✦ **Focus indicator.** This is a green dot that lets you know if the camera detects that the scene is in focus.

When focus is achieved, the green dot lights up; if the camera isn't in focus, no dot is displayed. When the camera attempts to find focus, this indicator blinks.

✦ **AE Lock indicator.** When this is lit, you know that the Autoexposure Lock button has been pressed.

✦ **FV Lock indicator.** When the FV Lock indicator is on, it means you have locked in the flash exposure value. The flash value can only be locked when the Function (Fn) button has been set to do this.

✦ **Shutter speed display.** This shows how long your shutter is set to stay open.

✦ **Aperture/f-stop display.** This shows what your current lens opening setting is.

✦ **Electronic analog exposure display.** Although Nikon gives this feature a long and confusing name, in simpler terms, this is your light meter. When the bars are in the center, you're at the proper settings for good exposure; when the bars are to the left, you're underexposed; and when the bars are to the right, you're overexposing your image. This feature is especially handy in getting the proper exposure when using Manual mode. When in P, S, and A mode, this meter shows you the exposure level when exposure compensation is being applied.

✦ **Battery indicator.** This icon displays how much of a charge remains in the battery.

✦ **FEC indicator.** When this is displayed, your Flash Exposure Compensation is on.

✦ **WB bracketing indicator.** This icon is shown when your auto-bracketing is set to white balance and bracketing is turned on. You can change the bracketing set in CSM e4.

✦ **Bracketing indicator.** This icon appears when auto-bracketing is turned on.

✦ **Exposure compensation indicator.** When this appears in the viewfinder, your camera has exposure compensation activated and you may not get a correct exposure.

✦ **Auto ISO indicator.** This is displayed when the Automatic ISO setting is activated to let you know that the camera is controlling the ISO settings.

✦ **ISO sensitivity indicator.** This tells you what the ISO sensitivity is currently set to.

✦ **Remaining exposures.** By default, this set of numbers lets you know how many more exposures can fit on the SD card. The actual number of exposures may vary according to file information and compression. When the Shutter Release button is half-pressed, the display changes to show how many exposures can fit in the camera's buffer before the buffer is full and the frame rate slows down. The buffer is in-camera RAM that stores your image data while the data is being written to the memory card. When recording a WB preset, this flashes PRE. When setting Flash Exposure

Compensation or exposure compensation, the EV number is displayed here. When the camera is connected to a computer running Camera Control Pro 2, this displays PC. This can also be set in CSM d3 to default to show the ISO setting.

✦ **K.** This lets you know that there are more than 1000 exposures remaining on your memory card.

✦ **Flash-ready indicator.** When this is displayed, the flash, whether it's the built-in flash or an external Speedlight attached to the hot shoe, is fully charged and ready to fire at full power.

Control Panel

The monochrome control panel on top of the camera displays some of the same shooting information that appears in the viewfinder, but there are also some settings that are only displayed here.

This LCD allows you to view and change the settings without looking through the viewfinder.

Because there is so much information contained in the LCD display, it is broken up over two figures. In figure 1.10, you can see these settings:

✦ **Shutter speed.** By default, this set of numbers shows you the shutter speed setting. This set of numbers also shows myriad other settings depending on which buttons are being pressed:

• **Exposure compensation value.** Pressing the Exposure Compensation button and then rotating the Sub-command dial displays the EV compensation number.

• **Flash Exposure Compensation value.** Pressing the Flash mode button and then rotating the Sub-command dial displays the Flash Exposure Compensation value.

• **WB fine-tuning.** Pressing the WB button and then rotating the Sub-command dial fine-tunes the white balance setting. A is warmer, and B is cooler.

• **Color temperature.** When the WB is set to K, the panel displays the color temperature in the Kelvin scale when you press the WB button.

Cross-Reference *For more on white balance and Kelvin, see Chapter 2.*

• **WB preset number.** When the WB is set to one of the preset numbers, pressing the WB button displays the preset number that's currently being used.

✦ **Battery indicator.** This display shows the charge remaining on the active battery.

✦ **Flash mode.** These icons denote which Flash mode you're using. The Flash modes include Red-Eye Reduction, Red-Eye with Slow Sync, Slow Sync, Slow/Rear Sync, and Rear-Curtain Sync.

✦ **Image size.** When shooting JPEG or RAW + JPEG files, this tells you whether you're recording Large, Medium, or Small files. This display is turned off when shooting RAW files.

1.10 Settings on the D90's LCD

✦ **Image quality.** This displays the type of file format you're recording. You can shoot RAW or JPEG. When shooting JPEG or RAW + JPEG, it displays the compression quality: FINE, NORM, or BASIC.

✦ **WB fine-tuning indicator.** When the white balance fine-tuning feature is activated, these two arrows are displayed to inform you that the WB is altered from the default setting.

✦ **WB indicator.** This shows you which white balance setting is currently selected.

✦ **ISO sensitivity compensation indicator.** Although Nikon gives this a lengthy and confusing name, this is basically the last zero in the ISO sensitivity number.

✦ **K.** This appears when the number of remaining exposures exceeds 1000. This isn't to be confused with the K that may appear in the WB area, which is used to denote the Kelvin temperature.

✦ **Beep indicator.** This icon, which looks like a musical note, informs you that the camera beeps when the self-timer is activated or when the camera achieves focus when in Single Focus mode. When the musical note appears inside a circle with a slash, the beep function is turned off. This can be done in CSM d1. Turning the beep off is usually the first thing I do when I configure a new camera.

✦ **GPS connection indicator.** This icon appears in the LCD control panel when a GPS system is connected to the D90's accessory terminal.

✦ **Release mode.** This set of icons shows which Release mode the camera is set to: Single, Continuous Low, Continuous High, Self-timer, Remote, or Delayed Remote.

✦ **F-stop/Aperture indicator.** At default settings, this displays the aperture at which the camera is set.

✦ **Color temperature.** This icon, which appears as a K, appears directly after the number when setting the white balance by selecting a color temperature.

In figure 1.11, you can see these settings:

✦ **FEC indicator.** When this is displayed, your Flash Exposure Compensation is on.

✦ **Exposure compensation indicator.** This icon is shown in the control panel when you press the Exposure Compensation button to adjust the exposure compensation or when exposure compensation has been applied.

✦ **Bracketing indicator.** This indicator appears when auto-bracketing is activated.

✦ **WB bracketing indicator.** When WB bracketing is selected for the Auto bracketing set (CSM e4), the WB icon appears in front of the bracketing indicator.

✦ **Clock indicator.** When this appears in the control panel, the camera's internal clock needs to be set.

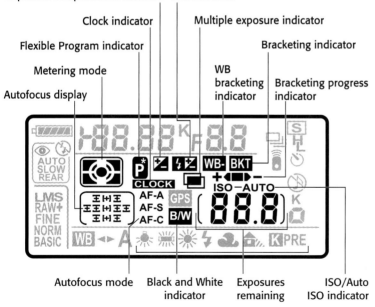

1.11 Settings on the D90's LCD

✦ **Flexible Program indicator.** This icon appears as a P with an asterisk only in Programmed Auto (P) mode. It indicates you have changed the default autoexposure set by the camera to better suit your creative needs.

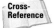 **Cross-Reference** *For more on Flexible Program mode, see Chapter 2.*

✦ **Metering mode.** This shows you which Metering mode the camera is currently set to: Matrix, Center-weighted, or Spot.

✦ **Autofocus display.** This shows you which AF Area mode the camera is set to and displays the active focus point when in Single Point AF or 3D Tracking mode.

✦ **Autofocus mode.** This tells you which of the camera's autofocus modes are in use (Single [AF-S], Continuous [AF-C], or Autofocus [AF-A]). The camera chooses between AF-S or AF-C by determining the subject.

✦ **Black and White indicator.** This icon (B/W) appears when the Picture Control is set to monochrome.

✦ **Exposures remaining.** This displays the number of exposures remaining on your SD card. Half-pressing the Shutter Release button to focus changes the display to show the remaining shots in the camera's buffer. In preset WB, the icon PRE appears when the camera is ready to set a custom WB. You can set your camera to display the ISO setting in this area when the light

meter is active by setting CSM d3 to Show ISO sensitivity. When connected to a computer running Nikon Camera Control Pro 2, PC appears.

✦ **ISO/Auto ISO indicator.** ISO is displayed when the ISO setting appears on the control panel. If the camera is set to Auto ISO, the word AUTO appears after ISO.

✦ **Bracketing progress indicator.** This icon shows you how many frames remain in your bracketing sequence.

✦ **Multiple exposure indicator.** This icon indicates the camera is set to record multiple exposures.

Shooting Info Display

The Shooting Info Display shows some of the same shooting information that appears in the viewfinder, but there are also some settings that are only displayed here. When this is displayed on the LCD, you can view and change the settings without looking through the viewfinder. To view this screen, simply press the Information (info) button near the right side of the LCD. The information remains on display until no buttons have been pushed for about 8 seconds or until the Shutter Release button is pressed.

This display shows you almost everything you need to know about your camera settings. This display comes in handy when the camera is set up on a tripod or if your eyes aren't very good and you have trouble seeing the LCD control panel.

This display can show you a lot of information. To make it easier to decipher, it is broken up over two figures. In figure 1.12, you see these settings:

✦ **Shooting mode.** This displays the Shooting mode that your camera is currently set to. This can be one of the Scene modes, in which case the display is the appropriate icon or one of the semiautomatic

modes, such as P, S, A, or M, in which case the display shows the corresponding letter. This display changes when the Mode dial is rotated.

✦ **Flexible Program indicator.** This asterisk appears when using Programmed Auto mode and you tweak the settings for the metered exposure.

1.12 Settings on the Shooting Info Display

✦ **Shutter speed.** By default, this set of numbers shows you the shutter speed setting. This set of numbers also shows myriad other settings depending on which buttons are pressed:

 • **Exposure compensation value.** Press the Exposure Compensation button to display the EV compensation number then rotate the main command dial to adjust.

 • **FEC value.** Press the Flash mode button to display the FEC number then rotate the sub-command dial to adjust.

 • **WB fine-tuning.** Pressing the WB button and then rotating the Sub-command dial fine-tunes the white balance setting. A is warmer, and B is cooler.

 • **Color temperature.** When the WB is set to K, the panel displays the color temperature in the Kelvin scale when you press the WB button.

✦ **F-stop/Aperture indicator.** At default settings, this displays the aperture at which the camera is set. This indicator also displays auto-bracketing compensation increments. The exposure bracketing can be adjusted to over- and underexpose in 1/3-stop increments. When the Function (Fn) button is set to auto-bracketing, the number of exposure value (EV) stops is displayed in this area. The choices are 0.3, 0.7, or 1.0 EV. The WB auto-bracketing can also be adjusted; the settings are 1, 2, or 3.

✦ **Release mode.** This set of icons shows which Release mode the camera is set to: Single, Continuous Low, or Continuous High.

✦ **Continuous shooting speed.** This displays the continuous shooting speed in frames per second (fps).

✦ **Self-timer/Remote.** These icons can show separately or together. When both icons are lit, the camera is in Delayed Remote mode.

✦ **ISO sensitivity indicator.** This appears above the ISO sensitivity setting number. When Auto ISO is activated, AUTO appears after ISO.

✦ **Beep indicator.** This icon, which looks like a musical note, informs you that the camera beeps when the self-timer is activated or when the camera achieves focus when in Single Focus mode. When the musical note appears inside a circle with a slash, the beep function is turned off. This can be done in CSM d1. Turning the beep off is usually the first the thing I do when I configure a new camera.

✦ **K.** This appears when the number of remaining exposures exceeds 1000. This isn't to be confused with the K that may appear in the WB area, which is used to denote the Kelvin temperature.

✦ **White balance settings.** These icons indicate which WB setting the camera is set to. A set of opposing arrows appears if the WB setting has been modified by applying fine-tuning.

✦ **AE-L/AF-L button assignment.** This tells you what custom function is assigned to the AE-L/AF-L button. This button can be assigned in CSM f4.

✦ **Function button assignment.** This tells you what custom function is assigned to the Function (Fn) button. This button can be assigned in CSM f3.

✦ **Picture Control indicator.** This icon shows which Picture Control setting is activated.

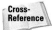 For more on Picture Controls, see Chapter 2.

✦ **Active D-Lighting indicator.** This icon alerts you to the status of the Active D-Lighting option. The settings are Auto, High (H), Normal (N), Low (L), and Off.

✦ **High ISO noise reduction indicator.** This lets you know if Long Exposure NR is being applied. The settings are High (H), Normal (N), Low (L), or Off.

✦ **Long Exposure Noise Reduction (NR) indicator.** This lets you know if Long Exposure NR is activated.

✦ **Metering mode display.** This display shows which Metering mode you're in: Matrix, Center-weighted, or Spot.

✦ **Flash mode indicator.** This area shows you the Flash mode the camera is using. This option is shown only when the built-in flash is raised or an accessory Speedlight is attached. When an accessory Speedlight is attached, an icon is displayed in the top-right corner of this box. Additionally, this option shows you if the Speedlight is in Through-the-Lens mode (TTL), Repeating Flash mode (RPT), or Commander mode (CMD).

Cross-Reference *For more on Flash modes and Speedlights, see Chapter 6.*

✦ **Electronic analog exposure display.** As discussed previously, this is your light meter. When the bars are in the center, you're at the proper settings for a good exposure for your photograph; when the bars are to the left, your image will be overexposed; when the bars are to the right, your image will be underexposed. This is displayed full-time when the camera is set to M mode. When in P, S, or A or one of the Scene modes, this is only displayed when the current settings will cause an under- or overexposure. When in Auto mode, if the camera can't achieve a proper setting, this simply blinks.

In figure 1.13, you see these settings:

✦ **AC adapter indicator.** When the optional EH-5a AC adapter is attached, this icon is displayed.

✦ **FV Lock indicator.** This icon is shown when the FV Lock is activated. The FV Lock can be assigned to the Function (Fn) or AE-L/AF-L button.

✦ **FEC indicator.** When this is displayed, your Flash Exposure Compensation is on. Adjust the FEC by pressing the Flash mode button and then rotating the Sub-command dial.

Battery indicator FEC indicator Multiple exposure indicator

AC adapter indicator Exposure compensation indicator Auto-bracketing indicator Active D-Lighting indicator

FV Lock indicator

AF Area indicator Image comment indicator

Clock indicator Autofocus mode

Image quality GPS connection indicator Exposures remaining

Image size ISO sensitivity indicator

1.13 Additional settings on the Shooting Info Display

✦ **Exposure compensation indicator.** When this appears in the Shooting Info Display, your camera has exposure compensation activated. This affects your exposure. Adjust the exposure compensation by pressing the Exposure Compensation button and then rotating the Main Command dial.

✦ **Multiple exposure indicator.** This icon informs you that the camera is set to record multiple exposures. You can set multiple exposures in the Shooting menu.

✦ **Auto-bracketing indicator.** When in Autoexposure mode or Flash Bracketing mode, this appears on the control panel; when using WB bracketing, a WB icon also appears above the icon. When using Active D-Lighting (AD-L) bracketing, you see an ADL icon in conjunction with BKT. You set auto-bracketing in CSM e4.

✦ **Active D-Lighting indicator.** This icon alerts you to the status of the Active D-Lighting option. The settings are Auto, Extra High (H*), High (H), Normal (N), Low (L), and Off.

✦ **Image comment indicator.** This icon is shown when the image comment option is enabled. You can add an image comment in the Setup menu.

✦ **Autofocus mode.** This shows you the AF mode that the camera is currently set to. The choices are Auto AF (AF-A), Single (AF-S), and Continuous (AF-C).

✦ **ISO sensitivity indicator.** These numbers indicate the ISO sensitivity settings.

✦ **Exposures remaining.** This number indicates the approximate amount of exposures you can store on your memory card.

✦ **GPS connection indicator.** When the optional GPS unit (GPS-1) is attached, this icon appears.

✦ **AF Area indicator.** This shows which AF Area mode the camera is set to. Information includes 3D Tracking, Wide Area Center AF Point, Auto Area, and Single AF Point.

✦ **Image quality.** This tells you the type and quality of file that's being written to your memory card as you take photos. The options are RAW, RAW + JPEG, and JPEG. JPEG and RAW + JPEG compression options (quality) are Fine, Normal, and Basic. Change this by pressing the Quality (QUAL) button and then rotating the Main Command dial.

✦ **Image size.** This tells you the resolution size of the file when saving to JPEG or Large (L), Medium (M), or Small (S). Change this setting by pressing the Quality (QUAL) button and then rotating the Sub-command dial.

✦ **Clock indicator.** This icon appears if the camera's internal clock hasn't been set. You can set the clock in the Setup menu by selecting World time.

✦ **Battery indicator.** This is where you can check the power levels of your camera's batteries. When the optional MB-D80 grip is attached by using two EN-EL3e batteries, two battery icons are shown.

Nikon D90 Essentials

When you familiarize yourself with the basic layout of the D90 and all the various dials, switches, and buttons, you should find it much easier to navigate to and adjust the settings that allow you to control and fine-tune the way you capture images with your camera. In this chapter, I cover some of the most commonly changed settings of the camera, such as the Exposure and Metering modes, autofocus (AF) settings, white balance, and ISO. All these settings combined create your image, and you can tweak and adjust them to reflect your artistic vision or to simply ensure that you create the best possible images in complex scenes.

Exposure settings include the Exposure modes that decide how the camera chooses the aperture and shutter speed and the Metering modes that decide how the camera gathers the lighting information so that the camera can choose the appropriate settings based on the Exposure mode. In this chapter, you also learn more about ISO, which also plays into exposure, and exposure compensation. Exposure compensation allows you to fine-tune the exposure to suit your needs or to achieve the proper exposure in situations where your light meter may be fooled.

In this chapter, I also explain the Autofocus modes, which decide which areas of the viewfinder are given preference when the camera is deciding what to focus on. Discussions of white balance, Picture Controls, and Live View round out this chapter.

Exposure Modes

Exposure modes are one of the most important settings of your camera. These modes determine the parameters of how the exposure settings are changed (or not) by the camera. The D90 has the four standard Exposure modes found on all Nikon dSLRs as well as some Scene modes, also referred to as Digital Vari-Program (DVP) modes. Scene modes are discussed later in this chapter.

The four standard Exposure modes range from an automatic mode that chooses the shutter speed and aperture for you to semi-automatic modes that allow you to choose the shutter speed or aperture, allowing the camera to make the other adjustments, or a fully manual setting in which you determine both the shutter speed and the aperture.

Programmed Auto

Programmed Auto mode, or P, is a fully automatic mode that's best for shooting snapshots and scenes where you're not concerned about controlling the settings.

When the camera is in Programmed Auto mode, it decides all the exposure settings for you based on a set of algorithms. The camera attempts to select a shutter speed that allows you to shoot handheld without suffering from camera shake while also adjusting your aperture so that you get good depth of field to ensure everything is in focus. When the camera body is coupled with a lens that has a CPU built in (all Nikon AF lenses have a CPU), the camera automatically knows what focal length and aperture range the lens has. The camera then uses this lens information to decide what the optimal settings should be.

This Exposure mode chooses the widest aperture possible until the optimal shutter speed for the specific lens is reached. Then, the camera chooses a smaller f-stop and increases the shutter speed as light levels increase. For example, when you're using the 18-105mm kit lens, the camera keeps the aperture wide open until the shutter speed reaches about 1/40 second (just above minimum shutter speed to avoid camera shake at a normal focal length). Upon reaching 1/40 second, the camera adjusts the aperture to increase the depth of field.

The exposure settings selected by the camera are displayed in both the LCD control panel and the viewfinder display. Although the camera chooses what it thinks are the optimal settings, the camera doesn't know what your specific needs are. You may decide that your hands aren't steady enough to shoot at the shutter speed the camera has selected or you may want a wider or smaller aperture for selective focus. Fortunately, you aren't stuck with the camera's exposure choice. You can engage what's known as *Flexible Program*. Flexible Program allows you to deviate from the camera's selected aperture and shutter speed when you're in P mode. You can automatically engage this feature by simply rotating the Main Command dial until the desired shutter speed or aperture is achieved. This allows you to choose a wider aperture/faster shutter speed when you rotate the dial to the right or a smaller aperture/slower shutter speed when you rotate the dial to the left. With Flexible Program, you can maintain the metered exposure while still having some control over the shutter speed and aperture settings.

A quick example of using Flexible Program would be if the camera has set the shutter speed at 1/60 second with an aperture of f/8, you're shooting a portrait, and you want a wider aperture to throw the background out of focus. By rotating the Main Command dial to the right, you can open the aperture up to f/4, which causes the shutter speed to increase to 1/250 second. This is what is known as an equivalent exposure, meaning you get the same exact exposure but the settings are different.

When Flexible Program is on, an asterisk appears next to the P on the LCD control panel. Rotate the Main Command dial until the asterisk disappears to return to the default Programmed Auto settings.

 Caution *Programmed Auto mode isn't available when you're using non-CPU lenses. When you're in P mode with a non-CPU lens attached, the camera automatically shows an aperture error. The camera must be in Manual mode to work with non-CPU lenses.*

Aperture Priority

Aperture Priority mode, or A, is a semiautomatic mode. In this mode, you decide which aperture to use and the camera sets the shutter speed for the best exposure based on your selection. Situations where you may want to select the aperture include when you're shooting a portrait and want a large aperture (small f-stop number) to blur out the background by minimizing the depth of field or when you're shooting a landscape and want a small aperture (large f-stop number) to ensure the entire scene is in focus by increasing the depth of field.

Choosing the aperture to control the depth of field is one of the most important aspects of photography and allows you to selectively control which areas of your image, from foreground to background, are in sharp focus and which areas are allowed to blur. Controlling the depth of field enables you to draw the viewer's eye to a specific part of the image, which can make your images more dynamic and interesting to the viewer.

Note *In Aperture Priority mode, if there's not enough light to make a proper exposure, the camera displays Lo in place of the shutter speed setting.*

Shutter Priority

Shutter Priority mode, or S, is another semi-automatic mode. In this mode, you choose the shutter speed and the camera sets the aperture.

Shutter Priority mode is generally used for shooting moving subjects or action scenes. Choosing a fast shutter speed allows you to freeze the action of a fast-moving subject. A good example would be if you were shooting a bicycle race. Bicycles can move extremely fast, so you need to use a fast shutter speed of about 1/1000 second to freeze the motion of the bicycle and prevent blur. This would allow you to capture most of the crisp details of the subject.

There are also times when you may want to use a slow shutter speed, and you can also use this mode for that. When you shoot night scenes, a long exposure is often preferable, and choosing your shutter speed can allow you to introduce many creative effects into your photography. I often like to shoot

city skylines at night, and more often than not, a skyline is located near a river. Selecting a slow shutter speed of about 2 to 4 seconds gives moving bodies of water a neat glass-like appearance that I find appealing. Be sure to bring along your favorite tripod for support.

Even when you shoot action, you have times when you may want to use a slower shutter speed. Panning along with a moving subject at a slower shutter speed allows you to blur the background while keeping the subject in relatively sharp focus. The blur of the background is extremely effective in portraying motion in a still photograph. I use this technique extensively when shooting motorsports. Using a shutter speed that's too high (fast) when shooting race cars causes the vehicle to look as if it's parked on the track because it may potentially freeze the motion of the wheels. Selecting a relatively slow shutter speed of about 1/320 second and panning along with the car allows me to capture some blur in the tires, showing rotation so that the viewer can see that the car is actually moving.

Note *In Shutter Priority mode, if there's not enough light to make a proper exposure, the camera displays Lo in place of the aperture setting.*

Manual

When in Manual mode, or M, you set both the aperture and shutter speed settings. You can estimate the exposure, use a handheld light meter, or use the D90's electronic analog exposure display to determine the exposure needed.

Cross-Reference *For more on the electronic analog exposure display, see Chapter 1.*

You're probably wondering why you'd use Manual exposure when you have the other modes. There are a few situations where you may want to manually set the exposure:

✦ **When you want complete control over your exposure.** In most situations, the camera decides the optimal exposure based on technical algorithms and an internal database of image information. Oftentimes, what the camera decides is optimal isn't necessarily what's optimal in your mind. You may want to underexpose to make your image dark and foreboding or you may want to overexpose a bit to make the colors *pop* (making colors bright and contrasty). If your camera is set to M, you can choose the settings and then place your image in whatever tonal range you want without having to fool with exposure compensation settings.

✦ **When using studio flash.** When you're using studio strobes or external nondedicated flash units, you don't use the camera's metering system. When using external strobes, you need a flash meter or manual calculation to determine the proper exposure. Using Manual mode, you can quickly set the aperture and shutter speed to the proper exposure; just be sure not to set the shutter speed above the rated sync speed of 1/250 second.

✦ **When using non-CPU lenses.** When you use older, non-CPU lenses, set the exposure to Manual. Non-CPU lenses lack a computer chip that allows the camera and lens to communicate, so all exposure settings must be calculated and applied manually.

Scene Modes

Scene modes are for photographing specific scene types, such as sports or portraits. Each of these types of photographic scenarios requires different settings to achieve optimal results. The D90's different scene modes allow you to capture the scene with the settings that are best for what you're photographing. The camera does this by automatically choosing the preferred setting for the scene type selected. For example, when shooting sports, it's usually preferable to use a fast shutter speed to freeze the action, but when shooting a portrait, you usually want to use a wider aperture.

The camera has these parameters programmed into it so you can just rotate the Mode dial to the scene type. This way, you can focus on capturing the moment rather than fretting over what the proper settings should be. When using these Scene modes, the camera controls all facets of the exposure process, including setting the shutter speed, aperture, and ISO. The Scene modes dictate which Picture Control is applied. The camera also determines if there's enough light to make an exposure and activates the built-in flash if there's not enough light. Some of these Scene modes also make sure that the flash isn't used even in low-light situations.

There are some parameters that you can control when using Scene modes, but some settings are fixed and can't be modified at all. These settings are covered throughout this chapter.

In all these Scene modes, you have complete control of the Release mode, meaning you can set the Release mode to any of the available settings: The Release mode controls how the Shutter Release button functions when pressed (Single, Continuous High, Continuous Low, etc.). Release modes are covered later in this chapter.

✦ **ISO.** By default, all the Scene modes use Auto ISO. To disable Auto ISO, simply press the ISO (Thumbnail) button and then rotate the Main Command dial to the desired ISO. To return to the Auto ISO setting, rotate the Main Command dial to the left past the L 1.0 ISO setting until the ISO setting reads AUTO.

Changing the Auto ISO setting when using Scene modes makes a global change that affects the ISO settings in all modes. Be sure to change the ISO setting back to Auto ISO when finished.

✦ **Metering modes.** All the Scene modes use Matrix metering as a default. This can't be changed.

✦ **Exposure compensation.** Exposure compensation is disabled altogether when using Scene modes.

✦ **Set Picture Control.** The camera automatically selects a Picture Control for the specific scene. The Picture Control can't be adjusted in-camera.

✦ **AF Area mode.** When using Auto, Auto (flash off), Portrait, Landscape, and Night Portrait Scene modes, the AF Area mode, which controls how the focus point is selected, is set to Auto Area by default. This allows the camera to automatically focus by using a number of focus points. When using Sports mode, the camera is set to Dynamic Area, and in Close-Up mode, the camera

is set to Single Point. You can change the default AF setting in CSM a1 to choose from Single Point, Dynamic, or 3D Tracking. Rotating the Mode dial to another setting reverts the setting back to default. AF Area modes are discussed in detail later in this chapter.

 For more on the Custom Setting menu, see Chapter 3.

✦ **White Balance.** The WB setting is set to Automatic for all Scene modes. The WB can't be modified in any way.

Auto mode

This mode is basically what can be described as a point-and-shoot mode. The camera takes complete control of the exposure. The camera's meter reads the light, the color, and the brightness of the scene and then runs the information through a sophisticated algorithm. The camera uses this information to determine what type of scene you're photographing and chooses the settings that it deems appropriate for the scene. If there isn't enough light to make a proper exposure, the camera's built-in flash pops up when the Shutter Release button is half-pressed for focus. The flash fires when the shutter is released, resulting in a properly exposed image.

This mode is great for taking snapshots or if you simply want to concentrate on capturing the image while letting the camera determine the proper settings.

The Flash mode is set to Auto. If there isn't enough light to get a proper exposure, the flash automatically pops up when the

Shutter Release button is half-pressed. Pressing the Flash mode button and then rotating the Main Command dial allows you to change the Flash mode to Auto with Red-Eye Reduction or you can choose to turn the flash off altogether.

Auto (flash off) mode

This mode functions in the same way as the Auto setting except that the flash is disabled even in low-light situations. In instances when the lighting is poor, the camera's AF-assist illuminator lights up to provide sufficient light to achieve focus. The camera uses the focus area where the closest subject is to focus on.

This setting is preferred when you want to use natural or ambient light for your subject or in situations where you aren't allowed to use flash, such as museums or at certain events, such as weddings, where the flash may cause distraction.

Portrait mode

This mode is for taking pictures of people. The camera selects the Portrait Picture Control to render natural-looking skin tones. The camera also attempts to use a wide aperture, if possible, to reduce the depth of field. This draws attention to the subject of the portrait, leaving distracting background details out of focus.

The built-in flash and AF-assist illuminator are automatically activated in low-light situations. The Flash mode is set to Auto by default and can be changed to Red-Eye Reduction mode or turned off completely by pressing the Flash mode button and then rotating the Main Command dial.

Landscape mode

This mode is used for taking photos of far-off vistas, but it also works well when shooting architecture or other types of scenic photos. The camera automatically selects the Landscape Picture Control to provide brighter greens and blues to skies and foliage and to give the image added contrast. The camera uses a smaller aperture to provide a greater depth of field to ensure focus throughout the entire image.

When using this mode, the AF-assist illuminator and the flash are automatically disabled.

Using a tripod is a necessity when using this mode in low-light situations.

Close-Up mode

This mode is for use when taking close-up or macro shots. This mode uses a fairly wide aperture to provide a soft background while giving the main subject a sharp focus. In this mode, the camera defaults to Single Area Focus in the center of the frame, although you can use the Multi-selector to choose one of the other focus points to create an off-center composition. You can also change the focus area mode in CSM a1. If you change the focus area mode, you can easily revert to default by switching to another mode and then switching back.

When the light is low, the built-in flash is automatically activated. Be sure to remove your lens hood when using the flash on close-up subjects because the lens hood can cast a shadow on your subject by blocking the light from the flash.

Sports mode

This mode uses a fast shutter speed to freeze the action of moving subjects. The camera focuses continuously as long as the Shutter Release button is half-pressed. The Sports mode uses Dynamic Area AF, which uses information from all the focus points to help track the subject if it moves from the selected focus area (the center focus point is default). You can change the AF Area mode by using CSM a1. Dynamic AF works best for this mode, but 3D Tracking can also work well.

The built-in flash and AF-assist illuminator are disabled when this mode is selected.

Night Portrait mode

This mode is for taking portraits in low-light situations. The flash is automatically activated and is set to Slow Sync, which allows the camera to use a longer shutter speed to capture the ambient light from the background. This balances the ambient light as well as the light from the flash, giving you a more natural-looking effect. You can also set Red-Eye Reduction to on or you can turn the flash off completely.

Using a tripod is recommended when this feature is selected to prevent blur from camera shake that can occur when using longer exposures times.

Release Modes

Release modes control how the Shutter Release button functions when pressed and also how fast the camera can continuously shoot. You can change the Release mode by

pressing the Release mode button located next to the LCD control panel. There are six release modes to choose from:

✦ **Single.** This mode only allows the camera to shoot one frame each time the Shutter Release button is fully depressed. The button can be half-released to reset the shutter to shoot again. This is a good default setting to use for most scenarios. This helps reduce taking any accidental shots when you hold the Shutter Release button down too long when snapping a photo.

✦ **Continuous Low.** This setting allows the camera to fire shots continuously as long as the Shutter Release button is pressed and held down. This is the low speed mode that fires at a lower frame rate. You can choose the frame rate in CSM a6. You can set the frame rate to 1, 2, 3, or 4 frames per second (fps).

✦ **Continuous High.** This setting allows the camera to fire continuously at the maximum frame rate as long as the Shutter Release button is pressed and held down. The highest frame rate is 4.5 fps.

 Note *The continuous frame rate can vary depending on the settings chosen. The frame rate can slow down depending on the shutter speed, buffer, and SD card speed.*

✦ **Self-timer.** This gives the Shutter Release a delay after the button is pressed, allowing you to get in the picture or allowing the camera to stop vibrating when using a tripod and a long shutter speed to reduce

blur from camera shake. The self-timer delay can be set in CSM c3. You can set the delay to 2, 5, 10, or 20 seconds. In CSM c3, you can also set the camera to fire a burst of shots (1–9 frames) at the Continuous Low setting.

✦ **Delayed Remote.** To use this mode, you need an optional Nikon ML-L3 infrared wireless remote. This allows you to trigger the Shutter Release remotely with a delay.

✦ **Quick Response Remote.** This mode also requires the ML-L3. When the button on the ML-L3 is pressed, the camera fires as soon as the scene is in focus. When in Manual focus mode, the shutter releases instantly.

Metering Modes

The D90 has three Metering modes — Multi-segment (Matrix), Center-weighted, and Spot — to help you get the best exposure for your image. You can change the modes by pressing the Metering mode button (located directly behind the Shutter Release button on the left side) and then rotating the Main Command dial.

Metering modes determine how the camera's light sensor collects and processes the information used to determine exposure. Each of these modes is useful for different types of lighting situations.

Note *Metering modes can't be changed when using Scene modes.*

Matrix metering

The default metering system that Nikon cameras use is a proprietary system called 3D Color Matrix Metering II, or Matrix metering for short. Matrix metering reads a wide area of the frame and sets the exposure based on the brightness, contrast, color, and composition. Then, the camera runs the data through sophisticated algorithms and determines the proper exposure for the scene. When using a Nikkor D- or G-type lens, the camera also takes the focusing distance into consideration.

 For more on lenses and lens specifications, see Chapter 4.

The D90 has a 420-pixel RGB (red, green, blue) sensor that measures the intensity of the light and the color of a scene. The camera then compares the information to information from 30,000 images stored in its database. The D90 determines the exposure settings based on the findings from the comparison. Simplified, it works like this: You're photographing a portrait outdoors, and the sensor detects that the light in the center of the frame is much dimmer than the edges. The camera takes this information along with the focus distance and then compares it to the ones in the database. The images in the database with similar light and color patterns and subject distance tell the camera that this must be a close-up portrait with flesh tones in the center and sky in the background. From this information, the camera decides to expose primarily for the center of the frame, although the background may be overexposed. The RGB sensor also takes note of the quantity of the colors and then uses that information.

The Matrix meter of the D90 performs several ways, automatically, based on the type of Nikon lens that's used:

✦ **3D Color Matrix Metering II.** As mentioned earlier, this is the default metering system that the camera employs when a G- or D-type lens is attached to the camera. Most lenses made since the early to mid-1990s are these types of lenses. The only difference between the G- and D-type lenses is that on G-type lens, there's no aperture ring. An aperture ring is a mechanical ring that allows the photographer to manually set the aperture on older film cameras that lacked a Sub-command dial (all cameras prior to the F100). When using the Matrix metering method, the camera decides the exposure setting mostly based on the brightness and contrast of the overall scene and the colors of the subject matter as well as other data from the scene. It also takes into account the distance of the subject and which focus point is used as well as the focal length of the lens to further decide which areas of the image are important to getting the proper exposure. For example, if you're using a wide-angle lens for a distant subject with a bright area at the top of the frame, the meter takes this into consideration when setting the exposure so that the sky and clouds don't lose critical detail.

✦ **Color Matrix Metering II.** This type of metering is used when a non-D- or non-G-type CPU lens is attached to the camera. Most AF lenses made from about 1986 to the early

to mid-1990s fit into this category. The Matrix metering recognizes this, and the camera uses only brightness, subject color, and focus information to determine the right exposure.

Matrix metering is suitable for use with most subjects, especially when you're in a particularly tricky or complex lighting situation. Given the large amount of image data in the Matrix metering database, the camera can make a fairly accurate assessment about what type of image you're shooting and then adjust the exposure accordingly. For example, with an image with a high amount of contrast and brightness across the top of the frame, the camera tries to expose for the scene so that the highlights retain detail. Paired with Nikon's Active D-Lighting, your exposures will have good dynamic range throughout the entire image.

Cross-Reference *For more on Active D-Lighting, see Chapter 3.*

Center-weighted metering

When the camera's Metering mode is switched to Center-weighted, the meter takes a light reading of the whole scene but bases the exposure settings mostly on the light falling on the center of the scene. The camera determines about 75 percent of the exposure from a circular pattern in the center of the frame and 25 percent from the area around the center.

The D90 incorporates a variable center-weighted meter so you can adjust the size of the center-weighted area based on the

scene you're trying to meter. By default, the circular pattern is 8mm in diameter, but you can choose to make the circle bigger or smaller depending on the subject. Your choices are 6mm, 8mm, or 10mm and are found in CSM b3.

 Cross-Reference *For more on changing the center-weighted circle diameter, see Chapter 3.*

Center-weighted metering is a very useful option. It works great when shooting photos where you know the main subject is in the middle of the frame. This Metering mode is useful when photographing a dark subject against a bright background or a light subject against a dark background. It works especially well for portraits where you want to preserve the background detail while exposing correctly for the subject.

With Center-weighted metering, you can get consistent results without worrying about the adjustments in exposure settings that can sometimes happen when using Matrix metering.

Spot metering

In Spot metering mode, the camera does just that: meters only a spot. This spot is only 3.5mm in diameter and only accounts for 2.5 percent of the entire frame. The spot is linked to the active focus point, which is good, so you can focus and meter your subject at the same time, instead of metering the subject, pressing the AE-L button, and then recomposing the photo. The D90 has 11 focus points, so it's like having 11 spot meters to choose from throughout the scene.

 Caution *When using Auto Area AF and Spot metering, the camera defaults to the center spot for metering. If your subject isn't in the center of the frame, this can cause incorrect exposures. Therefore, using Auto Area AF and spot metering isn't advisable.*

Choose Spot metering when the subject is the only thing in the frame that you want the camera to expose for. You select the spot meter to meter a precise area of light within the scene. This isn't necessarily tied to the subject. For example, when you're photographing a subject on a completely white or black background, you need not be concerned with preserving detail in the background; therefore, exposing just for the subject works out perfectly. One example where this mode works well is concert photography where the musician or singer is lit by a bright spotlight. You can capture every detail of the subject and just let the shadow areas go black.

Focus Modes

The Nikon D90 has a few different Focus modes, three of which are AF modes: Auto (AF-A), Continuous (AF-C), Single (AF-S), and Manual (M). Each of these modes is useful in its own distinct way for different types of shooting conditions, from sports to portraits to still-life photographs. To change the AF mode, press the AF mode button and then rotate the Main Command dial. The AF mode button is located on the top of the camera, just above the Main Command dial. To switch to full manual focus, simply flip the switch that's located near the base of the lens (labeled with an AF and M).

How the D90 autofocus works

The D90 has inherited the Multi-CAM 1000 AF module from the D200. This AF module is a very sophisticated and well-regarded AF system. It features 11 focus points: one cross-type sensor, eight vertical, and two horizontal.

Simplified, the Multi-CAM 1000 AF works by reading contrast values from a sensor inside the camera's viewing system. As I mentioned earlier, the D90 employs three sensor types: cross, vertical, and horizontal. As you may have guessed, cross-type sensors are shaped like a cross, while horizontal and vertical sensors are shaped like a line. You can think of cross-type sensors like plus and minus signs. Cross-type sensors are able to read the contrast in two directions: horizontally and vertically. Horizontal and vertical sensors can only interpret contrast in one direction. (When the camera is positioned in portrait orientation, the horizontal sensors are positioned vertically and vice versa.)

Cross-type sensors can evaluate for focus much more accurately than horizontal or vertical sensors, but horizontal and vertical sensors can do it a bit more quickly (provided that the contrast is running in the right direction). Cross-type sensors require more light to work properly, so horizontal and vertical sensors are used in the array to speed up the AF, especially in low-light situations.

Phase detection

The D90's AF system works by using *phase detection*, which uses a sensor in the camera's body. Phase detection is achieved by using a beam splitter to divert light that's

coming from the lens to two optical prisms that send the light as two separate images to the D90's AF sensor. This creates a type of rangefinder where the base is the same as the diameter or aperture of the lens. The larger the length of the base, the easier it is for the rangefinder to determine whether the two images are *in phase*, or in focus. This is why lenses with wider apertures focus faster than lenses with smaller maximum apertures.

This is also why the AF usually can't work with slower lenses coupled with a teleconverter, which reduces the effective aperture of the lens. The base length of the rangefinder images is simply too small to allow the AF system to determine the proper focusing distance. The AF sensor reads the contrast or phase difference between the two images that are being projected on it. This type of focus is also referred to as SIR-TTL — Secondary Image Registration–Through the Lens — given that the AF sensor relies on a secondary image, as opposed to the primary image, that's projected into the viewfinder from the reflex mirror.

Contrast detection

Contrast detection focus is only used by the D90 in Live View mode. This is the same method that smaller compact digital cameras use to focus. Contrast detection focus is slower and uses the image sensor itself to determine whether the subject is in focus. It's a relatively simple operation in which the sensor detects the contrast between different pixels in the scene. The camera does this by moving the lens elements until sufficient contrast is achieved between the pixels that lie under the selected focus point. With contrast detection, a wider area of the frame can be used to determine focus.

AF-C mode

When the camera is set to Continuous AF (AF-C), the camera continues to focus as long as the Shutter Release button is pressed halfway (or if the AE-L/AF-L button is set to AF-On (in CSM f4) and the button is pressed). If the subject moves, the camera activates Predictive Focus Tracking. With Predictive Focus Tracking on, the camera tracks the subject to maintain focus and attempts to predict where the subject is when the Shutter Release button is released. When in AF-C mode, the camera fires when the Shutter Release button is fully depressed, whether or not the subject is in focus. This custom AF setting is known as Release Priority. This is the best mode to use when your subject is moving around a lot.

AF-S mode

In Single AF, or AF-S mode (not to be confused with the lens designation), the camera focuses when the Shutter Release button is pressed halfway. When the camera achieves focus, the focus locks. The focus remains locked until the Shutter Release button is released or the Shutter Release button is no longer pressed. The camera doesn't fire unless focus has been achieved (Focus Priority). The AF-S mode is the best mode to use when shooting portraits, landscapes, or other photos where the subject is relatively static.

Using this mode helps ensure that you have fewer out-of-focus images.

AF-A mode

Using this mode, the camera selects Single or Continuous Focus by determining if the subject is moving. This setting is very intuitive,

and although I don't normally use automated settings such as this, I find that it works pretty well, and I recommend using this mode for most general types of photography.

Manual mode

When set to Manual (M) mode, the D90 AF system is off. You achieve focus by rotating the focus ring of the lens until the subject appears sharp as you look through the viewfinder. You can use the Manual focus setting when shooting still-life photographs or other nonmoving subjects when you want total control of the focus or simply when you're using a non-AF lens. You may want to note that the camera shutter releases regardless of whether the scene is in focus.

When using the manual focus setting, the D90 offers a bit of assistance in the way of an electronic rangefinder. Basically, you press the Shutter Release button halfway, rotate the focus ring, and then use the focus indicator located in the lower-left side of the viewfinder display to determine if your subject is in focus.

Autofocus Area Modes

The D90 has four AF Area modes to choose from: Single Point AF, Dynamic Area AF, Auto Area AF, and 3D Tracking. AF Area modes can be changed in CSM a1.

As discussed earlier in this chapter, the D90 employs 11 separate AF points. The 11 AF points can be used individually in Single Point AF mode or you can choose one point and have it work in conjunction with the nonactive points when in Dynamic Area AF mode.

The D90 can also be set to employ 3D Tracking, which enables the camera to automatically switch focus points and maintain sharp focus on a moving subject as it crosses the frame. 3D Tracking is made possible by the camera recognizing distance, color, and light information and then using it to track the subject across the frame.

Single Point AF mode

Single Point AF mode is the easiest mode to use when you're shooting slow-moving or completely still subjects. You can press the Multi-selector up, down, left, right, or diagonally to choose one of the AF points. The camera only focuses on the subject if it's in the selected AF area. Once the point is selected, it can be locked by rotating the focus selector lock to the L position. The selected AF point is displayed in the viewfinder.

Dynamic Area AF mode

Dynamic Area AF mode also allows you to select the AF point manually, but unlike Single Point AF, the remaining unselected points remain active; this way, if the subject happens to move out of the selected focus area, the camera's highly sophisticated autofocus system can track it throughout the frame.

When you set the focus mode to AF-S (discussed earlier in this chapter), the mode operates exactly the same as if you were using Single Point AF. To take advantage of Dynamic Area AF, the camera must be set to AF-C mode.

3D Tracking mode

This mode has all 11 AF points active. You select the primary AF point, but if the subject moves, the camera uses 3D Tracking to automatically select a new primary AF point. 3D Tracking is accomplished by the camera using distance and color information from the area immediately surrounding the focus point. The camera uses this information to determine what the subject is, and if the subject moves, the camera selects a new focus point. This mode works very well for subjects moving unpredictably; however, you need to be sure that the subject and the background aren't similar in color. When photographing a subject with a color similar to that of the background, the camera may lock focus on the wrong area, so use this mode carefully. I have problems with this mode particularly when shooting team sports where the players are wearing uniforms. The AF system can't accurately track the subjects.

Auto Area AF

Auto Area AF is exactly what it sounds like: The camera automatically determines the subject and then chooses one or more AF points to lock focus. Due to the D90's Scene Recognition System, when it's used with Nikkor D- or G-type lenses, the D90 is able to recognize human subjects. This means that the camera has a better chance of focusing where you want it than accidentally focusing on the background when shooting a portrait. Normally, I tend not to use a fully automatic setting such as this, but I've found that it works reasonably well and recommend using it when you're shooting candid photos. When the camera is set to Single AF mode, the active AF points light up in the viewfinder for about 1 second when the camera attains focus; when in Continuous AF mode, no AF points appear in the viewfinder.

ISO Sensitivity

ISO (International Organization for Standardization) is the rating for the speed of film, or, in digital terms, the sensitivity of the sensor. The ISO numbers are standardized, which allows you to be sure that when you shoot at ISO 100, you get the same exposure no matter what camera you're using.

The ISO for your camera determines how sensitive the image sensor is to the light that's reaching it through the lens opening. Increasing or reducing the ISO affects the exposure by allowing you to use faster shutter speeds or smaller apertures (raising the ISO) or use slower shutter speeds or wider apertures (lowering the ISO).

You can set the ISO very quickly on the D90 by pressing and holding the ISO button and then rotating the Main Command dial until the desired setting appears in the LCD control panel. As with other settings for controlling exposure, the ISO can be set in 1/3-stop increments.

The D90 has a native ISO range of 200 to 3200. In addition to these standard ISO settings, the D90 also offers some settings that extend the available range of the ISO so you can shoot in very bright or very dark situations. These are labeled as H (high speed) and L (low speed). By default, the H and L options are set in 1/3-stop adjustments up to H1. The options are as follows:

✦ **H0.3, H0.7, H1.0.** These settings are equivalent to approximately ISO 4000, 5000, and 6400, respectively.

✦ **L0.3, L0.7, and L1.0.** These settings are equivalent to approximately ISO 160, 125, and 100, respectively.

You can also set the ISO by going into the Shooting menu and then choosing the ISO sensitivity settings option.

 Caution *Using the H and L settings won't produce optimal results. Using the L setting can result in images that are slightly lower in contrast, and using the H setting can cause your images to have increased amounts of digital noise.*

Auto ISO

The D90 also offers a feature where the camera adjusts the ISO automatically for you when there isn't enough light to make a proper exposure. Auto ISO is meant to free you up from making decisions about when to raise the ISO. You can set the Auto ISO in the Shooting menu under the ISO sensitivity settings option.

By default, when Auto ISO is on, the camera chooses an ISO setting from 200 up to 3200 whenever the shutter speed falls below 1/30 second. Basically, what this means is that when Auto ISO is turned on, if you manually change the ISO, the camera can't be set to a lower ISO than what the Auto ISO was set to in the Shooting menu. So, if you set it to ISO 800, then when you're shooting, Auto ISO won't lower the ISO below 800.

You can also limit how high the ISO can be set so you can keep control of the noise created when a higher ISO is used (although the amount of overall noise generated by the D90 is much lower than most of the cameras that preceded it).

On the opposite end of the spectrum, if you manually set the ISO to 400, the Auto ISO function won't allow the ISO to go lower than ISO 400, no matter how bright the scene is. So, when using the Auto ISO feature, be sure to set your ISO to 200 to ensure that you can get the full range of ISO settings and avoid overexposing your images.

Using Auto ISO can sometimes yield questionable results because you can't be certain what ISO adjustments the camera will make. So, if you're going to use it, be sure to set it to conditions that you deem acceptable to ensure your images won't be blurry or noisy. In the past, I've shied away from using the Auto ISO feature, but with the D90's low noise, I've been using it quite often. I find that it works especially well when shooting live music events where the lighting is constantly changing. I set the Maximum sensitivity to 3200 and the minimum shutter speed to 1/125 and then shoot away without worrying about my ISO settings. It really frees me up and allows me to concentrate more on composition and getting the shots than worrying about my settings.

Be sure to set the following options in the Shooting menu/ISO sensitivity settings:

✦ **Maximum sensitivity.** Choose an ISO setting that allows you to get an acceptable amount of noise in your image. If you're not concerned about noisy images, then you can set it all the way up to H1. If you need your images to have less noise, you can choose a lower ISO. The choices are 400, 800, 1600, 3200, and H1.

✦ **Minimum shutter speed.** This setting determines when the camera adjusts the ISO to a higher level. At the default, the camera bumps up the ISO when the shutter speed falls below 1/30 second. If you're using a longer lens or you're photographing moving subjects, you may need a faster shutter speed. In that case, you can set the minimum shutter speed up to 1/4000. On the other hand, if you're not concerned about camera shake or if you're using a tripod, you can set a shutter speed as slow as 1 second.

Note *The minimum shutter speed is only taken into account when using Programmed Auto or Shutter Priority modes.*

Note *When using Auto ISO, the camera chooses random ISO settings that don't necessarily conform to 1/3-stop settings. For example, you can have an image shot at ISO 560 even though that setting isn't available for you to set manually.*

Noise reduction

Since the inception of digital cameras, they've been plagued with what is known as *noise*. Noise, simply put, is randomly colored dots that appear in your image. Noise is caused by extraneous electrons that are produced when your image is being recorded. When light strikes the image sensor in your D90, electrons are produced. These electrons create an analog signal that's converted into a digital image by the Analog-to-Digital (A/D) converter in your camera (yes, digital cameras start with an analog signal). There are two specific causes of noise. The first is *heat-generated*, or thermal noise.

While the shutter is open and your camera records an image, the sensor starts to generate a small amount of heat. This heat can free electrons from the sensor, which in turn contaminate the electrons that have been created as a result of the light striking the photocells on your sensor. This contamination appears as noise.

The second cause of digital noise is known as *high ISO noise*. Background electrical noise exists in any type of electronic device. For the most part, it's very miniscule and you never notice it. Cranking up the ISO amplifies the signals your sensor is receiving. Unfortunately, as these signals are amplified, so is the background electrical noise. The higher your ISO, the more the background noise is amplified until it shows up as randomly colored specks.

Digital noise is composed of two different elements: *chrominance* and *luminance*. Chrominance refers to the colored specks, and luminance refers mainly to the size and shape of the noise.

Fortunately, with every new camera released, the technology gets better and better, and the D90 is no exception. The D90 has one of the highest signal-to-noise ratios of any camera on the market; thus, you can shoot at ISO 3200 and not worry about excessive noise. In previous cameras, shooting at ISO 3200 produced a very noisy image that wasn't suitable for large prints.

Although it's very low in noise, noise does exist. Noise starts appearing in images taken with the D90 when you're shooting above ISO 1600 or using long exposure times. For this reason, most camera manufacturers have built-in noise reduction (NR) features.

The D90 has two types of NR: Long Exposure NR and High ISO NR. Each one approaches the noise differently to help reduce it.

Long Exposure NR

When this setting is turned on, the camera runs a noise-reduction algorithm to any shot taken with a long exposure (8 seconds or more). Basically, how this works is that the camera takes another exposure, this time with the shutter closed, and compares the noise from this dark image to the original one. The camera then applies the NR. This is called *dark frame noise reduction* and takes about the same amount of time to process as the length of the shutter speed; therefore, expect double the time it takes to make one exposure. While the camera is applying NR, the LCD control panel blinks a message that says Job nr. You can't take additional images until this process is finished. If you switch the camera off before the NR is finished, no noise reduction is applied.

You can turn Long Exposure NR on or off by accessing it in the Shooting menu.

High ISO NR

When this option is turned on, any image shot at ISO 800 or higher is run through the noise-reduction algorithm.

This feature works by reducing the coloring in the chrominance of the noise and then combining that with a bit of softening of the image to reduce the luminance noise. You can set how aggressively this effect is applied by choosing the High, Normal, or Low setting.

You may also want to be aware that High ISO NR slows down the processing of your images; therefore, the capacity of the buffer can be reduced, causing your frame rate to slow down when you're in a Continuous Shooting mode.

When the High ISO NR is off, the camera still applies NR to images shot at H0.3 and higher, although the amount of NR is less than when the camera is set to the Low setting with NR on.

> **Note** *When shooting in NEF (RAW), no actual noise reduction is applied to the image.*

For the most part, I choose not to use either of these in-camera NR features. In my opinion, even at the lowest setting, the camera is very aggressive in the NR, and for that reason, there is a loss of detail. For most people, this is a minor quibble and not very noticeable, but for me, I'd rather keep all the available detail in my images and apply noise reduction in post-processing. This way, I can decide how much to reduce the chrominance and luminance rather than letting the camera do it. The camera doesn't know whether you're going to print the image at a large size or just display it onscreen. I say it's better to be safe than sorry.

> **Note** *You can apply NR in Capture NX or NX 2 or by using Photoshop's Adobe Camera Raw or some other image-editing software.*

White Balance

Light — whether from sunlight, a lightbulb, fluorescent light, or a Speedlight — has its own specific color. This color is measured with the Kelvin scale. This measurement is also known as *color temperature.* The white balance (WB) setting allows you to adjust the camera so that your images can look natural no matter what the light source.

Given that white is the color that's most dramatically affected by the color temperature of the light source, this is what you base your settings on; hence, the term *white balance*. The white balance can be changed in the Shooting menu or by pressing the WB button on the top of the camera and then rotating the Main Command dial.

The term *color temperature* may sound strange. "How can a color have a temperature?" you might think. Once you know about the Kelvin scale, things make a little more sense.

What is Kelvin?

Kelvin is a temperature scale normally used in the fields of physics and astronomy, where absolute zero (0 K) denotes the absence of all heat energy. The concept is based on a mythical object called a *black body radiator*. Theoretically, as this black body radiator is heated, it starts to glow. As it's heated to a certain temperature, it glows a specific color. It's akin to heating a bar of iron with a torch. As the iron gets hotter, it turns red, then yellow, and then eventually white before it reaches its melting point (although the theoretical black body doesn't have a melting point).

The concept of Kelvin and color temperature is tricky, as it's the opposite of what you likely think of as warm and cool colors. For example, on the Kelvin scale, red is the lowest temperature, increasing through orange, yellow, white, and to shades of blue, which are the highest temperatures. Humans tend to perceive reds, oranges, and yellows as warmer and white and bluish colors as colder. However, physically speaking, the opposite is true as defined by the Kelvin scale.

White balance settings

Now that you know a little about the Kelvin scale, you can begin to explore the white balance settings. The reason that white balance is so important is that it helps ensure that your images have a natural look. When dealing with different lighting sources, the color temperature of the source can have a drastic effect on the coloring of the subject. For example, a standard incandescent lightbulb casts a very yellow light; if the color temperature of the lightbulb isn't compensated for by introducing a bluish cast, the subject can look overly yellow and not quite right.

In order to adjust for the colorcast of the light source, the camera introduces a colorcast of the complete opposite color temperature. For example, to combat the green color of a fluorescent lamp, the camera introduces a slight magenta cast to neutralize the green.

The D90 has nine white balance settings:

AUTO **Auto.** This setting is best for most circumstances. The camera takes a reading of the ambient light and then makes an automatic adjustment. This setting also works well when you use a Nikon CLS–compatible Speedlight because the color temperature is calculated to match the flash output. I recommend using this setting as opposed to the flash WB setting.

Incandescent. Use this setting when the lighting is from a standard household lightbulb.

Fluorescent. Use this setting when the lighting is coming from a fluorescent-type lamp. You can also adjust for different types of fluorescent lamps, including high-pressure sodium

and mercury vapor lamps. To make this adjustment, go to the Shooting menu, choose White balance, then choose Fluorescent. From there, use the Multi-selector to choose one of the seven types of lamps.

 Direct sunlight. Use this setting outdoors in the sunlight.

 Flash. Use this setting when using the built-in Speedlight, a hot-shoe Speedlight, or external strobes.

 Cloudy. Use this setting under overcast skies.

Shade. Use this setting when you're in the shade of trees or a building or even under an overhang or a bridge — any place where the sun is out but is being blocked.

K **Choose color temp.** This setting allows you to adjust the white balance to a particular color temperature that corresponds to the Kelvin scale. You can set it between 2500 K (red) and 10,000 K (blue).

PRE **Preset manual.** This setting allows you to choose a neutral object to measure for the white balance. It's best to choose an object that's either white or light gray. There are some accessories that you can use to set the white balance. One accessory is a gray card, which is fairly inexpensive. Simply put the gray card in the scene and balance off it. Another accessory is the Expodisc. This attaches to the front of your lens like a filter; you then point the lens at the light source and set your WB. This setting (PRE) is best used under difficult lighting

situations, such as when there are two different light sources lighting a scene (mixed lighting). I usually use this setting when photographing with my studio strobes.

Cross-Reference *For details on setting a preset WB, see Chapter 3.*

Tip *By keeping your digital camera set to Auto WB, you can reduce the amount of images taken with incorrect color temperatures. In most lighting situations, Auto WB is very accurate. You may discover that your camera's capability to evaluate the correct white balance is more accurate than setting white balance manually.*

Figures 2.1 to 2.7 show the difference that white balance settings can make to your image. This particular image was shot under incandescent lighting.

2.1 Auto, 5900K

2.2 Incandescent, 2850K

2.4 Flash, 5500K

2.3 Fluorescent, 3800K

2.5 Daylight, 5500K

2.6 Cloudy, 6500K

2.7 Shade, 7500K

Picture Controls

With the release of the D3 and the D300, Nikon introduced its Picture Control System. The D90 has also been equipped with this handy option. This feature allows you to quickly adjust your image settings, including sharpening, contrast, brightness, saturation, and hue based on your shooting needs. This is great for photographers who shoot more than one camera and do batch processing to their images. It allows both cameras to record the images the same, so global image correction can be applied without worrying about differences in color, tone, saturation, and sharpening.

Picture Controls can also be saved to the SecureDigital (SD) card and imported into Nikon's image-editing software: Capture NX or View NX. You can then apply the settings to RAW images or even to images taken with other camera models. You can also save and share these Picture Control files with other Nikon users, either by importing them to Nikon software or loading them directly onto another camera.

The D90 comes with six standard Picture Controls already loaded on the camera, and you can customize up to nine Picture Control settings in-camera. Nikon also offers Custom Picture Controls that are available for download on the Nikon Web site. At the time of this writing, Nikon doesn't offer any Custom Picture Controls that work with the D90, but some may become available in the future. Keep an eye on this Web site for Picture Controls should they become available: http://nikonimglib.com/opc/.

Original Picture Controls

As mentioned, the D90 comes with six Picture Controls installed:

✦ **SD.** This is the Standard setting. This applies slight sharpening and a small boost of contrast and saturation. This is the recommended setting for most shooting situations.

✦ **NL.** This is the Neutral setting. This setting applies a small amount of sharpening and no other modifications to the image. This setting is preferable if you do extensive post-processing to your images.

✦ **VI.** This is the Vivid setting. This setting gives your images a fair amount of sharpening, and the contrast and saturation are boosted highly, resulting in brightly colored images. This setting is recommended for printing directly from the camera or SD card as well as for shooting landscapes. Personally, I feel that this mode is a little too saturated and often results in unnatural color tones. This mode is not ideal for portrait situations, as skin tones aren't typically reproduced with accuracy.

✦ **MC.** This is the Monochrome setting. As the name implies, this option makes the images monochrome. This doesn't simply mean black and white; you can also simulate photo filters and toned images, such as sepia, cyanotype, and more. The settings for sharpening, contrast, and brightness can also be adjusted.

✦ **PT.** This is the setting for Portraits. It gives you just a small amount of sharpening, which gives the skin a smoother appearance. The colors are muted just a bit to help with achieving realistic skin tones.

✦ **LS.** This is the Landscape setting. Obviously, this setting is for shooting landscapes and natural vistas. This control is similar to the Vivid setting, with slightly less saturation and a slightly higher contrast.

Custom Picture Controls

All the Original Picture Controls can be customized to fit your personal preferences. You can adjust the settings to your liking, giving the images more sharpening and less contrast or myriad other options. One of the coolest things about these Picture Controls is that you can save them and transfer them to another camera that uses Picture Controls, such as the D3, D300, or D700. You can also import them into Nikon software or share them with your friends.

Note *Although you can adjust the Original Picture Controls, you can't save over them, so there's no need to worry about losing them.*

There are a few different customizations to choose from:

✦ **Quick adjust.** This option works with SD, VI, PT, and LS. It exaggerates or de-emphasizes the effect of the Picture Control in use. Quick adjust can be set from ±2.

✦ **Sharpness.** This controls the apparent sharpness of your images. You can adjust this setting from 0 to 9, with 9 being the highest level of sharpness. You can also set this to Auto (A) to allow the camera's imaging processor to decide how much sharpening to apply.

✦ **Contrast.** This setting controls the amount of contrast your images are given. In photos of scenes with high contrast (sunny days), you may want to adjust the contrast down; in low-contrast scenes, you may want to add some contrast by adjusting the settings up. You can set this from ±3 or to A.

✦ **Brightness.** This adds or subtracts from the overall brightness of your image. You can choose 0 (default) + or −.

✦ **Saturation.** This setting controls how vivid or bright the colors in your images are. You can set this between ±3 or to A. This option isn't available in the MC setting.

Note *The Brightness and Saturation options are unavailable when Active D-Lighting is turned on.*

✦ **Hue.** This setting controls how your colors look. You can choose ±3. Positive numbers make the reds look more orange, the blues look more purple, and the greens look more blue. Choosing a negative number causes the reds to look more purple, the greens to look more yellow, and the blues to look more green. This setting is not available in the MC setting. I highly recommend leaving this at the default setting of 0.

✦ **Filter effects.** This setting is only available when you set your D90 to MC. The monochrome filters approximate the types of filters traditionally used with black-and-white film. These filters increase contrast and create special effects. The options are:

- **Yellow.** Adds a low level of contrast. It causes the sky to appear slightly darker than normal and anything yellow to appear lighter. It's also used to optimize contrast for brighter skin tones.

- **Orange.** Adds a medium amount of contrast. The sky appears darker, giving greater separation between the clouds. Orange objects appear light gray.

- **Red.** Adds a great amount of contrast, drastically darkening the sky while allowing the clouds to remain white. Red objects appear lighter than normal.

- **Green.** Darkens the sky and lightens any green plant life. This color filter can be used for portraits, as it softens skin tones.

✦ **Toning.** Toning adds a color tint to your monochrome (black-and-white) images. Toning options are:

- **B&W.** The black-and-white option simulates the traditional black-and-white film prints done in a darkroom. The camera records the image in black, white, and shades of gray. This

mode is suitable when the color of the subject isn't important. You can use it for artistic purposes or, as with the Sepia mode, to give your image an antique or vintage look.

- **Sepia.** The Sepia color option duplicates a photographic toning process that's done in a traditional darkroom by using silver-based black-and-white prints. Sepia-toning a photographic image requires replacing the silver in the emulsion of the photo paper with a different silver compound, thus changing the color, or *tone*, of the photograph. Antique photographs were sometimes treated to this type of toning; therefore, the sepia color option gives the image an antique look. The images have a reddish-brown look to them. You may want to use this option when trying to convey a feeling of antiquity or nostalgia to your photograph. This option works well with portraits as well as still-life and architecture images. You can also adjust the saturation of the toning from 1 to 7, with 4 being the default and the middle ground.

- **Cyanotype.** The cyanotype is another old photographic printing process; in fact, it's one of the oldest. When the image is exposed to the light, the chemicals that make up the cyanotype turn a deep blue color. This method was used to create the first blueprints and was later adapted to photography. The images taken while in this setting are in shades of cyan.

Because cyan is considered to be a cool color, this mode is also referred to as cool. You can use this mode to make very interesting and artistic images. You can also adjust the saturation of the toning from 1 to 7, with 4 being the default setting.

- **Color toning.** You can also choose to add colors to your monochrome images. Although this is similar to the Sepia and Cyanotype toning options, this type of toning isn't based on traditional photographic processes. It's simply adding a colorcast to a black-and-white image. There are seven color options from which you can choose: red, yellow, green, blue-green, blue, purple-blue, and red-purple. As with Sepia and Cyanotype, you can adjust the saturation of these toning colors.

Figures 2.8 to 2.11 show the same image with different toning applied to each one.

To customize an Original Picture Control, follow these steps:

1. **Go to the Set Picture Control option in the Shooting menu and then press the Multi-selector right.**

2. **Choose the Picture Control you want to adjust and then press the Multi-selector right.** For small adjustments, choose the NL or SD option. To make larger changes to color and sharpness, choose the VI mode. To make adjustments to monochrome images, choose MC.

2.8 Black and White

2.10 Cyanotype

2.9 Sepia

2.11 Green toning

3. **Press the Multi-selector up or down to highlight the setting you want to adjust (sharpening, contrast, brightness, etc.).** When the setting is highlighted, press the Multi-selector left or right to adjust the settings. Repeat this step until you've adjusted the settings to your preferences.

4. **Press OK to save the settings.**

> **Note** *To return the Picture Control to the default setting, follow the preceding steps 1 and 2 and then press the Delete button. A dialog box appears asking for confirmation. Select Yes to return to default or No to continue to use the Picture Control with the current settings.*

> **Note** *When the Original Picture Control settings have been altered, an asterisk is displayed next to the Picture Control setting (SD*, VI*, etc.).*

To save a Custom Picture Control, follow these steps:

1. **Go to the Manage Picture Control option in the Shooting menu and press the Multi-selector right.**

2. **Press the Multi-selector up or down to select Save/edit and then press the Multi-selector right.**

3. **Choose the Picture Control to edit and then press the Multi-selector right.**

4. **Press the Multi-selector up or down to highlight the setting you want to adjust (sharpening, contrast, brightness, etc.).** When the setting is highlighted, press the Multi-selector left or right to adjust the settings. Repeat this step until you've adjusted the settings to your preferences.

5. **Press OK to save the settings.**

6. **Use the Multi-selector to highlight the Custom Picture Control you want to save to and then press the Multi-selector right.** You can store up to nine Custom Picture Controls; they're labeled C-1 through C-9.

7. **When the Rename Menu appears, press the Zoom Out button and then press the Multi-selector left or right to move the cursor to any of the 19 spaces in the name area of the dialog box.** New Picture Controls are automatically named with the Original Picture Control name and a two-digit number (for example, STANDARD_02 or VIVID_03).

8. **Press the Multi-selector (without pressing the Zoom) to select letters in the keyboard area of the dialog box.**

9. **Press the Zoom In button to set the selected letter and then press the Delete button to erase the selected letter in the Name area.**

10. **After you type the name you want, press OK to save it.** The Custom Picture Control is then saved to the Picture Control menu and can be accessed through the Set Picture Control option in the Shooting menu.

Note *To return the Picture Control to the default setting, follow the preceding steps 1 to 3 and then press the Delete button. A dialog box appears asking for confirmation. Select Yes to return to default or No to continue to use the Picture Control with the current settings.*

Your Custom Picture Controls can be renamed or deleted at any time by using the Manage Picture Control option in the Shooting menu. You can also save the Custom Picture Control to your memory card so that you can import the file to Capture NX, Capture NX 2, or View NX.

To save a Custom Picture Control to the memory card, follow these steps:

1. **Go to the Manage Picture Control option in the Shooting menu and then press the Multi-selector right.**

2. **Press the Multi-selector up or down to highlight the Load/save option and then press the Multi-selector right.**

3. **Press the Multi-selector up or down to highlight the Copy to card option and then press the Multi-selector right.**

4. **Press the Multi-selector up or down to select the Custom Picture Control to copy and then press the Multi-selector right.**

5. **Select a destination on the memory card to copy the Picture Control file to.** Each SD card has 99 slots in which to store Picture Control files.

6. **After you select the destination, press the Multi-selector right.** A message appears to let you know that the file has been stored to your SD card.

After you copy your Custom Picture Control file to your card, you can then import the file to the Nikon software by mounting the SD card to your computer by your usual means (card reader or USB camera connection). See the software user's manual for instructions on importing to the specific program.

You can also upload Picture Controls to your camera that are saved to an SD card. Follow these steps:

1. **Go to the Manage Picture Control option in the Shooting menu and then press the Multi-selector right.**

2. **Press the Multi-selector up or down to highlight the Load/save option and then press the Multi-selector right.**

3. **Press the Multi-selector up or down to highlight the Copy to camera option and then press the Multi-selector right.**

4. **Select the Picture Control to copy and then press the OK button or press the Multi-selector right to confirm.** The camera then displays the Picture Control settings.

5. **Press OK.** The camera automatically displays the Save A menu.

6. **Select an empty slot to save to (C-1 through C-9).**

7. **Rename the file if necessary.**

8. **Press OK.**

JPEG

JPEG (Joint Photographic Experts Group) is a method of compressing photographic files and also the name of the file format that supports this type of compression. JPEG is the most common file type used to save images on digital cameras. Due to the small size of the file that's created and the relatively good image quality it produces, JPEG has become the default file format for most digital cameras.

The JPEG compression format came into being because of the immense file sizes that digital images produce. Photographic files contain millions upon millions of separate colors, and each individual color is assigned a number, which causes the files to contain vast amounts of data, therefore making the file size quite large. In the early days of digital imaging, the huge file sizes and relatively small storage capacity of computers made it almost impossible for most people to store images. Less than 10 years ago, a standard laptop hard drive was only about 5GB. For people to efficiently store images, a file that could be compressed without losing too much of the image data during reconstruction was needed. Enter the Joint Photographic Experts Group. This group of experts came in and designed what we now affectionately know as the JPEG.

JPEG compression is a very complicated process involving many mathematical equations, but it can be explained quite simply. The first thing the JPEG process does is break down the image into 8 × 8 pixel blocks. The RGB color information in each 8 × 8 block is then treated to a color space transform where the RGB values are changed to represent luminance and chrominance values. The luminance value describes the brightness of the color, while the chrominance value describes the hue.

After the luminance and chrominance values are established, the data is run through what's known as the Discrete Cosine Transform (DCT). This is the basis of the compression algorithm. Basically, what the DCT does is take the information about the 8 × 8 block of pixels and assigns it an average number because, for the most part, the changes in the luminance and chrominance values aren't very drastic in such a small part of the image.

The next step in the process is *quantizing* the coefficient numbers that were derived from the luminance and chrominance values by the DCT. Quantizing is basically the process of rounding off the numbers. This is where the file compression comes in. How much the file is compressed is dependent on the *quantization* matrix. The quantization matrix defines how much the information is compressed by dividing the coefficients by a quantizing factor. The larger the number of the quantizing factor, the higher the quality (therefore, the less compression). This is basically what's going on in Photoshop when you save a file as a JPEG and the program asks you to set the quality; you're simply defining the quantizing factor.

When the numbers are quantized, they're run through a binary encoder that converts the numbers to the ones and zeros our computers love so well. You now have a compressed file that's on average about one-fourth the size of an uncompressed file.

The one important consideration with JPEG compression is what's known as a *lossy* compression. When the quantizing is put in effect, rounding off the numbers necessarily looses information. For the most part, this loss of information is imperceptible to the human eye. A bigger issue to consider with JPEGs comes from what's known as *generation loss*. Every time a JPEG is opened and resaved, a small amount of detail is lost. After multiple openings and savings, the image's quality starts to deteriorate, as less and less information is available. Eventually, the image may start to look pixilated or jagged (this is known as a JPEG artifact). Obviously, this can be a problem, but the JPEG would have to be opened and resaved many hundreds of times before you notice a drop in image quality — as long you save at high-quality settings.

Image Size

When saving a file as a JPEG, the D90 allows you to choose an image size. Reducing the image size is like reducing the resolution on your camera; it allows you to fit more images on your card. The size you choose depends on what your output is going to be. If you know you'll be printing your images at a large size, then you definitely want to record large JPEGs. If you're going to print at a smaller size (8 × 10 or 5 × 7), you can get away with recording at the Medium or Small setting. Image size is expressed in pixel dimensions. Large records your images at 4288 × 2848 pixels; this gives you a file that's equivalent to 12 megapixels. Medium gives you an image of 3216 × 2136 pixels, which is in effect the same as a 6.8-megapixel camera. Small size gives you a dimension of 2144 × 1424 pixels, which gives you about a 3-megapixel image.

You can quickly change the image size by pressing the Quality (QUAL) button and then rotating the Sub-command dial on the front of the camera. You can also change the image size in the Shooting menu by selecting the Image Size menu option.

Note *You can only change image size when using the JPEG file format. RAW files are recorded only at the largest size.*

Image Quality

For JPEGs, other than the size setting, which changes the pixel dimension, you have the Quality setting, which is the setting that decides how much of a compression ratio is applied to your JPEG image. Your choices are Fine, Normal, and Basic. Fine files are compressed to approximately 1:4; Normal files are compressed to about 1:8; and Basic files are compressed to about 1:16. To change the image quality setting, simply press the Quality (QUAL) button and then rotate the Main Command dial. Doing this scrolls you through all the file-type options available, including RAW, Fine (JPEG), Normal (JPEG), and Basic (JPEG). You can also shoot RAW and JPEG simultaneously with all the JPEG compression options available (RAW + Fine, RAW + Normal, or RAW + Basic).

NEF Files

Nikon's RAW files are referred to as NEF (Nikon Electronic File) in Nikon literature. RAW files contain all the image data acquired by the camera's sensor. When a JPEG is

created, the camera applies different settings to the image, such as WB, sharpness, noise reduction, etc. When the JPEG is saved, the rest of the unused image data is discarded to help reduce file size. With a RAW file, this image data is saved so it can be used more extensively in post-processing. In some ways, the RAW file is like a *digital negative*, in which the RAW files are used in the same way as a traditional photographic negative; that is, you take the RAW information and process it to create your final image.

Although some of the same settings are tagged to the RAW file (WB, sharpening, saturation, etc.), these settings aren't fixed and applied as in the JPEG file. This way, when you import the RAW file into your favorite RAW converter, you can make changes to these settings with no detrimental effects.

Capturing your images in RAW allows you to be more flexible when post-processing your images and generally gives you more control over the quality of the images.

RAW versus JPEG

This issue has caused quite a controversy in the digital-imaging world, with some people saying that RAW is the only way to go to have more flexibility in processing images and others saying if you get it right in-camera, then you don't need to use RAW images. For what it's worth, both factions are right in their own way.

Choosing between RAW and JPEG basically comes down to the final output or what you're using the images for. Remember that you don't have to choose one file format and stick with it. You can change the settings to suit your needs as you see fit or you can even choose to record both RAW and JPEG simultaneously.

Some reasons to shoot JPEGs include:

✦ **Small file size.** JPEGs are much smaller in size than RAW files; therefore, you can fit many more of them on your SD card and later on your hard drive. If space limitations are a problem, shooting JPEG allows you to get more images in less space.

✦ **Printing straight from camera.** Some people like to print their images straight from the camera or SD card. RAW files can't be printed without first being converted to JPEG.

✦ **Continuous shooting.** Given JPEG files are smaller than RAW files, they don't fill up the camera's buffer as quickly, allowing you longer bursts without the frame rate slowing down.

✦ **Less post-processing.** If you're confident in your ability to get the image exactly as you want it at capture, you can save yourself time by not having to process the image in a RAW converter and then save straight to JPEG.

✦ **Snapshot quality.** If you're just shooting snapshots of family events or if you only plan to post your images on the Internet, saving as JPEG is fine.

Some reasons to shoot RAW files include:

✦ **16-bit images.** The D90 can capture RAW images in the 12-bit format. When converting the file by using a RAW converter, such as Adobe Camera RAW (ACR) or Capture NX or Capture NX 2, you can save your images with 16-bit color information. When the information is written to JPEG in the camera, the JPEG is saved as an 8-bit file. This gives you the option of working with more colors in post-processing. This can be extremely helpful when you're trying to save an under- or overexposed image. For more information on bit depth, see the bit depth sidebar later in this chapter.

✦ **White balance.** Although the WB that the camera was set to is tagged in the RAW file, it isn't fixed in the image data. Oftentimes, the camera can record a WB that isn't quite correct. This isn't always noticeable by looking at the image on the LCD screen. Changing the WB on a JPEG image can cause posterization and usually doesn't yield the best results. Because you have the RAW image data on hand, changing the WB settings doesn't degrade the image at all.

✦ **Sharpening and saturation.** As with WB, these settings are tagged in the RAW file but not applied to the actual image data. You can add sharpening and saturation (or other options, depending on your software).

✦ **Image quality.** Because the RAW file is an unfinished file, it allows you the flexibility to make many changes in the details of the image without any degradation to the quality of the image.

Live View

Live View is one of the newest innovations in dSLR technology and is finding its way into most cameras these days. It allows you to use the LCD screen as a viewfinder. This can be very helpful when you're taking pictures where the camera is set up as a remote or when shooting at an awkward angle. For example, at a concert, you could hold the camera over your head and use the screen to frame the shot.

When using Live View, the camera focuses by using contrast detection, which is discussed earlier in this chapter. For this reason, the camera focuses much more slowly than it does when focusing in the standard mode.

Live View is accessed simply by pressing the Live View (Lv) button on the back of the camera, just above the Multi-selector.

Keep these details in mind when you shoot in the Live View mode:

✦ **HDMI.** If the camera is connected to an HDTV, the LCD monitor is switched off, and the TV can be used to preview the image.

✦ **Grid lines.** You can turn off the grid and then view the detailed shooting by pressing the Information (info) button. Pressing the button twice clears all the information except the shooting information (Exposure mode, Metering mode, shutter speed, aperture, ISO, and shots remaining).

✦ **Monitor brightness.** You can adjust the brightness of the LCD monitor by pressing the Play button and then pressing the Multi-selector up and down.

✦ **Remote release.** If using an optional remote release cable, you can activate the AF by pressing the button halfway for more than a second. If you fully depress the button without activating the AF, your image may be blurry.

Bit Depth

Simply put, bit depth is how many separate colors your sensor can record. The term *bit depth* is derived from digital terminology. A bit is the smallest unit of data; it's expressed in digital language as either a 1 or a 0. Most digital images saved as JPEG or TIFF are recorded in 8 bits, or 1 byte, per channel (each primary color being a separate color: red, green, and blue [RGB]), resulting in a 24-bit image. For each 8 bits, there are 256 possible colors; multiply this by 3 channels, and you get over 16 million colors, which is plenty of information to create a realistic-looking digital image. By default, the D90 records its RAW files by using a bit depth of 12 bits per channel, which gives you a 36-bit image. What this means is that your sensor can recognize far more shades of color, which gives you a smoother gradation in tones, allowing the color transitions to be much smoother.

Using the Nikon D90 Menus

The first couple of chapters in this book cover how to change the main settings of your D90. This chapter delves a little more in depth into the menu options. Here, you can customize the D90 options to fit your shooting style, to help refine your workflow, or to make adjustments to refine the camera settings to fit different shooting scenarios.

The D90 has a lot of customizable features to make taking pictures easier for you. You can assign a number of buttons to different functions that you find yourself using a lot. Using the My Menu feature, you can create your own personal list of menu options so that you don't have to scroll through all the menu options for settings that you often need to access.

Some of these options are the same as those you can access and adjust by pushing a button and/or rotating a command dial. Most of the options, though, are to change settings that don't need to be changed very often or quickly.

The menus are accessed by pressing the Menu button on the back of the camera. Use the Multi-selector to scroll through the tabs on the right side of the LCD. When the desired menu is highlighted in yellow, press the OK button or press the Multi-selector right to enter the menu. Pressing the Menu button again or tapping the Shutter Release button exits the Menu mode screen and readies the camera for shooting.

Playback Menu

The Playback menu is where you manage the images stored on your memory card. The Playback menu is also where you control how the images are displayed and what image information is displayed during review. There are nine options available from the Playback menu, which are explained in the following sections. The Playback menu is represented by a Play button similar to the one on a DVD player.

3.1 The Playback menu. The top image shows the first eight options; the bottom is scrolled to show the bottom option, Print set (DPOF).

Delete

This option allows you to delete selected images from your memory card or to delete all the images at once.

To delete selected images, choose delete from the Playback menu and then follow these steps:

1. **Press the Multi-selector right, highlight Selected (default), and press the Multi-selector to the right again.** The camera displays an image selection screen. You can now select the image(s) you want to delete.

2. **Press the Multi-selector left, right, up or down to choose the image.** You can use the Zoom In button to review the image close up before deleting.

3. **Press the Thumbnail/Zoom Out button to set the image for deletion; more than one image can be selected.** When the image is selected for deletion, a small trash can icon appears in the right-hand corner.

3.2 Selecting images to delete

4. **Press the OK button to erase the selected images.** The camera asks for confirmation before deleting the images.

5. **Select Yes, and then press the OK button to delete.** To cancel the deletion, highlight No (default) and then press the OK button.

You can also choose to delete all images that were taken on a certain date by following these steps:

1. **Choose Select date from the Delete options in the Playback menu and then press the Multi-selector right.**

2. **A list of dates is shown along with a thumbnail of one of the images that was taken on that day.** To view all the images taken on that date, press the Thumbnail/ Zoom Out button. Use the Multi-selector to browse the images. The Zoom In button can be used to take a closer look at any of the images.

3. **Press OK to select the set for deletion.**

4. **Press the Multi-selector right to set or unset the date.** A small box is shown next to the date when a check mark is shown in the box for the images taken on that date that are selected for deletion.

5. **Press the OK button to delete.** A confirmation screen is displayed. Select Yes to delete the images or No to cancel the action.

To delete all images, select Delete from the Playback menu and then follow these steps:

1. **Press the Multi-selector to highlight All and then press the OK button.** The camera asks for confirmation before deleting the images.

2. **Select Yes and then press the OK button to delete.** To cancel deletion, highlight No (default) and then press the OK button.

| Note | *Protected and hidden images aren't deleted when using the Delete All option. Protecting and hiding images is covered later in this chapter.* |

The Nikon D90 automatically creates folders to store your images in. The main folder that the camera creates is called DCIM. Within this folder, the camera creates a subfolder to store the images; the first subfolder the camera creates is titled 100NCD90. After shooting 999 images, the camera automatically creates another folder, 101NCD90, etc. Use this menu to choose which folder or folders to display images from. Keep in mind that if you have used the SD card in another camera and haven't formatted it, there are additional folders on the card.

There are two choices for displaying images:

◆ **Current.** This option displays images only from the folder that the camera is currently saving to. This feature is useful when you have multiple folders from different sessions. Using

this setting allows you to preview only the most current images. The current folder can be changed by using the Active folder option in the Shooting menu.

✦ **All.** This option plays back images from all folders that are on the memory card, regardless of whether they were created by the D90.

Hide image

This option is used to hide images so that they can't be viewed during playback. Hiding images also protects them from being deleted. To select images to be hidden, press the Multi-selector right, highlight Select/set (default), and then press the Multi-selector right. Use the Multi-selector to highlight the thumbnail images you want to hide, press the Thumbnail/ Zoom Out button to select them, and then press the OK button.

You can also select images to hide by the date on which they were taken by following these steps:

1. **Choose Select date from the Hide image option in the Playback menu and then press the Multi-selector right.**

2. **A list of dates is shown along with a thumbnail of one of the images that was taken on that day.** To view all the images taken on that date, press the Thumbnail/ Zoom Out button. Use the Multi-selector to browse the images. The Zoom In button can be used to take a closer look at any of the images. Press OK to select the set for deletion.

3. **Press the Multi-selector right to set or unset the date.** A small box is shown next to the date when a check mark is shown in the box for the images taken on that date that are selected for deletion.

4. **Press the OK button to delete.** A confirmation screen is displayed. Select Yes to delete the images or No to cancel the action.

To allow the hidden images to be displayed, highlight Deselect all. The camera asks for confirmation before revealing the images. Select Yes and then press OK to display during playback. To cancel and continue hiding the images, highlight No (default) and then press the OK button.

 Allowing hidden images to be displayed allows the images to be deleted as normal.

Display mode

There is quite a bit of image information that's available for you to see when you review images. The Display mode settings allow you to customize the information that's shown when reviewing the images that are stored on your SD card. Enter the Display mode menu by pressing the Multi-selector right. Then, use the Multi-selector to highlight the option you want to set. When the option is highlighted, press the Multi-selector right or press the OK button to set the display feature. The feature is set when a check mark appears in the box to the left of the setting. Be sure to scroll up to Done and press the OK button to set the setting. If this step isn't done, the information won't appear in the display.

The Display mode options are:

✦ **Highlights.** When this option is activated, any highlights that are blown out will blink. If this happens, you may want to apply some exposure compensation or adjust your exposure to be sure to capture highlight detail.

 Cross-Reference *For more on exposure compensation, see Chapter 5.*

✦ **RGB histogram.** When this option is turned on, you can view the separate histograms for the Red, Green, and Blue channels along with a standard luminance histogram.

✦ **Data.** This option allows you to review the shooting data (metering, exposure, lens focal length, etc.).

Generally, the only setting that I use is the RGB Histogram. I can usually tell from the histograms whether the highlights are blown out.

 Cross-Reference *For more on histograms, see Chapter 9.*

Image review

This option allows you to choose whether the image is shown on the LCD immediately after the image is taken. When this option is turned off, the image can be viewed by pressing the Playback button. Typically, when you take a picture, you want the image to automatically be displayed. This allows you to preview the image to check the exposure, framing, and sharpness. There are times, however, when you may not want the images to be displayed. For example, when shooting sports at a rapid frame rate,

you may not need to check every shot. Turning this option off also conserves battery power because the LCD is actually the biggest drain on your battery. I often turn off the image review when shooting weddings to deter people from asking to see the shots. (You could miss some good shots while the bridesmaids are peering over your shoulder to see the images on your LCD.)

Rotate tall

The D90 has a built-in sensor that can tell whether the camera was rotated while the image was taken. This setting rotates images that are shot in portrait orientation to be displayed upright on the LCD screen. I usually turn this option off because the portrait orientation image appears substantially smaller when displayed upright on the LCD.

The options are:

✦ **On.** The camera automatically rotates the image to be viewed while holding the camera in the standard upright position. When this option is turned on (and the Auto image rotation setting is set to on in the Setup menu), the camera orientation is recorded for use in image-editing software.

✦ **Off.** When the auto-rotating function is turned off, images taken in portrait orientation are displayed on the LCD sideways in landscape orientation.

I use the Off setting for this option. I prefer to turn the camera to view the image full size. When the image is rotated, it's displayed much smaller on the LCD.

Pictmotion

This option creates a multimedia slideshow of selected images with special effects and music. This feature is best used when displaying the Pictmotion movie on a large screen. You can select the images to be displayed, you can choose all the images to be added to the movie, or you can select images by the date they were taken.

Slide show

This allows you to display a slideshow of images from the current active folder. You can use this to review the images that you've shot without having to use the Multi-selector. This is also a good way to show friends or clients your images. You can even connect the camera to a standard or HDTV to view the slideshow on a big screen. You can choose an interval of 2, 3, 5, or 10 seconds.

While the slideshow is in progress, you can use the Multi-selector to skip forward or back (left or right) and view shooting information or histograms (up or down). You can also press the Menu button to return to the Playback menu, press the Playback button to end the slideshow, or press the Shutter Release button lightly to return to the Shooting mode.

Pressing OK while the slideshow is in progress pauses the slideshow and offers you the options of restarting the slideshow, changing the frame rate, or exiting the slideshow. Press the Multi-selector up or down to make your selection and then press the OK button to make your selection.

Print set (DPOF)

DPOF stands for Digital Print Order Format. This option allows you to select images to be printed directly from the camera. This can be used with PictBridge-compatible printers or DPOF-compatible devices, such as a photo kiosk at your local photo printing shop. This is a pretty handy feature if you don't have a printer at home and want to get some prints made quickly or if you do have a printer and want to print your photos without downloading them to your computer.

To create a print set, follow these steps:

1. **Press the Multi-selector to choose the Print set (DPOF) option and then press the Multi-selector right to enter the menu.**

2. **Press the Multi-selector to highlight Select/set and then press the Multi-selector right to view thumbnails.** You can press and hold the Zoom In button to view a larger preview of the selected image.

3. **Press the Multi-selector right or left to highlight an image to print.** When the desired image is highlighted, press the Multi-selector up or down while holding the Thumbnail/Zoom Out button to set the image and then choose the number of prints you want of that specific image. You can choose from 1 to 99. The number of prints and a small printer icon appear on the thumbnail. Continue this procedure until you've selected all the images that you want to print.

Press the Multi-selector down to reduce the number of prints and to remove it from the print set.

4. **Press the OK button.** A menu appears with three options:

 - **Done (default).** Press the OK button to save and print the images as they are.

 - **Data imprint.** Press the Multi-selector right to set. A small check mark appears in the box next to the menu option. When this option is set, the shutter speed and aperture setting appear on the print.

 - **Imprint date.** Press the Multi-selector right to set. A small check mark appears in the box next to the menu option. When this option is set, the date the image was taken appears on the print.

5. **If you choose to set the imprint options, be sure to return to the Done option and then press the OK button to complete the print set.**

Note *RAW files can't be added to a DPOF print set. If you shoot in RAW, you can use the NEF (RAW) processing option in the Retouch menu to create a JPEG copy of the image, which can then be added to the DPOF print set.*

Shooting Menu

The shooting controls that you find yourself using most often have dedicated buttons to access them. These are controls such as

ISO, QUAL, and WB. These features can also be set in the Shooting menu. There are also other settings here that are used quite often, such as Picture Controls, Active D-Lighting, and Noise Reduction. The Shooting menu is represented in the Menu tab by a camera icon.

SHOOTING MENU	
Set Picture Control	⊠SD
Manage Picture Control	--
Image quality	RAW
Image size	⊡
White balance	AUTO
ISO sensitivity settings	▤
Active D-Lighting	OFF
Color space	Adobe

SHOOTING MENU	
ISO sensitivity settings	▤
Active D-Lighting	OFF
Color space	Adobe
Long exp. NR	OFF
High ISO NR	OFF
Active folder	BBBBB
Multiple exposure	OFF
Movie settings	▤

3.3 The Shooting menu is shown here in two sections so you can see all the available options.

Set Picture Control

You might find yourself using this menu item quite often. Picture Controls allow you to choose how the images are processed,

and they can also be used in Nikon's image-editing software: Nikon View and Nikon Capture NX. These Picture Controls allow you to get the same results when using different cameras that are compatible with the Nikon Picture Control System.

There are six standard Nikon Picture Controls available in the D90:

✦ **Standard (SD).** This applies slight sharpening and a small boost of contrast and saturation. This is the recommended setting for most shooting situations.

✦ **Neutral (NL).** This setting applies a small amount of sharpening and no other modifications to the image. This setting is preferable if you often do extensive post-processing to your images.

✦ **Vivid (VI).** This setting gives your images a fair amount of sharpening. The contrast and saturation are boosted dramatically, resulting in brightly colored images. This setting is recommended for printing directly from the camera or flash card as well as for shooting landscapes. Personally, I feel that this mode is a little too saturated and often results in unnatural color tones. This mode isn't recommended for portrait situations, as skin tones aren't reproduced well.

✦ **Monochrome (MC).** As the name implies, this option makes the images monochrome. This doesn't simply mean black and white, but you can also simulate photo filters and toned images, such as sepia, cyanotype, and more.

✦ **Portrait (PT).** This setting gives your subject natural color and smooth skin tones.

✦ **Landscape (LS).** This Picture Control boosts the saturation of the greens and the blues for vibrant foliage and skies.

All these standard Nikon Picture Controls can be adjusted to suit your specific needs or tastes. In the Color modes — SD, NL, VI, PT, and LS — you can adjust the sharpening, contrast, brightness, hue, and saturation. In MC mode, you can adjust the filter effects and toning. After the Nikon Picture Controls are adjusted, you can save them for later use. You can do this in the Manage Picture Control option described in the next section.

 Cross-Reference *For more on customizing and saving Picture Controls, see Chapter 2.*

Note *When saving to NEF, the Picture Controls are imbedded into the metadata. Only Nikon's software can use these settings. When opening RAW files with a third-party program, such as Adobe Camera RAW in Photoshop, the Picture Controls aren't used.*

Manage Picture Control

This menu item is where you can edit, save, and rename your Custom Picture Controls. There are four menu options:

✦ **Save/edit.** With this option, you choose a Picture Control, make adjustments to it, and then save it. You can rename the Picture Control to help you remember what adjustments were made or to remind you what the Custom Picture Control is

to be used for. For example, I have one named ultra-VIVID, which has the contrast, sharpening, and saturation boosted as high as it can go. I sometimes use this setting when I want crazy, oversaturated, unrealistic-looking images for abstract shots or light trails.

✦ **Rename.** This option allows you to rename any of your Custom Picture Controls. You can't, however, rename the standard Nikon Picture Controls.

✦ **Delete.** This gives you the option of erasing any Custom Picture Controls you've saved. This menu only includes controls you've saved or may have downloaded from an outside source. The standard Nikon Picture Controls can't be deleted.

✦ **Load/save.** This menu allows you to upload Custom Picture Controls to your camera from your memory card, delete any Picture Controls saved to your memory, or save a Custom Picture Control to your memory card to export it to Nikon View or Capture NX or to another camera that's compatible with Nikon Picture Control.

The D90 also allows you to view a grid graph that shows you how each Picture Control relates to each other in terms of contrast and saturation. Each Picture Control is displayed on the graph represented by a square icon with the letter of the Picture Control it corresponds to. Custom Picture Controls are denoted by the number of the custom slot it has been saved to. Standard Picture Controls that have been modified are displayed with an asterisk next to the letter. Picture Controls that have been set with one or more auto

settings are displayed in green with lines extending from the icon to show you that the settings will change depending on the images.

To view the Picture Control grid, select the Set Picture Control option from the Shooting menu. Press the OK button to then display the Picture Control list. Press the Thumbnail/ Zoom Out button to view the grid. After the Picture Control grid is displayed, you can use the Multi-selector to scroll through the different Picture Control settings. When you highlight a setting, you can press the Multi-selector right to adjust the settings or press the OK button to set the Picture Control. Press the Menu button to exit back to the Shooting menu or tap the Shutter Release button to ready the camera for shooting.

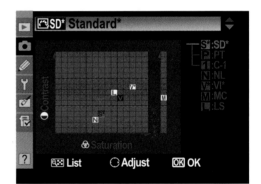

3.4 The Picture Control grid

Image quality

This menu option allows you to change the image quality of the file. You can choose from these options:

✦ **NEF (RAW) + JPEG fine.** This option saves two copies of the same image — one in RAW and one in JPEG with minimal compression.

✦ **NEF (RAW) + JPEG normal.** This option saves two copies of the same image — one in RAW and one in JPEG with standard compression.

✦ **NEF (RAW) + JPEG basic.** This option saves two copies of the same image — one in RAW and one in JPEG with high compression.

✦ **NEF (RAW).** This option saves images in RAW format.

✦ **JPEG fine.** This option saves images in JPEG with minimal compression of about 1:4.

✦ **JPEG normal.** This option saves images in JPEG with standard compression of about 1:8.

✦ **JPEG basic.** This option saves images in JPEG with high compression of about 1:16.

These settings can also be changed by pressing the Quality (QUAL) button and then rotating the Main Command dial to choose the file type and compression setting. The setting can be viewed on the LCD control panel on the top of the camera.

Cross-Reference *For more on image quality, compression, and file formats, see Chapter 2.*

Image size

This allows you to choose the size of the JPEG files. Change the image size depending on the intended output of the file or to save space on your memory card.

The choices are:

✦ **Large.** This setting gives you a full resolution image of 4288 × 2848 pixels, or 12.2 megapixels.

✦ **Medium.** This setting gives you a resolution of 3216 × 2136 pixels, or 6.9 megapixels.

✦ **Small.** This setting gives your images a resolution of 2144 × 1424 pixels, or 3.1 megapixels.

Cross-Reference *For more on image size, see Chapter 2.*

 Note *Image size for JPEG files can also be changed by pressing the Quality (QUAL) button and then rotating the Sub-command dial. The settings are shown on the LCD control panel on the top of the camera.*

White balance

You can change the white balance options by using this menu option. Changing the WB settings through this menu option allows you to fine-tune your settings with more precision and gives you a few more options than you get when using the WB button located on the back of the camera (this button doubles as the Zoom Out button in Playback mode. You can select a WB setting from the standard settings (Auto, Incandescent, Fluorescent, Direct sunlight, Flash, Cloudy, Shade) or you can choose to set the WB according to color temperature by selecting a Kelvin temperature. You can choose between 2500 K to 10,000 K. A third option is to select from a preset WB that you have set.

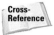 **Cross-Reference** *For more on white balance settings and color temperature, see Chapter 2.*

Using standard WB settings

To select one of the standard settings, choose the White balance option from the Shooting menu and then use the Multi-selector to highlight the preferred setting. Press the Multi-selector right or press the OK button to display a new screen that gives you the option to fine-tune the standard setting. Displayed on this screen is a grid that allows you to adjust the color tint of the WB setting selected. The horizontal axis of the grid allows you to adjust the color from amber to blue, making the image warmer or cooler, while the vertical axis of the grid allows you to change the tint by adding a magenta or green cast to the image.

Using the Multi-selector, you can choose a setting from 1 to 6 in either direction; additionally, you can add points along the horizontal and vertical axes simultaneously. For example, you can add 4 points of amber to give it a warmer tone and also add 2 points of green, shifting the amber tone more toward yellow.

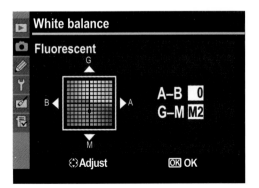

3.5 The WB fine-tuning grid

Choosing the Fluorescent setting displays additional menu options. You can choose from among seven non-incandescent lighting types. This is handy if you know what specific type of fixture is being used.

For example, I was shooting a night football game recently. I had the camera set to Auto WB, but I was getting very different colors from shot to shot, and none of them looked right. Because I wasn't shooting RAW, I needed to get more consistent shots. I knew that most outdoor sporting arenas used mercury vapor lights to light the field at night. I selected the Fluorescent WB setting from the Shooting menu and chose the #7 option, High temp, Mercury vapor. I took a few shots and noticed I was still getting a sickly greenish cast, so I went back to the fine-tuning option and added 2 points of magenta to cancel out the green colorcast. This gave me an accurate and consistent color.

There are seven Florescent settings:

✦ **Sodium-vapor.** These are the types of lights often found in streetlights and parking lots. They emit a distinct deep yellow color.

✦ **Warm-white fluorescent.** These types of lamps give a white light with a bit of an amber cast to add some warmth to the scene. These lights burn at around 3000 K, which is similar to an incandescent bulb.

✦ **White fluorescent.** These lights cast a very neutral white light at around 3700 K.

✦ **Cool white fluorescent.** As the name suggests, this type of lamp is a bit cooler than a white fluorescent lamp and has a color temperature of 4200 K.

✦ **Day white fluorescent.** This lamp approximates sunlight at about 5000 K.

✦ **Daylight fluorescent.** This type of lamp gives you about the same color as daylight. This lamp burns at about 6500 K.

✦ **High temp mercury-vapor.** These lights vary in temperature depending on the manufacturer and usually run between 200 and 7200 K.

The D90 defaults this setting at 7200 K, so you may have to fine-tune this setting or set a custom WB for best results.

Note *Sunlight and daylight are quite different color temperatures. Sunlight is light directly from the sun and is about 5500 K. Daylight is the combination of sunlight and skylight and has a color temperature of about 6300 K.*

10,000 — North light (blue sky)

9000 —

8000 —

7000 — Overcast daylight

6000 —

5000 — Noon daylight, direct sun
Electronic flash bulbs

4000 —

3000 — Household light bulbs
Early sunrise

2000 — Tungsten light
Candlelight

1000 —

3.6 The Kelvin color temperature scale

Choosing a color temperature

Using the K white balance option, you can choose a specific color temperature, assuming that you know the actual color temperature. Some lightbulbs and fluorescent lamps are calibrated to put out light at a specific color temperature; for example, full-spectrum lightbulbs burn at a color temperature of 5000 K.

As with the other settings, you get the option of fine-tuning the setting by using the grid.

Preset white balance

Preset white balance allows you to make and store up to five custom white balance settings. You can use this option when shooting in mixed lighting; for example, in a room with an incandescent light bulb and sunlight coming in through the window or when the camera's auto white balance isn't quite getting the correct color.

You can set a custom white balance in two ways: direct measurement, when you take a reading from a neutral-colored object (a gray card works the best for this) under the light source; or copy from an existing photograph, which allows you to choose a WB setting directly from an image that's stored on your memory card.

The camera can store up to five presets that are labeled d-0 through d-4. When taking a direct measurement, the camera automatically stores the preset image to d-0, so if you want to save a previous measurement, be sure to copy it over to one of the other presets (d-1 to d-4) before taking another measurement. Saving these presets is covered later in this section.

Direct measurement

To take a direct measurement and save it to d-0 (default), follow these steps:

1. **Place a neutral object (preferably a gray card) under the light source you want to balance for.**

2. **Press the WB button located on the back of the camera body and then rotate the Main Command dial until PRE is displayed on the LCD control panel.**

3. **Release the WB button for a moment and then press and hold it until the LCD control panel shows a blinking PRE.** This displays for about 6 seconds.

4. **Looking through the viewfinder, frame the reference object.** Press the Shutter Release button as if you were taking a photo.

> **Note** When presetting a custom WB, it's usually best to switch the camera to Manual focus, since the AF system will have a hard time focusing on an object with little contrast, such as a gray card. You don't need to be in focus to set the WB.

5. **If the camera is successful in recording the white balance, GOOD flashes in the control panel.** If the scene is too dark or too bright, the camera may not be able to set the WB. In this case, No Gd flashes on the control panel. You may need to change your settings to adjust the exposure settings on your camera. If the result is unsuccessful, repeat steps 2 to 5 until you obtain results that are acceptable to you.

If you plan on using this preset to take pictures right away, be sure that your preset white balance is set to d-0. Do this by pressing the WB button and then rotating the Sub-command dial until d-0 is displayed on the control panel.

If you want to save the current preset white balance setting for future use, copy the setting to another preset (d-1 to d-4). If you don't save this, the next time you make a preset, the d-0 slot is overwritten.

To save a preset, follow these steps:

1. **Press the Menu button and then use the Multi-selector to choose White balance from the Shooting menu.**

2. **Select Preset manual from the White balance menu and then press the Multi-selector right to view the preset choices.**

3. **Use the Multi-selector to highlight one of the four available presets — d-1, d-2, d-3, or d-4 — and then press the Zoom Out button to select a preset.** A menu appears.

4. **Use the Multi-selector to highlight Copy d-0 and then press the OK button to copy.**

The D90 also allows you to add a comment to any of the presets. You can use this to remember the details of your WB setting. For example, if you have a set of photographic lights in your studio, you can set the WB for these particular lights and then type **photo lights** into the comment section. You can enter up to 36 characters (including spaces).

To enter a comment on a WB preset, follow these steps:

1. **Press the Menu button and then use the Multi-selector to choose White balance from the Shooting menu.**

2. **Select Preset manual from the White balance menu and then press the Multi-selector right to view the preset choices.**

3. **Use the Multi-selector to highlight one of the presets — d-0, d-1, d-2, d-3, or d-4 — and then press the Zoom Out button.** The Preset menu is displayed.

4. **Use the Multi-selector to highlight Edit comment and then press the Multi-selector right.** The text-entry screen is displayed.

 • Using the Multi-selector, you can scroll around within the set of letters, numbers, and punctuation marks. There are several buttons you can use to maneuver in the text-entry screen.

 • Press the Zoom In button to insert the letter that's highlighted.

 • Press the Thumbnail/Zoom Out button and then press the Multi-selector left or right to move the cursor within the text box. You can use it to add spaces or to overwrite another character.

 • To erase a character you have inserted, move the cursor over the top of the character and then press the Delete button.

5. **Enter your text and then press the OK button to save the comment.**

> **Note** *The text-entry screen is used for various functions, including naming Custom Picture Controls and renaming folders.*

Copy white balance from an existing photograph

As mentioned earlier, you can also copy the white balance setting from any photo that's saved on the memory card that's inserted into your camera. You can do this if you're shooting in a similar lighting situation or if you simply like the effect. Follow these steps:

> **Tip** *If you have particular settings that you like, you might consider saving the images on a small SD card. This way, you can always have your favorite WB presets saved so you don't accidentally erase them from the camera. You can also use this card to save Custom Picture Controls.*

1. **Press the Menu button and then use the Multi-selector to choose White balance from the Shooting menu.**

2. **Select Preset manual from the White balance menu and then press the Multi-selector right to view the preset choices.**

3. **Use the Multi-selector to highlight one of the four available presets — d-1, d-2, d-3, or d-4 — and then press the Zoom Out button.** A menu appears. Note that d-0 is not available for this option.

4. **Use the Multi-selector to highlight Select image.** The LCD displays thumbnails of the images saved to your SD card. This is similar to the Delete and DPOF thumbnail display. Use the Multi-selector directional buttons to scroll through the images. You can zoom in on a highlighted image by pressing the Zoom In button.

5. **Press the OK button to set the image to the selected preset (d-1, d-2, etc.) and then press the OK button again to save the setting.** This displays the fine-tuning graph. Adjust the colors if necessary and then press the OK button to save changes.

When your presets are in order, you can quickly choose between them by following these steps:

1. **Press the WB button located on the back of the camera.**

2. **Rotate the Main Command dial until PRE appears on the LCD control panel.**

3. **Continue to press the WB button and rotate the Sub-command dial.** The top right of the LCD control panel displays the preset option from d-0 to d-4.

ISO sensitivity settings

This menu option allows you to set the ISO. This is the same as pressing the ISO button and rotating the Main Command dial. You also use this menu to set the Auto ISO parameters.

Cross-Reference *For more on ISO settings and noise reduction, see Chapter 2.*

Active D-Lighting

Active D-Lighting is a setting that's designed to help ensure that you retain highlight and shadow detail when shooting in a high-contrast situation, such as shooting a picture in direct sunlight, which can cause dark shadows and bright highlight areas. Active D-Lighting basically tells your camera to underexpose the image a bit; this underexposure helps keep the highlights from becoming blown out and losing detail. The D90 also uses a subtle adjustment to avoid losing any detail in the shadow area that the underexposure may cause.

Note *Active D-Lighting is a separate and different setting than the D-Lighting option found in the Retouch menu. For more on standard D-Lighting, see Chapter 9.*

Using Active D-Lighting changes all the Picture Control brightness and contrast settings to Auto. Adjusting the brightness and contrast is how Active D-Lighting keeps detail in the shadow areas.

Active D-Lighting has six settings, which are pretty self-explanatory: Auto, Extra high, High, Normal, Low, and Off. The Extra high setting is a new option for Active D-Lighting that was introduced with the D90.

From my experiences using Active D-Lighting on both the D300 and the D90, I find that it works, but it's very subtle in the changes that it makes. If you're going to use this feature for general shooting, I recommend setting Active D-Lighting to Auto and forgetting

it. I prefer to shoot in RAW, and although the settings are saved to the metadata for use with Nikon software, I would rather do the adjustments myself in Photoshop, so I turn this feature off.

The extra time that must be taken to process the images when using Active D-Lighting causes your buffer to fill up faster when shooting continuously, so expect shorter burst rates.

Color space

Color space simply describes the range of colors (also known as the gamut) that a device can reproduce. The color space you choose depends on what the final output of your images will be. You have two choices of color spaces with the D90:

✦ **sRGB.** This is a narrow color space, meaning that it deals with fewer colors than the larger Adobe RGB color space. The sRGB color space is designed to mimic the colors that can be reproduced on most low-end monitors and is more saturated than the Adobe RGB color space.

✦ **Adobe RGB.** This color space has a much broader color spectrum than is available with sRGB. The Adobe gamut was designed for dealing with the color spectrum that can be reproduced with most high-end printing equipment.

This leads to the question of which color space you should use. As mentioned earlier, the color space you use depends on what the final output of your images is going to be. If you take pictures, download them straight to your computer, and typically only

view them on your monitor or upload them for viewing on the Web, then sRGB is fine. The sRGB color space is also useful when printing directly from the camera or memory card with no post-processing.

If you're going to have your photos printed professionally or you intend to do a bit of post-processing to your images, using the Adobe RGB color space is recommended. This allows you to have subtler control over the colors than is possible by using a narrower color space like sRGB.

For the most part, I capture my images by using the Adobe RGB color space. I then do my post-processing and make a decision on the output. Anything that I know I will be posting to the Web, I convert to sRGB; anything destined for my printer is saved as Adobe RGB. I usually end up with two identical images saved with different color spaces. Because most Web browsers don't recognize the Adobe RGB color space, any images saved as Adobe RGB and posted on the Internet usually appear dull.

Long exp. NR

This menu option allows you to turn on noise reduction (NR) for exposures of 1 second or longer. When this option is on, after taking a long exposure photo, the camera runs a dark frame noise-reduction algorithm, which involves taking a second exposure and analyzing the noise and reducing it.

High ISO NR

This allows you to choose how much noise reduction (NR) is applied to images that are taken at ISO 2000 or higher. There are four settings:

✦ **High.** This setting applies a fairly aggressive NR. A fair amount of image detail can be lost when this setting is applied.

✦ **Normal.** This is the default setting. Some image detail may be lost when using this setting.

✦ **Low.** A small amount of NR is applied when this option is selected. Most of the image detail is preserved when using this setting.

✦ **Off.** When this setting is chosen, no NR is applied to images taken between ISO 100 (L 0.1) and 3200; however, a very small amount of NR is applied to images shot at H 0.3 and above.

Active folder

As discussed earlier, the D90 automatically creates folders in which you can store your images. The camera creates a folder named DCIM and then stores the images in subfolders, starting with folder 100NCD90. When a folder gets 999 images in it, the camera automatically starts a new folder. You can choose to rename this folder or change the folder that the camera is saving to. You can name this folder whatever you like. You can use this option to separate different subjects into different folders. When I shoot SCCA sports car races, there are different groups of cars. I use a different folder for each group to make it easier to sort through the images later. If there are five groups, I start out naming my folder GRP1, then GRP2 for the second group, etc. If you're on a road trip, you can save your images from each destination to separate folders. These are just a couple of examples of how this feature can be used.

When selecting the active folder, you can choose a new folder or you can select a folder that has already been created. When you format your SD card, all preexisting folders are deleted, and the camera creates a folder with whatever number the active folder is set to. So, if you set it to a folder named ABC01, when the card is formatted, the camera creates folder 100ABC01.

To change the Active folder, follow these steps:

1. **In the Shooting menu, use the Multi-selector to choose Active folder and then press the Multi-selector right to view the options.**

2. **Select the Select folder option (default) to start a new folder and then press the Multi-selector right.** Use the Multi-selector up and down buttons to select from the list of folders. Of course, if you haven't created any new folders, you only have the NCD90 folder to choose from.

3. **Press the OK button to save changes.**

To create a new folder, follow these steps:

1. **In the Shooting menu, use the Multi-selector to choose Active folder and then press the OK button to view the options.**

2. **Select the New folder option and then press OK or press the Multi-selector right.** A text-entry menu appears. You have five spaces in which you can input numbers or letters. Enter a name for your new folder and then press the OK button to save the folder. The folder is now active.

You can also rename preexisting folders by selecting the Rename option, selecting a folder to rename, and then applying a new name by using the text-entry menu. To delete a folder, it must be empty. Select Delete from the menu to delete all empty folders.

Multiple exposure

This allows you to record multiple exposures in one image. You can record from two to three shots in a single image. This is an easy way to get off-the-wall multiple images without using image-editing software.

To use this feature, follow these steps:

1. **Select Multiple exposure from the Shooting menu and then press the Multi-selector right.**

2. **Select the Number of shots menu option and then press the Multi-selector right.**

3. **Press the Multi-selector up or down to set the number of shots (2 or 3) and then press the OK button when the number of shots selected is correct.**

4. **Select the Auto gain option and then press the Multi-selector right.**

5. **Set the gain and then press the OK button.** Using Auto gain enables the camera to adjust the exposure according to the number of images in the multiple exposures. This is the recommended setting for most applications. Setting the gain to Off doesn't adjust the exposure values and can result in an overexposed image.

The Gain-off setting is recommended only in low-light situations. When the desired setting is chosen, press the OK button.

6. **Use the Multi-selector to highlight Done and then press the OK button.** This step is very important. If you don't select Done, the camera won't be in Multiple Exposure mode.

7. **Take your pictures.** After you take the selected amount of images, the camera exits Multiple Exposure mode and returns to the default shooting setting. To do additional multiple exposures, repeat the steps.

Movie settings

This menu option is where you adjust the resolution and aspect ratio of the movies that your camera films. You can also turn off the sound recording option here. All the filming options record at 24 frames per second (fps) to ensure high-quality video that doesn't appear jerky.

Under the Quality submenu, there are three options:

✦ **1280 × 720 (16:9).** This is the HD setting. The camera records high-definition video by using an aspect ratio of 16:9, which is the same aspect ratio in which most major films are shot. The file size of videos shot at this resolution can get pretty big pretty fast. Using this resolution,

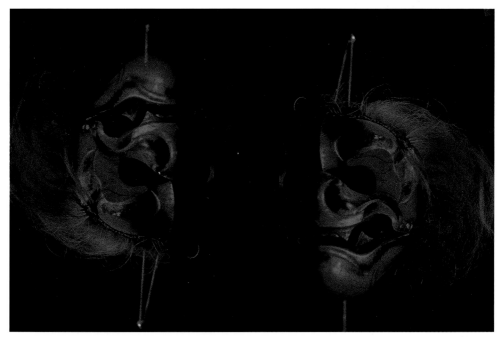

3.7 I took this multiple exposure by framing the mask on the left side; then, after flipping the camera upside-down, I took another shot. I spot-metered for the highlights and applied −1 EV exposure compensation to ensure a black background.

you're limited to shooting clips that run no longer than 5 minutes. This is the type of video you want to shoot if you're planning on showing your movies on an HD display.

✦ **640 × 420 (3:2).** This is the default setting. Videos shot with this setting have a standard aspect ratio of 3:2, which is the same aspect ratio as your still photos. This setting is good for videos that will be published to the Web on sites such as YouTube.com. There is no time limit on the length of the clips you can record (as long as you have space on your card).

✦ **320 × 216 (3:2).** This is the setting that records at the lowest resolution, resulting in smaller file sizes. This setting also shoots video with an aspect ratio of 3:2. You can use this setting to film videos that you can easily send as an e-mail attachment due to the smaller file size.

Custom Setting Menu

The Custom Setting menu (CSM) is where you really start getting into customizing your D90 to shoot to your personal preferences. Basically, this is where you make the camera yours. There are dozens of options that you can turn off or turn on to make shooting easier for you as shown in Table 3.1 and discussed in the following sections. The Custom Setting menu is probably the most powerful menu in the camera.

The CSM is set up with six sets of submenus to make it easier for you to navigate through the menus so you can find what you need

and change it quickly. These menus are broken into different types of camera functions that are fairly self-explanatory.

3.8 The Custom Setting menu (CSM)

Reset custom settings

Use this option to restore the camera's default settings for all the CSM menu options.

CSM a Autofocus

The CSM submenu a controls how the camera performs its autofocus (AF) functions. Because focus is a critical operation, this is a very important menu. There are seven options in this menu.

3.9 CSM a Autofocus menu

a1 AF-area mode

This is where you set the mode that controls how the active focus point is selected. There are four options:

✦ **Single point.** Use the Multi-selector to choose which focus point is active.

✦ **Dynamic area.** Use the Multi-selector to choose the active focus point. If the subject leaves the focus point, the camera uses information from the surrounding focus points to maintain focus on the subject.

✦ **Auto-area.** When this option is selected, the camera automatically chooses the focus point.

✦ **3D-tracking (11 points).** With this option activated, the camera tracks moving subjects across the frame.

Cross-Reference *For more on AF Area modes, see Chapter 2.*

Table 3.1
CSM Default Settings

Custom Setting menu	Default Setting
a1: AF-area mode	Auto-area
a2: Center focus point	Normal zone
a3: Built-in AF-assist illuminator	On
a4: AF point illumination	Auto
a5: Focus point wrap-around	No wrap
a6: AE-L/AF-L for MB-D80	AE/AF lock
a7: Live view autofocus	Wide area
b1: EV steps for exposure cntrl.	1/3 stop
b2: Easy exposure compensation	Off
b3: Center-weighted area	8 mm
b4: Fine tune optimal exposure	No
c1: Shutter-release button AE-L	Off
c2: Auto meter-off delay	6 s
c3: Self-timer	Self-timer delay (10 s) Number of shots (1)
c4: Monitor off delay	Playback (10 s) Menus (20 s) Shooting info display (10 s) Image review (4 s)
c5: Remote on duration	1 min

continued

Table 3.1 *(continued)*

Custom Setting menu	Default Setting
d1: Beep	On
d2: Viewfinder grid display	Off
d3: ISO display and adjustment	Show frame count
d4: Viewfinder warning display	On
d5: Screen tips	On
d6: CL mode shooting speed	3 fps
d7: File number sequence	Off
d8: Shooting info display	Auto
d9: LCD illumination	Off
d10: Exposure delay mode	Off
d11: Flash warning	On
d12: MB-D80 battery type	LR6 (AA alkaline)
e1: Flash shutter speed	1/60 s
e2: Flash cntrl for built-in flash	TTL
e3: Modeling flash	Off
e4: Auto bracketing set	AE & flash
e5: Auto FP	Off
e6: Bracketing order	MTR > under > over
f1: illuminator switch	LCD backlight
f2: OK button (shooting mode)	Select center focus point
f3: Assign FUNC. button	FV lock
f4: Assign AE-L/AF-L button	AE/AF lock
f5: Customize command dials	Reverse rotation (No) Change main/sub (Off) Menus and playback (On)
f6: No memory card?	Release locked
f7: Reverse indicators	

a2 Center focus point

This setting allows you to set the center focus point to normal or wide zone. Changing the focus to wide zone helps the camera maintain focus on moving subjects that are in the center of the frame.

a3 Built-in AF-assist illuminator

The AF-assist illuminator lights up when there isn't enough light for the camera to focus properly. In certain instances, you may want to turn this option off, such as when shooting faraway subjects in dim settings (concerts or plays). When set to On, the

AF-assist illuminator lights up in a low-light situation. When in Single Point mode, Dynamic Area AF, or 3D Tracking, the center AF point must be active. The illuminator doesn't function if the camera is set to Continuous Autofocus (AF-C).

When set to Off, the AF-assist illuminator doesn't light at all, even in dim lighting.

a4 AF point illumination

This menu option allows you to choose whether the active AF point is momentarily highlighted in red in the viewfinder when the autofocus is activated. When the viewfinder grid is turned on, the grid is also highlighted in red. When choosing Auto, which is the default, the focus point is lit only to establish contrast from the background when it's dark. When set to On, the active AF point is highlighted even when the background is bright. When set to Off, the active AF point isn't highlighted in red but appears black.

a5 Focus point wrap-around

When using the Multi-selector to choose your AF point, this setting allows you to be able to keep pressing the Multi-selector in the same direction and wrap around to the opposite side (wrap) or stop at the edge of the focus point frame (no wrap).

a6 AE-L/AF-L for MB-D80

This allows you to assign a specific function to the AE-L/AF-L button on the optional MB-D10 battery grip. You can choose from:

✦ **AE/AF lock.** This locks the camera's focus and exposure while the button is pressed.

✦ **AE lock only.** This only locks the exposure while the button is pressed.

✦ **AF lock only.** This locks the focus until the button is released.

✦ **AE lock (hold).** The exposure is locked when the button is pressed and remains locked until the button is pressed again or until the exposure meter turns off.

✦ **AF-ON.** This allows you to use the button to activate the autofocus.

✦ **FV lock.** This setting locks the flash output. Use this option to meter your subject and then recompose while retaining the proper flash exposure for the subject.

✦ **Focus point selection.** This allows you to change the active focus point by pressing the button and then rotating the Sub-command dial.

a7 Live view autofocus

CSM a7 allows you to choose how your AF functions when using the Live View mode. You can choose between using a normal-size focus point or a focus point with a wide area. You can also choose Face priority AF, which scans the frame and determines if there's a face in the subject area. If the camera detects a face, then the camera automatically focuses on that area. Face priority can recognize one or more faces. Use this option when photographing portraits or groups of people.

CSM b Metering/ exposure

This is where you change the settings that control exposure and metering. These settings allow you to adjust the exposure, ISO, and exposure compensation adjustment increments. There are four options in this menu.

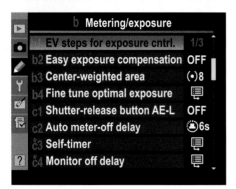

3.10 CSM b Metering/exposure menu

b1 EV steps for exposure cntrl.

This determines how the shutter speed, aperture, exposure compensation, and auto-bracketing increments are set. The choices here are also 1/3 or 1/2 stop. Choosing a smaller increment gives a much less drastic change in exposure and allows you to get a more exact exposure in critical situations.

b2 Easy exposure compensation

By default, to set the exposure compensation, you must first press the EV button and then use the Main Command dial to add or subtract from the selected exposure. If you tend to use exposure compensation frequently, you can save yourself some time by using this option to set Easy exposure compensation.

When this function is set to On, it's not necessary to press the EV button to adjust the exposure compensation. Simply rotate the Main Command dial when in Aperture Priority mode or the Sub-command dial when in Programmed Auto or Shutter Priority

mode to adjust the exposure compensation. The exposure compensation is then applied until you rotate the appropriate command dial until the exposure compensation indicator disappears from the LCD control panel. Be sure you remember to reset the exposure compensation to the default setting when finished.

When set to Off, exposure compensation is applied normally by pressing the Exposure Compensation button and then rotating the Main Command dial.

b3 Center-weighted area

This option allows you to choose the size of your Center-weighted metering area. You can choose from three sizes: 6, 8, or 10. Choose the spot size depending on how much of the center of the frame you want the camera to meter for. The camera determines the exposure by basing 75% of the exposure on the circle.

> **Cross-Reference** *For more on Center-weighted metering, see Chapter 2.*

b4 Fine tune optimal exposure

If your camera's metering system consistently over- or underexposes your images, you can adjust it to apply a small amount of exposure compensation for every shot. You can apply a different amount of exposure fine-tuning for each of the Metering modes: Matrix, Center-weighted, and Spot.

You can set the EV ±1 stop in 1/6-stop increments.

When Fine tune optimal exposure is on, there's no warning indicator that tells you that exposure compensation is being applied.

CSM c Timers/AE lock

This submenu controls the D90's various timers and also the autoexposure lock setting. There are five options in this menu.

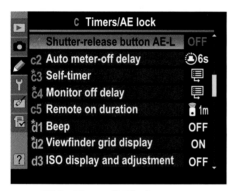

3.11 CSM c Timers/AE lock menu

c1 Shutter-release button AE-L

Set to default (Off), the camera only locks exposure when the AE-L/AF-L button is pressed. When set to On, the autoexposure settings are locked when the camera's Shutter Release button is half-pressed.

c2 Auto meter-off delay

This menu option is used to determine how long the camera's exposure meter is active before turning off when no other actions are being performed. You can choose 4, 6, 8, 16, or 30 seconds or 1, 5, 10, or 30 minutes.

c3 Self-timer

This setting puts a delay on when the shutter is released after the Shutter Release button is pressed when using the Self-timer mode. This is handy when you want to do a self-portrait and you need some time to get yourself into the frame. The self-timer can also be employed to reduce camera shake caused by pressing the Shutter Release button on long exposures. You can set the delay at 2, 5, 10, or 20 seconds. Additionally, you can set the self-timer for 1–9 shots. This causes the camera to fire a continuous series of shots at the Continuous Low setting.

For some people, especially those interested in HDR imaging, there's a trick you can do to allow the camera to fire off an auto-bracketing burst with one press of the Shutter Release button. This allows you to ensure that you get no camera movements between shots so your images are in perfect registration. Follow these steps:

1. **Press the Bracketing (BKT) button and then set the bracketing to 3F by rotating the Main Command dial.** Using the Sub-command dial, set the exposure increment to whatever you want. I prefer 1-stop intervals.

2. **Go to CSM c3 Self-timer to set the delay time.** Five seconds should be enough to allow the camera and tripod to stabilize. Next, set the number of shots to 3.

3. **This step is optional.** Go to CSM d6 to set the Continuous Low shooting speed to 4 fps.

4. **Press the Release mode button and then rotate the Main Command dial until the self-timer icon appears with the Continuous Low shooting icon above it.**

5. **Press the Shutter Release button.** After the self-timer delay, the camera will perform auto-bracketing with one press of the Shutter Release button.

c4 Monitor off delay

This controls how long the LCD monitor remains on when no buttons are being pushed. Because the LCD monitor is the main source of power consumption for any digital camera, choosing a shorter delay time is usually preferable. You can set the monitor to turn off after 4, 10, or 20 seconds or 1, 5, or 10 minutes.

You can choose a different time for each function that the monitor performs: playback, menus, Shooting Info Display, and image review.

c5 Remote on duration

This setting controls how long the camera waits for a signal from the optional ML-L3 infrared remote control before the camera exits the Remote Release mode and returns to the default Release mode (Single Frame).

CSM d Shooting/display

CSM submenu d is where you make changes to some of the minor shooting and display details. There are 12 options in this menu.

d Shooting/display	
d1 Beep	OFF
d2 Viewfinder grid display	ON
d3 ISO display and adjustment	OFF
d4 Viewfinder warning display	ON
d5 Screen tips	OFF
d6 CL mode shooting speed	🖵4
d7 File number sequence	ON
d8 Shooting info display	AUTO

d Shooting/display	
d9 LCD illumination	OFF
d10 Exposure delay mode	OFF
d11 Flash warning	ON
d12 MD-D80 battery type	🔋LR6
Flash shutter speed	1/60
Flash cntrl for built-in flash	RPT⚡
Modeling flash	ON
Auto bracketing set	AE

3.12 The CSM d Shooting/display menu is shown on two screens so that all options are visible.

d1 Beep

When this option is on, the camera emits a beep when the self-timer is counting down or when the AF locks in Single Focus mode. You can choose High, Low, or Off. For most photographers, this option is absolutely the first thing that gets turned off when the camera is taken out of the box. Although the beep can be useful when in Self-timer mode, it's an annoying option, especially if you're photographing in a relatively quiet area.

d2 Viewfinder grid display

This handy option displays a grid in the viewfinder to assist you with composition of the photograph.

d3 ISO display and adjustment

This menu has a few different options for changing and viewing the ISO settings:

✦ **Show ISO sensitivity.** When this option is set to On, the ISO sensitivity setting appears in the area where the remaining number of images is displayed on the control panel.

✦ **Show ISO/Easy ISO.** Turning this option on shows the ISO on the control panel and sets the camera to Easy ISO. This allows you to quickly change the ISO sensitivity without pressing the ISO button on the rear of the camera. When Easy ISO is set to on, you can change the ISO by rotating the Main Command dial (Aperture Priority) or the Sub-command dial (Shutter Priority or Programmed Auto). When the camera is set to Manual or to one of the Scene modes, Easy ISO is disabled.

✦ **Show frame count.** This is the default setting. This shows the number of images that you can fit on the memory card.

d4 Viewfinder warning display

This allows you to turn off warnings that are shown in the viewfinder display. The warnings that can be displayed are the B/W indicator, low battery indicator, and no memory card warning. When this option is turned off, none of these warnings are displayed.

d5 Screen tips

When this option is turned on, the camera displays descriptions of the menu options available when using the Quick Settings Display. The menu options in the display are pretty self-evident as to what they are, so I have this option turned off. If you're unsure of any menu option, pressing the Protect/Help button displays a screen that describes the function.

d6 CL mode shooting speed

This allows you to set the maximum frame rate in the Continuous Low Shooting mode. You can set the frame rate between 1 fps and 4 fps. This setting limits your burst rate for shooting slower-moving action. This is a handy option to use when you don't necessarily need the highest frame rate, such as when shooting action that isn't moving very fast but also isn't moving slow. I have this set at 2 fps, which is about half the normal frame rate.

d7 File number sequence

The D90 names files by sequentially numbering them. This option controls how the sequence is handled. When set to Off, the file numbers reset to 0001 when a new folder is created, a new memory card is inserted, or the existing memory card is formatted. When set to On, the camera continues to count up from the last number until the file number reaches 9999. The camera then returns to 0001 and counts up from there. When this is set to Reset, the camera starts at 0001 when the current folder is empty. If the current folder has images, the camera starts at one number higher than the last image in the folder.

d8 Shooting info display

This controls how the Shooting Info Display on the LCD panel is colored. When set to Auto (default), the camera automatically sets it to Light on dark or Dark on light to maintain contrast with the background. The setting is automatically determined by the amount of light coming in through the lens. You can also choose for the information to be displayed consistently no matter how dark or light the scene is. You can choose B (black lettering on a light background) or W (white lettering on a dark background).

d9 LCD illumination

When this option is set to Off (default), the LCD control panel on the camera (and on a Speedlight if attached) is lit only when the power switch is turned all the way to the right, engaging the momentary switch. When set to On, the LCD control panel is lit as long as the camera's exposure meter is active, which can be quite a drain on the batteries (especially for the Speedlight).

d10 Exposure delay mode

Turning this option on causes the shutter to open about 1 second after the Shutter Release button is pressed and the reflex mirror has been raised. This option is for shooting long exposures with a tripod where camera shake from pressing the Shutter Release button and mirror slap vibration can cause the image to be blurry.

d11 Flash warning

When this option is set to On, a blinking flash indicator (it's shaped like a lightning bolt) is displayed on the right side of the viewfinder display when the exposure meter determines that there isn't enough light in the scene to make a proper exposure or if the subject is backlit.

d12 MB-D80 battery type

When using the optional MB-D10 battery pack with AA batteries, use this option to specify what type of batteries are being used to ensure optimal performance. Your choices are:

✦ **LR6 (AA alkaline).** These are your standard AA batteries. I don't recommend their use because they don't last very long when using them with the D90.

✦ **HR6 (AA Ni-Mh).** These are your standard nickel–metal hydride rechargeable batteries available at most electronics stores. I recommend buying several sets of these. If you do buy these batteries, be sure to buy the ones that are rated at least 2500 MaH for longer battery life.

✦ **FR6 (AA Lithium).** These lightweight batteries are nonrechargeable but last up to seven times longer than standard alkaline batteries. These batteries cost about as much as a good set of rechargeable batteries.

✦ **ZR6 (AA Ni-Mn).** These are nickel maganese batteries. These are the standard low-budget batteries. They don't last long, and I don't recommend using them.

CSM e Bracketing/flash

This submenu is where you set the controls for the built-in Speedlight. Some of these options also affect external Speedlights. This

menu is also where the controls for bracketing images are located. There are seven options in this menu.

▣	ⓔ Bracketing/flash	
●	e1 **Flash shutter speed**	1/60
🖉	e2 Flash cntrl for built-in flash	RPT⚡
Ψ	e3 Modeling flash	ON
🗹	e4 Auto bracketing set	AE
🗒	e5 Auto FP	ON
	e6 Bracketing order	—➔+
f1	🔆 switch	🔆
?	f2 OK button (shooting mode)	RESET

3.13 CSM e Bracketing/flash menu

e1 Flash shutter speed

This option lets you decide the slowest shutter speed that's allowed when you do flash photography using Front-Curtain Sync or Red-Eye Reduction mode when the camera is in P or A Exposure mode. You can choose from 1/60 second all the way down to 30 seconds.

When the camera is set to Shutter Priority or the flash is set to any combination of Slow Sync, this setting is ignored.

e2 Flash cntrl for built-in flash

This submenu has other submenus nested within it. Essentially, this option controls how your built-in flash operates. The four submenus are:

✦ **TTL.** This is the fully automatic Flash mode. Minor adjustments can be made using FEC (Flash Exposure Compensation).

✦ **Manual.** You choose the power output in this mode. You can choose from Full power all the way down to 1/128 power.

✦ **Repeating flash.** This mode fires a specified number of flashes.

✦ **Commander mode.** Use this setting to control a number of off-camera CLS-compatible Speedlights.

Cross-Reference *For more on flash photography with Nikon Speedlights, see Chapter 6 or pick up a copy of the Nikon Creative Lighting System Digital Field Guide (Wiley).*

e3 Modeling flash

When using the built-in flash or an optional SB-900, SB-600, or SB-800 Speedlight, pressing the Depth of Field Preview button fires a series of low-power flashes that allow you to preview what the effect of the flash is going to be on your subject. When using CLS and Advanced Wireless Lighting with multiple Speedlights, pressing the button causes all the Speedlights to emit a modeling flash. You can set this to On or Off.

e4 Auto bracketing set

This option allows you to choose how the camera brackets when auto-bracketing is turned on. You can choose for the camera to bracket AE and flash, AE only, Flash only, WB bracketing, or a series of images by using Active D-Lighting. WB bracketing isn't available when the image quality is set to record RAW images.

e5 Auto FP

This allows you to use a shutter speed faster than 1/200 when using an SB-900, SB-800, or SB-600 Speedlight. Auto FP is disabled when using the built-in flash.

Cross-Reference *For more on Auto FP, see Chapter 6.*

e6 Bracketing order

This determines the sequence in which the bracketed exposures are taken. When set to default (N), the camera first takes the metered exposure, the underexposures next, and then the overexposures. When set to (--> +), the camera starts with the lowest exposure and then increases the exposure as the sequence progresses.

CSM f Controls

This submenu allows you to customize some of the functions of the different buttons and dials of your D90. There are seven options in this menu.

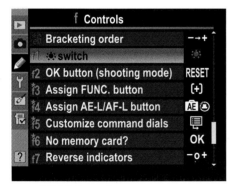

3.14 CSM f Controls menu

f1 illuminator switch

The On/Off switch can be rotated past the On setting that acts as a momentary switch. You can use this option to light up the LCD control panel (LCD backlight) or you can light up the LCD control panel and display the information screen on the rear LCD monitor (Both).

f2 OK button (shooting mode)

This allows you to set specific options for pressing the OK button. The options vary depending on whether the camera is in Shooting or Playback mode.

The options are as follows:

✦ **Select center focus point.** This allows you to automatically select the center focus point by pressing the OK button.

✦ **Highlight selected focus point.** This causes the active focus point to light up in the viewfinder when the OK button is pressed.

✦ **Not used.** The OK button has no effect when in Shooting mode.

f3 Assign FUNC. button

This button chooses what functions the Function (Fn) button performs when pressed. The function assigned to the button makes it easy to change a setting quickly and can speed up your shooting process.

✦ **Framing grid.** Pressing the Function (Fn) button and then rotating the Main Command dial turns the framing grid option on or off.

✦ **AF-area mode.** Press the Function (Fn) button and then rotate the Main Command dial to change the AF Area mode.

✦ **Center focus point.** Pressing the Function (Fn) button and then rotating the Main Command dial toggles between normal and wide area center focus point.

✦ **FV lock.** This is the default setting. The camera fires a pre-flash to determine the proper flash exposure value and locks the setting, allowing you to meter the subject and then recompose the shot without altering the flash exposure.

✦ **Flash off.** With this option, the built-in flash (if popped up) or an additional Speedlight will not fire when the shutter is released as long as the Function (Fn) button is pressed. This allows you to quickly take available light photos without having to turn off the flash. This is quite handy, especially when shooting weddings and events.

✦ **Matrix metering.** This option allows you to automatically use Matrix metering no matter what Metering mode the camera is set to.

✦ **Center-weighted metering.** This option allows you to automatically use Center-weighted metering no matter what Metering mode the camera is set to.

✦ **Spot metering.** This option allows you to automatically use Spot metering no matter what Metering mode the camera is set to.

✦ **Access top item in My Menu.** This displays the top item set in the My Menu option. You can use this to quickly access your most-used menu option.

✦ **+ NEF (RAW)** Pressing the Function (Fn) button when this is activated and the camera is set to record JPEG allows the camera to simultaneously record a RAW file and a JPEG. Pressing the button again or turning the camera off allows the camera to return to recording only JPEGs.

f4 Assign AE-L/AF-L button

This allows you to customize the function of the AE-L/AF-L button. There are six options in this menu:

✦ **AE/AF lock.** This locks the exposure and the focus as long as the button is pressed and held. Releasing the button resets the meter and allows the AF to function normally.

✦ **AE lock only.** This locks the exposure as long as the button is pressed and held.

✦ **AF lock only.** This locks the AF on your subject, allowing you to recompose the shot while maintaining focus on your subject.

✦ **AE lock (hold).** This locks the exposure when the button is pressed. To unlock the exposure, press the button a second time or turn the camera off. This option is useful when shooting video to keep the

exposure from changing, which causes your video to dim and brighten intermittently.

✦ **AF-ON.** This allows you to activate the camera's AF system without pressing the Shutter Release button.

✦ **FV lock.** This allows you to lock the flash output value when recomposing a shot.

f5 Customize command dials

This menu allows you to control how the Main Command and Sub-command dials function. The options are:

✦ **Reverse rotation.** This causes the settings to be controlled in reverse of what is normal. For example, by default, rotating the Sub-command dial right makes your aperture smaller. Reversing the dials gives you a larger aperture when rotating the dial to the right.

✦ **Change main/sub.** This switches functions of the Main Command dial to the front and the Sub-command dial to the rear of the camera.

✦ **Menus and playback.** This allows you to use the command dials to scroll the menus and images in much the same fashion the Multi-selector is used. In Playback mode, the Main Command dial is used to scroll through the preview images, and the Sub-command dial is used to view the shooting information and/or histograms. When in Menu mode, the Main Command dial functions the same as pressing the Multi-selector up and down, and

the Sub-command dial operates the same as pressing the Multi-selector left and right.

f6 No memory card?

This setting controls whether the shutter will release when no memory card is present in the camera. When set to Enable release, the shutter fires, and an image is displayed in the monitor. The image is temporarily saved. When set to Release locked, the shutter won't fire. If you happen to be using Camera Control Pro 2 shooting tethered directly to your computer, the shutter will release no matter what this option is set to.

f7 Reverse indicators

This allows you to reverse the indicators on the electronic light meter displayed in the viewfinder and on the LCD control panel on the top of the camera. For some, the default setting showing the overexposure on the left and the underexposure on the right is counterintuitive. Reversing these makes more sense to some people (including me). This option also reverses the display for the auto-bracketing feature.

Setup Menu

This menu contains a smattering of options, most of which aren't changed very frequently. Some of these settings include the time and date and the Video mode. A couple of other options are the Clean image sensor and Battery info, which you may want to access from time to time. There are 20 options in this menu.

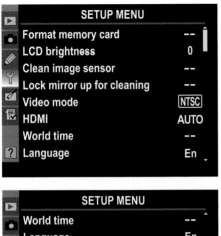

SETUP MENU

Format memory card	--
LCD brightness	0
Clean image sensor	--
Lock mirror up for cleaning	--
Video mode	NTSC
HDMI	AUTO
World time	--
Language	En

SETUP MENU

World time	--
Language	En
Image comment	OFF
Auto image rotation	ON
Image Dust Off ref photo	--
Battery info	--
GPS	--
Firmware version	--

3.15 The Setup menu is shown in two sections so you can see all options.

Format memory card

This allows you to completely erase everything on your memory card. Formatting your memory card erases all the data on the card. It's a good idea to format your card every time you download the images to your computer (just be sure all the files are successfully transferred before formatting). Formatting the card helps protect against corrupt data. Simply erasing the images leaves the data on the card and allows it to be overwritten; sometimes, this older data can corrupt the new data as it's being written. Formatting the card gives your camera a blank slate on which to write.

You can also format the card by using the more-convenient two-button method (pressing and holding the Delete and Metering mode buttons simultaneously).

LCD brightness

This menu sets the brightness of your LCD screen. You may want to make it brighter when viewing images in bright sunlight or make it dimmer when viewing images indoors or to save battery power. You can adjust the LCD ±3 levels. The menu shows a graph with ten bars from black to gray to white. The optimal setting is where you can see a distinct change in color tone in each of the bars. If the last two bars on the right blend together, your LCD is too bright; if the last two bars on the left side blend together, your LCD is too dark.

Clean image sensor

This is a great feature that was released with the D300 and added to the D90. The camera uses ultrasonic vibration to knock any dust off the filter in front of the sensor. This helps keep most of the dust off of your sensor but isn't going to keep it absolutely dust-free forever. You may have to have the sensor professionally cleaned periodically.

You can choose Clean now, which cleans the image sensor immediately, or you have four separate options for cleaning, which you access in the Clean at startup/shutdown option:

✦ **Clean at startup.** The camera goes through the cleaning process immediately upon turning the camera on. This may delay your startup time a little bit.

✦ **Clean at shutdown.** The camera cleans the sensor when the camera is switched to off. This is my preferred setting because it doesn't interfere with the startup time.

✦ **Clean at startup and shutdown.** The camera cleans the image sensor when the camera is turned on and also when it's powered down.

✦ **Cleaning off.** This disables the dust-reduction function when turning the camera on and off. You can still use the Clean now option when this is set.

Lock mirror up for cleaning

This locks up the mirror to allow access to the image sensor for inspection or for additional cleaning. The sensor is also powered down to reduce any static charge that may attract dust. Although some people prefer to clean their own sensor, I recommend taking your camera to an authorized Nikon service center for any sensor cleaning. Any damage caused to the sensor by improper self-cleaning isn't covered by warranty and can lead to a very expensive repair bill.

Video mode

There are two options in this menu: NTSC and PAL. Without getting into too many specifics, these are types of standards for the resolution of televisions. North America uses the NTSC standard, while most of Europe and Asia use the PAL standard. Check your television owner's manual for the specific setting if you plan to view your images on a TV directly from the camera.

HDMI

The D90 has an HDMI (high-definition multimedia interface) output that allows you to connect your camera to a HDTV to review your images. There are five settings: 480p, 576p, 720p, 1080i, and Auto. The Auto feature automatically selects the appropriate setting for your TV. Before plugging your camera into an HDTV, I recommend reading your TV's owner's manual for specific settings. When the camera is attached to an HDMI device, the LCD monitor on the camera is automatically disabled.

World time

This is where you set the camera's internal clock. You also select a time zone, choose the date display options, and turn the daylight-saving time options on or off.

Language

This is where you set the language that the menus and dialog boxes display.

Image comment

You can use this feature to attach a comment to the images taken by your D90. You can enter the text by using the Input Comment menu. The comments can be viewed in Nikon's Capture NX or View NX software or can be viewed in the photo information on the camera. Setting the Attach comment option applies the comment to all images taken until this setting is disabled. Some comments you may want to attach are copyright information, your name, or the location where the photos were taken.

Auto image rotation

This tells the camera to record the orientation of the camera when the photo is shot (portrait or landscape). This allows the camera and also image-editing software to show the photo in the proper orientation so you don't have to take the time in post-processing to rotate images shot in portrait orientation.

Image Dust Off ref photo

This option allows you to take a dust reference photo that shows any dust or debris that may be stuck to your sensor. Capture NX then uses the image to automatically retouch any subsequent photos where the specks appear.

To use this feature, either select Start or Clean sensor and then start. Next, you're instructed by a dialog box to take a photo of a bright, featureless white object that's about 10 cm from the lens. The camera automatically sets the focus to infinity. A Dust Off reference photo can only be taken when using a CPU lens. It's recommended to use at least a 50mm lens, and when using a zoom lens, you should zoom all the way in to the longest focal length.

Battery info

This handy little menu allows you to view information about your batteries. It shows you the current charge of the battery as a percentage and how many shots have been taken with that battery since the last charge. This menu also shows the remaining charging life of your battery before it's no longer able to hold a charge. I find myself accessing this menu quite a bit to keep a real-time

watch on my camera's power levels. Using AA batteries in the MB-D80 won't provide the camera with data.

✦ **Bat. meter.** This tells you the percentage of remaining battery life from 100–0%. When the MB-D10 is attached and loaded with AA batteries, a percentage isn't shown, but there's a battery indicator that shows full, 50%, and 0% power levels.

✦ **Pic. meter.** This tells you how many shutter actuations the battery has had since its last charge. This option isn't displayed for the MB-D10 when using AA batteries.

✦ **Battery age.** This is a gauge that goes from 0–4 that tells you how much working life you have left in your battery. Because Li-ion batteries have a finite life, this option isn't shown for AA batteries. When shooting outside in temperatures below 41° F (5° C), this gauge may temporarily show that the battery life has lost some of its charging life. The battery will show normal when brought back to normal operating temperature of about 68° F.

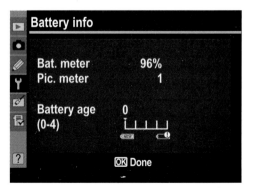

3.16 The Battery info display

GPS

This menu is used to adjust the settings of an optional GPS unit, which can be used to record longitude and latitude to the images' EXIF data. The GPS is connected to the camera's accessory terminal. There are two options:

✦ **Auto meter off.** This option allows you to control whether the exposure meter turns off when the optional GP-1 is connected. The GPS unit is synced with the exposure meters so that if the exposure meter turns off, the GPS unit's connection is severed. It may take several minutes for the GP-1 to regain contact with the GPS satellites. Choosing the Enable option allows your meters to turn off by using the parameters set in CSM c2. Choosing Disable allows the meters to stay on, keeping the connection with the GPS unit active.

✦ **Position.** This option provides the position details from information received from the GP-1.

Firmware version

This menu option displays the firmware version your camera is currently operating under. Firmware is a computer program that's embedded in the camera that tells it how to function. Camera manufacturers routinely update the firmware to correct for any bugs or to make improvements on the camera's functions. Nikon posts firmware updates on its Web site at www.nikonusa.com.

Retouch Menu

The Retouch menu allows you to make changes and corrections to your images with the use of imaging-editing software. As a matter of fact, you don't even need to download your images. You can make all the changes in-camera by using the LCD preview (or hooked up to a TV if you prefer).

The options include D-Lighting, Red-eye correction, Trim, Monochrome, Color effects, Color balance, and Image overlay.

> **Cross-Reference** *For more on the Retouch menu, see Chapter 8.*

My Menu

This is a great menu option that was introduced with the D300. It's much better than the Recent Settings menu in the D200 (you can also choose to replace the My Menu tab with the Recent Settings tab). The My Menu option allows you to create your own customized menu by choosing the options you want. You can also set the different menu options to whatever order you want. This allows you to have all the settings you change the most right at your fingertips without having to go searching through all the menus and submenus. For example, I have the My Menu option set to display all the menu options I frequently use, including Set Picture Control, Battery info, CSM e3, and Active D-Lighting, among others. This saves me an untold amount of time because I don't have to go through a lot of different menus.

3.17 This figure shows the My Menu options I have set on my camera (on two screens so you can see all the options).

To set up your custom My Menu, follow these steps:

1. **Select My Menu and then press the OK button.**

2. **Select Add items and then press the OK button.**

3. **Use the Multi-selector to navigate through the menus to add specific menu options and then press the OK button.**

4. **Use the Multi-selector to position where you want the menu item to appear and then press the OK button to save the order.**

5. **Repeat steps 2 to 4 until you've added all the menu items you want.**

To reorder the items in My Menu, follow these steps:

1. **Select My Menu and then press the OK button.**

2. **Select Rank items and then press the OK button.** This displays a list of all the menu options that you have saved to My Menu.

3. **Use the Multi-selector to highlight the menu option you want to move and then press the OK button.**

4. **Using the Multi-selector, move the yellow line to where you want to move the selected item and then press the OK button to set.** Repeat this step until you've moved all the menu options that you want.

5. **Press the Menu button or tap the Shutter Release button to exit.**

To delete options from My Menu, simply press the Delete button when the option is highlighted. The camera asks for confirmation that you indeed want to delete the setting. Press the Delete button again to confirm or press the Menu button to exit without deleting the highlighted menu option.

As mentioned earlier, you can replace the My Menu option with the Recent Settings option. The Recent Settings menu stores the last 20 settings you've adjusted. To switch from My Menu to Recent Settings, follow these steps:

1. **Select My Menu and then press the OK button.**

2. **Use the Multi-selector to scroll down to the Choose tab menu option and then press the OK button.**

3. **Select Recent Settings and then press the OK button or press the Multi-selector right to change the setting.**

4. **Press the Menu button or tap the Shutter Release button to exit.**

Quick Settings Display

Although this isn't a true menu, it allows you access to several of the most commonly changed menu items. To access the Quick Settings Display, press the Information (info) button. This displays the Shooting Info Display on the rear LCD. While the shooting information is displayed, press the Information button again. This grays out the shooting

information and highlights the settings shown at the bottom of the Shooting Info Display. Use the Multi-selector buttons to highlight the setting you want to change and then press the OK button. This takes you straight to the specific menu option. The Quick Settings Display options are:

✦ Long Exposure NR

✦ High ISO NR

✦ Active D-Lighting

✦ Set Picture Control

✦ Assign Function Button

✦ Assign AE-L/AF-L Button

Tip *You can turn off the Quick Settings Display Screen tips in CSM d5.*

3.18 The Quick Settings Display with Screen tips on

Capturing Great Images with the Nikon D90

Selecting and Using Lenses for the Nikon D90

The lens that you put on your camera is almost as important as the camera body itself. Some may argue that the lens is more important than the camera itself. There are many different types of lenses, from ultrawide-angle lenses to super-telephoto lenses. The lens that you use depends on the subject you're photographing as well as how you want your image to be perceived. For example, using an ultrawide-angle lens to add some apparent perspective distortion to make your image seem more expansive. Shooting the same scene with a normal or short telephoto lens won't yield such drastic results.

In order to take full advantage of your D90, I recommend buying the best lenses that you can afford. The build and optical quality of a lens can have a serious impact on your image quality. Lower-quality lenses often have undesirable characteristics that will show up in your images. Often, low-priced lenses have problems, such as softness, lack of contrast, *chromatic aberration* (CA), and *vignetting* (darkening of the edges). Chromatic aberration is characterized by colored fringing on the edges of certain areas of the image, particularly in the corners and especially in areas of high contrast. This is caused by the inability of the lens to focus all wavelengths of light on the same optical axis. This aberration can be somewhat fixed by adding different coatings, such as fluorite, to the lens elements, thereby allowing the wavelengths of light to be focused sharply on the same axis.

One of the great things about photography is that through your lens choice, you can show things in a way that the human eye can't perceive. The human eye is basically a fixed focal-length lens. We can only see a certain set angular distance. This is called our *field of view* (or angle of view). Our eyes have about the same field of view as a 35mm lens on a DX-format Nikon dSLR camera (such as the D90). Changing the focal length of your lens, whether by switching lenses or zooming, changes the field of view, allowing the camera to see more or less of the scene you're photographing. Changing the focal length of the lens allows you to change the perspective of your images. In the following sections, I discuss the different types of lenses and how they can influence the subjects that you're photographing.

If you've decided to upgrade your kit lens — or you just want to add to your lens collection — there are literally hundreds of options to choose from. You have a lot to consider when purchasing a lens, whether it's a zoom or prime lens, a wide-angle or telephoto lens, or any of the numerous other options. The goal of this chapter is to give you a head start on knowing what kind of lens you want before you actually start looking.

Lens Compatibility

Nikon has been manufacturing its own lenses since about 1937, and with this history backing it up, you can be sure Nikon knows how to make some quality lenses. Although Nikon has been manufacturing lenses for many decades, with the D90, you can use almost every Nikon lens made since about 1977, although some lenses will have limited functionality. In 1977, Nikon introduced the Auto Indexing (AI) lens. Auto-indexing allows the aperture diaphragm on the lens to stay wide open until the shutter is released; the diaphragm then closes down to the desired f-stop. This allows maximum light to enter the camera, which makes focusing easier. You can also use some of the earlier lenses, known now as pre-AI, but most need some modifications to work with the D90.

All these early lenses are manual focus, and the D90 light meter doesn't work when using them, so you need to either buy a separate light meter or estimate the exposure. The camera only functions when using Manual mode. You also lose some of the D90's functions, such as 3D Color Matrix Metering and Balanced Fill-Flash.

In the 1980s, Nikon started releasing AF lenses. Many of these lenses are very high-quality and can be found at a much lower cost than their 1990s counterparts, the AF-D lenses. The main difference between the lenses is that the D lenses provide the camera with distance information based on the focus of the subject. These lenses are focused by using a screw-type drive motor that's typically found inside the camera body. During this time while Nikon was refining its AF motor, many of the super-telephoto lens remained MF. Nikon fitted these lenses with a CPU for the lens to convey information with the camera body. These are known as AI-P lenses, and they are the only type of MF lenses that allow the D90's light meter to function.

More recently, Nikon has been producing its line of AF-S lenses. These lenses have a Silent Wave Motor that's built into the lens. The AF-S motor allows the lenses to focus

much quicker than the traditional screw-type lenses and also allows the focusing to be ultraquiet. Most of these lenses are also what are known as G-type lenses. These lenses are lacking a manual aperture ring. The aperture is controlled by using the Sub-command dial on the camera body. A few years ago, only the very expensive pro lenses had the Silent Wave Motor. Nikon now offers this in even the entry-level lenses. To date, Nikon offers almost 30 AF-S lenses. These lenses range from a super-wide 12–24mm zoom lens all the way up to a 600mm super-telephoto lens. Most of the AF-S lenses are zoom lenses, but Nikon does offer a few fixed focal-length lenses. These fixed focal-length or prime lenses are mostly in the telephoto to super-telephoto range, with the exceptions being the 50mm f/1.4G and 60mm f/2.8G macro lens. Nikon's AF-S lenses range in price from around $150 for the 18–55mm f/3.5–5.6 to almost $10,000 for the 600mm f/4 with VR, so there's a lens available for whatever your budget is.

Deciphering Nikon's Lens Codes

When shopping for lenses, you may notice all sorts of letter designations in the lens name. For example, the kit lens is the AF–S DX NIKKOR 18–105mm f/3.5–5.6G ED VR. So, what do all those letters mean? Here's a simple list to help you decipher them:

✦ **AI/AIS.** These are auto-indexing lenses that automatically adjust the aperture diaphragm down when the Shutter Release button is pressed. All lenses made after 1977 are AI lenses. They are all manual focus lenses.

✦ **E.** These lenses were Nikon's budget series lenses, made to go with the lower-end film cameras, such as the EM, FG, and FG-20. Although these lenses are compact and are often constructed with plastic parts, some of these lenses, especially the 50mm f/1.8, are of quite good quality. These lenses are also manual focus only.

✦ **D.** Lenses with this designation convey distance information to the camera to aid in metering for exposure and flash.

✦ **G.** These are newer lenses that lack a manually adjustable aperture ring. You must set the aperture ring of the lens to the smallest setting and adjust the aperture setting by using the Main Command dial on the camera body.

✦ **AF, AF-D, AF-I, and AF-S.** All these denote that the lens is an autofocus lens. The AF-D represents a distance encoder for distance information, the AF-I is for internal focusing motor type, and the AF-S is for an internal Silent Wave Motor.

✦ **DX.** This lets you know the lens was optimized for use with Nikon's DX-format sensor (all Nikon dSLRs, with the exception of the D700 and D3). These lenses can be used on the D700 (or D3) when set to DX-format mode. This effectively decreases the image resolution of the camera to 5.1 megapixels.

Continued

Continued

✦ **VR.** This code denotes the lens is equipped with Nikon's Vibration Reduction image stabilization system.

✦ **ED.** This indicates that some of the glass in the lens is Nikon's Extra-Low Dispersion glass, which means the lens is less prone to lens flare and chromatic aberrations.

✦ **Micro-NIKKOR.** Even though they're labeled as micro, these are Nikon's macro lenses.

✦ **IF.** IF stands for internal focus. The focusing mechanism is inside the lens, so the lens doesn't change length and the front of the lens doesn't rotate when focusing. This feature is useful when you don't want the front of the lens element to move; for example, when you use a polarizing filter. The internal focus mechanism also allows for faster focusing.

✦ **DC.** DC stands for Defocus Control. Nikon only offers a couple of lenses with this designation. These lenses make the out-of-focus areas in the image appear softer by using special lens elements to add spherical aberration. The parts of the image that are in focus aren't affected. Currently, the only Nikon lenses with this feature are the 135mm and the 105mm f/2. Both of these are considered portrait lenses.

✦ **CRC.** CRC stands for Close Range Correction. Lenses that have this feature have floating elements inside that allow the images to retain sharpness when focusing at close distances. Although you won't find this designation in the actual lens name, you may come across it in the owner's manual or in Nikon's literature or on its Web site.

Wide-Angle and Ultrawide-Angle Lenses

Wide-angle lenses, as the name implies, provide a very wide angle of view of the scene you're photographing. Wide-angle lenses are great for photographing a variety of subjects, but they're really excellent for subjects such as landscapes and group portraits where you need to capture a wide area of view.

The focal-length range of wide-angle lenses starts out at about 10mm (ultrawide) and extends to about 24mm (wide angle). Most of the most common wide-angle lenses on the market today are zoom lenses, although there are quite a few prime lenses available. Wide-angle lenses are generally *rectilinear* meaning that there are lens elements built into the lens to correct the distortion that's common with wide-angle lenses; this way, the lines near the edges of the frame appear straight. Fisheye lenses, which are also a type of wide-angle lens, are *curvilinear*; the lens elements aren't corrected, resulting in severe optical distortion. I discuss fisheye lenses later in this chapter.

In recent years, lens technology has grown by leaps and bounds, making high-quality ultrawide-angle lenses affordable. In the past, ultrawide-angle lenses were rare, pro-hibitively expensive, and out of reach for most amateur photographers. These days, it's very easy to find a relatively inexpensive ultrawide-angle lens. Ultrawide-angle lenses usually run in focal length from about 12mm to 20mm.

Most wide-angle zoom lenses run the gamut from ultrawide to wide angle. Some of the ones that work with the D90 include:

✦ **Nikkor 14–24mm f/2.8.** This is Nikon's newest ultrawide zoom and probably the best lens on the market. This lens gives you a wide field of view. It also gives you excellent image sharpness from corner to corner at all apertures. It has a fast constant aperture and is great for low-light shooting. It's a truly spectacular lens, but it comes at a premium cost. At just over $1500, this lens isn't cheap. If you plan on upgrading to an FX camera in the future, this may be a good

consideration for you. If your plan is to stick with Nikon's DX-format cameras, the Nikon 12–24mm f/4 may be a better buy. Another caveat about this lens is that you can't use any filters with it due to the protruding front element.

✦ **Nikkor 12–24mm f/4.** This lens was specifically designed for DX cameras (such as the D90). It's moderately wider than the 14–24mm and a lot smaller and lighter. It also comes in at about half the price of the 14–24mm. This lens is very sharp at all aper-tures but shows its best perfor-mance stopped down a couple of stops. With a fast-focusing and quiet AF-S motor, this lens is prob-ably the best wide-angle choice for your D90 — and at a good price.

✦ **Tokina 12–24mm f/4.** This is a great low-cost alternative to the Nikon wide-angle lenses. The Tokina goes for about half the price of the Nikon 12–24 and offers nearly the same image quality as the Nikon 12–24. The Tokina has a

Image courtesy of Nikon
4.1 Nikkor 12–24mm f/4

scew-type focus motor and therefore focuses a little slower, and it has a little more CA than the Nikon, but all in all, this lens offers a good option for those on a budget.

Sigma also offers a 12–24mm lens. It's not a top performer when compared with the lenses in the previous list, but the Sigma is built like a tank and has an HSM motor (which is similar to Nikon's Silent Wave AF-S motor). The Sigma is also useable with Nikon FX cameras.

There's no shortage of options when it comes to ultrawide-angle and wide-angle lenses. Sigma offers an amazing 10–20mm ultrawide, while Tamron has the 11–18mm option.

Of course, Nikon and other manufacturers also make wide-angle prime lenses. Today's wide-angle zoom lenses are just as sharp (if not sharper in the case of the 14–24mm) as the prime lenses. I find that a wide-angle zoom gives you more bang for your buck, but prime lenses are smaller and lighter. The standard wide-angle primes are 14mm, 20mm, and 24mm. All these prime lenses are sharp and come in apertures of at least f/2.8 or faster. Most of these lenses can be found for under $400, with the exception of the 14mm f/2.8, which costs $1200–$1400.

When to use a wide-angle lens

You can use wide-angle lenses for a broad variety of subjects, and they're great for creating dynamic images with interesting results. Once you get used to seeing the world through a wide-angle lens, you may find that your images start to be more creative, and you may look at your subjects differently. There are many different considerations to think about when you use a wide-angle lens. Here a few examples:

✦ **More depth of field.** Wide-angle lenses allow you to get more of the scene in focus than you can when you're using a midrange or telephoto lens at the same aperture and distance from the subject.

✦ **Wider field of view.** Wide-angle lenses allow you to fit more of your subject into your images. The shorter the focal length, the more you can fit in. This can be especially beneficial when you're shooting landscape photos where you want to fit an immense scene into your photo or when you're shooting a large group of people.

✦ **Perspective distortion.** Using wide-angle lenses causes things that are closer to the lens to look disproportionately larger than things that are farther away. You can use perspective distortion to your advantage to emphasize objects in the foreground if you want the subject to stand out in the frame.

✦ **Handholding.** At shorter focal lengths, it's possible to hold the camera steadier than you can at longer focal lengths. At 14mm, it's entirely possible to handhold your camera at 1/15 second without worrying about camera shake.

✦ **Environmental portraits.** Although using a wide-angle lens isn't the best choice for standard close-up portraits, wide-angle lenses work great for environmental portraits where you want to show a person in his or her surroundings.

Wide-angle lenses can also help pull you into a subject. With most wide-angle lenses, you can focus very close. This helps you get right up close and personal with said subject while creating the perspective distortion that wide-angle lenses are known for. Don't be afraid to get close to your subject to make a more dynamic image. The worst wide-angle images are the ones that have a tiny subject in the middle of an empty area.

Understanding limitations

Wide-angle lenses are very distinctive when it comes to the way they portray your images, and they also have some limitations that you may not find in lenses with longer focal lengths. There are also some pitfalls that you need to be aware of when using wide-angle lenses:

✦ **Soft corners.** The most common problem that wide-angle lenses, especially zooms, have is that they soften the images in the corners. This is most prevalent at wide apertures, such as f/2.8 and f/4, and the corners usually sharpen up by f/8 (depending on the lens). This problem is greatest in lower-priced lenses.

✦ **Vignetting.** This is the darkening of the corners in the image. This occurs because the light that's needed to capture such a wide angle of view must come from an oblique angle. When the light comes in at such an angle, the aperture is effectively smaller. The aperture opening no longer appears as a circle but is shaped like a cat's eye. Stopping down the aperture reduces this effect, and reducing the aperture by 3 stops usually eliminates the vignetting.

✦ **Perspective distortion.** Perspective distortion is a double-edged sword: It can make your images look very interesting or make them look terrible. One of the reasons that a wide-angle lens isn't recommended for close-up portraits is that it distorts the face, making the nose look too big and the ears too small. This can make for a very unflattering portrait.

✦ **Barrel Distortion.** Wide-angle lenses, even rectilinear lenses, are often plagued with this specific type of distortion, which causes straight lines outside the image center to appear to bend outward (similar to a barrel). This can be unwanted when doing architectural photography. Fortunately, Photoshop and other image-editing software allow you to fix this problem relatively easily.

4.2 A shot taken with a wide-angle lens

DX Crop Factor

Crop factor is a ratio that describes the size of a camera's imaging area as compared to another format; in the case of SLR cameras, the reference format is 35mm film.

SLR camera lenses were designed around the 35mm film format. Photographers use lenses of a certain focal length to provide a specific field of view. The field of view, also called the angle of view, is the amount of the scene that's captured in an image. This is usually described in degrees. For example, when you use a 16mm lens on a 35mm camera, it captures the scene almost 180 degrees horizontally of the scene, which is quite a bit. Conversely, when you use a 300mm focal length, the field of view is reduced to a mere 6.5 degrees horizontally, which is a very small part of the scene. The field of view is consistent from camera to camera because all SLRs use 35mm film, which has an image area of 24mm × 36mm.

With the advent of digital SLRs and because the sensors are more expensive to manu-facture, the sensor was made smaller than a frame of 35mm film to keep costs down. This sensor size was called APS-C or, in Nikon terms, the DX format. The lenses that are used with DX-format dSLRs have the same focal length they've always had, but because the sensor doesn't have the same amount of area as the film, the field of view is effectively decreased. This causes the lens to provide the field of view of a longer focal lens when compared to 35mm film images.

Fortunately, the DX sensors are a uniform size, thereby supplying consumers with a standard to determine how much the field of view is reduced on a DX-format dSLR with any lens. The digital sensors in Nikon DX cameras have a 1.5X crop factor, which

means that to determine the equivalent focal length of a 35mm or FX camera, you simply have to multiply the focal length of the lens by 1.5. Therefore, a 28mm lens provides an angle of coverage similar to a 42mm lens, a 50mm is equivalent to a 75mm, etc. This figure shows the relationship between the crop factor. This image was shot with a 28mm lens on a D700 FX camera. Inside the red square is the amount of the scene that would be captured with the same lens on a DX camera like the D90.

Early on, when dSLRs were first introduced, all lenses were based on 35mm film. The crop factor effectively reduced the coverage of these lenses, causing ultrawide-angle lenses to act like wide-angle lenses, wide-angle lenses performed like normal lenses, normal lenses provided the same coverage as short telephotos, and so on. Nikon created specific lenses for dSLRs with digital sensors. These lenses are known as DX-format lenses. The focal length of these lenses was shortened to fill the gap to allow true super-wide-angle lenses. These DX-format lenses were also redesigned to cast a smaller image inside the camera so that the lenses could actually be made smaller and use less glass than conventional lenses. The byproduct of designing a lens to project an image circle to a smaller sensor is that these same lenses can't effectively be used with FX format and can't be used at all with 35mm film cameras (without severe vignetting) because the image won't completely fill an area the size of the film sensor. FX cameras can use the DX, but the image is cropped in the camera, resulting in an image with a much lower resolution.

There is an upside to this crop factor. Lenses with longer focal lengths now provide a bit of extra reach. A lens set at 200mm now provides the same amount of coverage as a 300mm lens, which can be a great advantage for sports and wildlife photography or when you simply can't get close enough to your subject.

Midrange Zoom Lenses

Midrange, or standard, zoom lenses fall in the middle of the focal-length scale. Zoom lenses of this type usually start at a moderately wide angle of around 16–18mm and zoom in to a short telephoto range. These lenses work great for most general photography applications and can be used successfully for everything from architectural to portrait photography. Basically, this type of lens covers the most useful focal lengths and will probably spend the most time on your camera. For this reason, I recommend buying the best quality lens you can afford.

Some of the options for midrange lenses include:

✦ **Nikkor 17–55mm f/2.8.** This is Nikon's top-of-the-line standard DX zoom lens. It's a professional lens; it has a fast aperture of f/2.8 over the whole zoom range and is extremely sharp at all focal lengths and apertures. The build quality on this lens is excellent, as most of Nikon's pro lenses are. The 17–55mm has Nikon's super-quiet and fast-focusing Silent Wave Motor as well as ED glass elements to reduce chromatic aberration. This lens is top-notch all around and is worth every penny of the price tag.

✦ **Nikkor 18–105mm f/3.5–5.6 VR.** This is the kit lens option that's available with the D90. This lens covers a very wide range of focal lengths, but it doesn't have a fast constant aperture. To make up for this, Nikon has added Vibration Reduction (VR) to this lens to help when you're shooting in low-light situations. If you need a lightweight, versatile lens for walking around and shooting, this lens is perfectly suited for that. As usual, the VR system works like a charm and is great for shooting still objects in low-light conditions that typically call for slower shutter speeds.

Image courtesy of Nikon
4.3 Nikkor 17–55mm f/2.8

✦ **Tamron 17–50mm f/2.8.** This lens is a low-cost alternative to the Nikon 17–55 and has a fast f/2.8 aperture. You can get this lens for about one-third the cost of the Nikon 17–55. It doesn't have AF-S or the heavy-duty build quality of the Nikon 17–55, but the image quality is decent, and the lens is much lighter. I used one of these lenses for quite a while and never had any problems with it.

There are also some good third-party lens options from Sigma and Tokina in this focal-length range. I recommend doing some research on the Internet to find the best lens for the best deal.

There are a few prime lenses that fit into this category: the 28mm, 30mm, and 35mm. These lenses are considered normal lenses for DX cameras, being that they approximate the normal field of view of the human eye.

These lenses are great all-around lenses. They come with apertures of f/2.8 or faster and can be found for less than $400, with the exception of the rare Nikon 28mm f/1.4, which can run up to $5000 in new condition (if you can find it). Sigma offers a highly regarded 30mm f/1.4 with an HSM motor at a reasonable price.

Telephoto Lenses

Telephoto lenses are lenses with very long focal lengths that are used to get closer to distant subjects. They provide a very narrow field of view and are handy when you're trying to focus on the details of a subject. Telephoto lenses have a much shallower depth of field than wide-angle and mid-range lenses, and you can use them effectively to blur out background details to isolate a subject.

Image courtesy of Nikon
4.4 The 18-105mm kit lens

4.5 Portrait shot with a 200mm f/2 telephoto lens

Telephoto lenses are commonly used for sports and wildlife photography. The shallow depth of field also makes them one of the top choices for photographing portraits.

As with wide-angle lenses, telephoto lenses also have their quirks, such as perspective distortion. As you may have guessed, telephoto perspective distortion is the opposite of the wide-angle variety. Because everything in the photo is so far away with a telephoto lens, the lens tends to *compress* the image. Compression causes the background to look too close to the foreground. Of course, you can use this effect creatively. For example, compression can flatten out the features of a model, resulting in a pleasing effect. Compression is another reason why photographers often use a telephoto lens for portrait photography.

Super-Zooms

Most lens manufacturers, Nikon included, offer what's commonly termed a *super-zoom* or sometimes called a *hyper-zoom.* Super-zooms are lenses that encompass a very wide focal length, from a wide angle to telephoto. The most popular of the super-zooms is the Nikon 18–200mm f/3.5–5.6 VR shown at the top of the next page.

These lenses allow you to have a huge focal-length range that you can use in a wide variety of shooting situations without have to switch out lenses. This can come in handy if, for example, you were photographing a landscape scene by using a wide-angle setting, and lo and behold, Bigfoot appears on the horizon. You can quickly zoom in with the super-telephoto setting and get a good close-up shot without having to fumble around in your camera bag to grab a telephoto and switching out lenses, possibly causing you to miss the shot of a lifetime.

Image courtesy of Nikon

Of course, there's no free lunch, and these super-zooms come with a price (figuratively and literally). In order to achieve the great ranges in focal length, some concessions must be made with regard to image quality. These lenses are usually less sharp than lenses with a shorter zoom range and are more often plagued with optical distortions and chromatic aberration. Super-zooms often show pronounced barrel distortion at the wide end and can have moderate to severe pincushion distortion at the long end of the range. Luckily, these types of distortions can be fixed in Photoshop or other image-editing software.

Another caveat to using these lenses is that they more often than not have appreciably smaller maximum apertures than zoom lenses with shorter ranges. This can be a problem, especially because larger apertures are generally needed at the long end to keep a high enough shutter speed to avoid blurring from camera shake when hand-holding. Of course, some manufacturers include some sort of Vibration Reduction to help control this problem.

Some popular super-zooms include the Nikon 18–200mm f/3.5–5.6 VR (mentioned earlier), the Sigma 18–200mm f/3.5–6.3 with Optical Stabilization, and the Tamron 18–200mmm f/3.5–5.6. There are also a few super-zoom super-telephoto lenses, including the Nikon 80–400mm and the Sigma 50–500mm.

A standard telephoto zoom lens usually has a range of about 70–200mm. If you want to zoom in close to a subject that's very far away, you may need an even longer lens. These super-telephoto lenses can act like telescopes, really bringing the subject in close. They range from about 300mm up to about 800mm. Almost all super-telephoto lenses are prime lenses, and they're very heavy, bulky, and expensive. A lot of these lenses are a little slower than your normal high-end telephoto zoom lens, such as the 70–200mm f/2.8G, and often have a maximum aperture of f/4 or smaller.

There are quite a few telephoto prime lenses available. Most of them, especially the longer ones (105mm and longer), are pretty expensive, although you can sometimes find some older Nikon primes that are discontinued or

used — and at decent prices. One of these lenses is the 300mm f/4. A couple of relatively inexpensive telephoto primes are in the shorter range of 50–85mm. The 50mm is considered a normal lens for FX format, but the DX format makes this lens a 75mm equivalent, landing it squarely in the short telephoto range for use with the D90.

There are two very popular versions of the 50mm: the f/1.4 and f/1.8. Both of these lenses are extremely sharp and can be found used at great prices. The 50mm f/1.8 in particular is an excellent bargain. This lens can be found new for about $100 and used for much less. This is probably the best lens value on the market. The fast aperture makes the lens great for shooting in low light and even better for achieving a shallow depth of field. Although this lens was originally introduced as a normal lens for film cameras, with the dSLR cameras' smaller sensor and the 1.5X crop factor, this lens is now equivalent to a 75mm lens — perfect for portraits. The most popular portrait lens for the film camera was the 85mm f/1.8, so the 50mm essentially replaces that for the digital DX-format cameras.

For those of you that prefer a longer lens for portraits, you may want to consider the 85mm prime lens. The 85mm also comes in two versions: the f/1.4 and f/1.8. The 85mm f/1.8 is the more affordable of the two, costing about $400 as compared to the 1.4, which can run you $1000 or more. As with the 50mm lenses, both of these lenses are super sharp.

Some of the most common telephoto lenses include:

✦ **Nikkor 70–200mm f/2.8 VR.** This is Nikon's top-of-the-line standard telephoto lens. The VR makes this lens useful when photographing far-off subjects handheld. This is a great lens for sports, portraits, and wildlife photography.

✦ **Nikkor 55–200mm f/4–5.6 VR.** This is one of Nikon's most affordable lenses and is actually a pretty strong performer for its price range. The 55–200 VR is quite sharp and only has mild barrel distortion issues.

✦ **Nikkor 80–200 mm f/2.8D.** This is a great, affordable alternative to the 70–200mm VR lens. This lens is sharp and has a fast constant f/2.8 aperture.

✦ **Nikkor 80–400mm f/4.5–5.6 VR.** This is a high-power, VR image stabilization zoom lens that gives you quite a bit of reach. Its very versatile zoom range makes it especially useful for wildlife photography where the subject is very far away. As with most lenses with a very broad focal-length range, you make concessions with fast apertures and a moderately lower image quality when compared to the 70–200mm or 80–200mm f/2.8 lenses.

The most important features of the prime lens are that they can have a faster maximum aperture, they are far lighter, and they cost much less. The standard prime lenses aren't very long, so the maximum aperture can be faster than with zoom lenses. Standard primes also require fewer lens elements and moving parts, so the weight can be kept down considerably. And because there are fewer elements, the overall cost of production is less; therefore, you pay less.

Image courtesy of Nikon
4.6 Nikkor 55–200mm f/4–5.6 VR

Zoom Lenses versus Prime Lenses

This debate has been a hot topic for many years. More recently, in the past 8 years or so, lens technology has grown by leaps and bounds, and zoom lenses are just about as sharp as primes or, in the case of the Nikkor 14–24mm f/2.8, even sharper than most primes.

Some photographers prefer primes, and some prefer zooms. It's largely a personal choice, and there are some things to consider.

One of the main advantages of the zoom lens is its versatility. You can attach one lens to your camera and use it in a wide variety of situations. Gone is the need for constantly changing out lenses, which is a very good feature because every time you take the lens off your camera, the sensor is vulnerable to dust and debris.

Although today's zoom lenses can be just as sharp as a prime lens, you do have to pay for this quality. A $150 zoom lens isn't going to give you nearly the same quality as a $1500 zoom lens. These days, you can easily find a fast zoom lens — one with an aperture of at least f/2.8. Because you can easily change the ISO on a digital camera and the noise created from using a high ISO is lessening, a fast zoom lens isn't a complete necessity. I prefer a zoom lens with a wider aperture — not so much for the speed of the lens but for the option of being able to achieve a shallower depth of field, which is very important in shooting portraits.

Before zoom lenses were available, the only option a photographer had was using a prime lens. Because each lens is fixed at a certain focal length, such as 50mm, when the photographer wants to fit more of the subject in the frame, he or she has to either physically move farther away from or closer to the subject or swap out the lens with one that has a focal length more suited to the range.

Continued

Continued

Prime lenses still offer some advantages over zoom lenses. For example, prime lenses don't require as many lens elements as zoom lenses do, and this means prime lenses are sometimes sharper than zoom lenses. The differences in optical quality aren't as noticeable as they were in the past, but with digital camera resolutions getting higher, the differences are definitely becoming more noticeable.

Special-Purpose Lenses

Nikon has a few options when it comes to lenses that are designed specifically to handle a certain task. Some of Nikon's special-purpose lenses include the De-focus Control (DC) and Micro-Nikkor (macro) lenses. It even has a lens that combines both of these features! These lenses, especially the PC lenses, aren't typically designed for everyday use and are pretty specific in their applications.

Micro-NIKKOR lenses

A macro lens is a special-purpose lens used in macro and close-up photography. It allows you to have a closer focusing distance than regular lenses, which in turn allows you to get more magnification of your subject, revealing small details that would otherwise be lost. True macro lenses offer a magnification ratio of 1:1; that is, the image projected onto the sensor through the lens is the exact same size as the actual object being photographed. Some lower-priced macro lenses offer a 1:2 or even a 1:4 magnification ratio, which is half to one-quarter of the size of the original object. Although lens manufacturers refer to these lenses as macro, strictly speaking, they aren't.

One major concern with a macro lens is the depth of field. When focusing at such a close distance, the depth of field becomes very shallow; it's often advisable to use a small aperture to maximize your depth of field and ensure everything is in focus. Of course, as with any downside, there's an upside: You can also use the shallow depth of field creatively. For example, you can use it to isolate a detail in a subject.

Macro lenses come in a variety of different focal lengths, and the most common is 60mm. Some macro lenses have substantially longer focal lengths, which allow more distance between the lens and the subject. This comes in handy when the subject needs to be lit with an additional light source. A lens that's very close to the subject while focusing can get in the way of the light source, casting a shadow.

When buying a macro lens, you should consider a few things: How often are you going to use the lens? Can you use it for other purposes? Do you need AF? Because newer dedicated macro lenses can be pricey, you may want to consider some cheaper alternatives.

The first thing you should know is that it's not absolutely necessary to have an AF lens. When shooting very close up, the depth of focus is very small, so all you need to do

is move slightly closer or farther away to achieve focus. This makes an AF lens a bit unnecessary. You can find plenty of older Nikon manual focus (MF) macro lenses that are very inexpensive, and the good thing is that the lens quality and sharpness are still superb.

 Note *Some other manufacturers also make good-quality MF macro lenses. I have a 50mm f/4 Macro-Takumar made for early Pentax screw-mount camera bodies. I bought this lens for next to nothing, and I found an inexpensive adapter that allows it to fit the Nikon F-mount. The great thing about this lens is that it's super-sharp and allows me to focus close enough to get a 4:1 magnification ratio, which is 4X life size.*

 Caution *When using MF non-CPU lenses, the D90's light meter won't function, and metering must be done manually by using a light meter or the Sunny 16 principle.*

Nikon currently offers three different focal-length macro lenses under the Micro-NIKKOR designation:

✦ **Nikkor 60mm f/2.8.** Nikon offers two versions of this lens — one with a standard AF drive and one with an AF-S version with the Silent Wave Motor. The AF-S version also has the new Nano Crystal Coat lens coating to help eliminate ghosting and flare.

✦ **Nikkor 105mm f/2.8 VR.** This is a great lens that not only allows you to focus extremely close but also enables you to back off and still get a good close-up shot. This lens is equipped with VR. This can be invaluable with macro photography because it allows you to handhold at slower shutter speeds — a

4.7 A shot taken with a macro lens

necessity when stopping down to maintain a good depth of field. This lens can also double as a very impressive portrait lens. This is currently the favored lens in my arsenal.

✦ **Nikkor 200mm f/4.** This telephoto macro lens provides a longer working distance, which can be beneficial when you're photographing small animals or insects. This is a good lens for nature and wildlife photography and gives you a true 1:1 macro shot.

Defocus Control lenses

Defocus Control (DC) lenses are Nikon's dedicated portrait lenses. These lenses allow you to control the spherical aberration of the lens. Spherical aberration is evident in the out-of-focus areas of the image and is the determining factor in whether the lenses' bokeh is considered pleasing or not. *Bokeh* is a term derived from the Japanese word *boke*, which is roughly translated as fuzzy. Bokeh refers to the out-of-focus areas of the image.

Without going into specific technical details on how this lens achieves this effect, just know that it does. It can make the out-of-focus areas, either in front of or behind the subject, appear sharper or softer and can produce ethereal soft focus effects on your subject. This lens takes some time and effort to learn how to use effectively, but once you master this lens, you find that your portraits look amazing.

Nikon currently offers two lenses with DC: the 105mm f/2D and the 135mm f/2D. Both of these lenses are telephoto lenses and have a wide f/2 aperture for achieving a super-shallow depth of field. These lenses are fairly expensive but well worth the cost if you shoot a lot of portraits.

4.8 A portrait taken with a Nikon 105mm f/2 DC lens

Fisheye lenses

Fisheye lenses are ultrawide-angle lenses that aren't corrected for distortion like standard rectilinear wide-angle lenses. These lenses are known as *curvilinear*, meaning that straight lines in your image, especially near the edge of the frame, are curved. Fisheye lenses have extreme barrel distortion, but that's what makes them fisheye lenses.

Fisheye lenses cover a full 180-degree field of view, allowing you to see everything that's immediately to the left and right of you in the frame. Special care has to be taken so that you don't get your feet in the frame, as so often happens when you're using a lens with a field of view this extreme.

Fisheye lenses aren't made for everyday shooting, but with their extreme perspective distortion, you can achieve interesting, and sometimes wacky, results. You can also de-fish, or correct, for the extreme fisheye by using image-editing software, such as Photoshop, Capture NX or NX2, and DxO Optics. The end result of de-fishing your image is that you get a reduced field of view. This is akin to using a rectilinear wide-angle lens.

There are two types of fisheye lenses available: circular and full frame. A circular fisheye projects a complete 180-degree hemispherical image onto the frame, resulting in a circular image surrounded by black in the rest of the frame. A full-frame fisheye completely covers the frame with an image. The 10.5mm

DX Nikkor fisheye is a full-frame fisheye on a DX-format dSLR. Sigma also makes a series of fisheye lenses that are both circular and full frame. There are a couple of Russian companies that also manufacture high-quality but affordable MF fisheye lenses. AF is not truly a necessity on fisheye lenses, given their extreme depth of field and short focusing distance. Peleng makes an 8mm circular fisheye that also works well with the D90, almost covering the full frame. This lens is fairly soft wide open, but the images are sharp when you stop them down to 5.6. You can find this Peleng lens on eBay for a reasonable price.

 Caution *Using the Nikkor 16mm fisheye isn't recommended with DX cameras because the majority of the image affected by the fisheye lens is cropped out due to the DX crop factor.*

Using Vibration Reduction Lenses

Nikon has an impressive list of lenses that offer Vibration Reduction (VR). This technology is used to combat image blur caused by camera shake, especially when you're hand-holding the camera at long focal lengths. The VR function works by detecting the motion of the lens and shifting the internal lens elements. This allows you to shoot up to 3 stops slower than you would normally. If you're an old hand at photography, you probably know this rule of thumb: To get a reasonably sharp photo when handholding the camera, you should use a shutter speed that corresponds to the reciprocal of the lens' focal length. In simpler terms, when shooting at a 200mm zoom setting, your shutter speed should be at least 1/200 second. When shooting with a

4.9 An image taken with a Nikon 10.5mm fisheye lens

wider setting, such as 28mm, you can safely handhold at around 1/30 second. Of course, this is just a guideline; some people are naturally steadier than others and can get sharp shots at slower speeds. With the VR enabled, you should be able to get a reasonably sharp image at a 200mm setting with a shutter speed of around 1/30 second.

Although the VR feature is good for providing some extra latitude when you're shooting with low light, it's not made to replace a fast shutter speed. To get a good, sharp photo when shooting action, you need to have a fast shutter speed to freeze the action. No matter how good the VR is, nothing can freeze a moving subject but a fast shutter speed.

Another thing to consider with the VR feature is that the lens's motion sensor may overcompensate when you're panning, causing the image to actually be blurrier. So, in situations where you need to pan with the subject, you may need to switch off the VR. The VR function also slows down the AF a bit, so when catching the action is very important, you may want to keep this in mind. However, Nikon's newest lenses have been updated with VR II, which Nikon claims can tell the difference between panning motion and regular side-to-side camera movement.

While VR is a great advancement in lens technology, few things can replace a good exposure and a solid monopod or tripod for a sharp image.

Image courtesy of Nikon
4.10 The NIKKOR 105mm f/2.8G VR

Essential Photography Concepts

This chapter contains some concepts that may be well-known to some D90 users, while other users may need a refresher. Some of this information may be brand-new to those of you who are just stepping into the world of dSLR photography. If you're an advanced user, you may want to skip this chapter, although you may discover some new information or something you may have forgotten. This chapter covers information on exposure, the effects aperture has on depth of field, and some tips and hints on composition and lighting.

Exposure Review

An exposure is made of three elements that are all interrelated. Each depends on the others to create a good exposure. If one of the elements changes, the others must increase or decrease proportionally. The following are the elements you need to consider:

+ **Shutter speed.** The shutter speed determines the length of time the sensor is exposed to light.

+ **ISO sensitivity.** The ISO setting you choose influences your camera's sensitivity to light.

+ **Aperture/f-stop.** How much light reaches the sensor of your camera is controlled by the aperture, or f-stop. Each camera has an adjustable opening on the lens. As you change the aperture (the opening), you allow more or less light to reach the sensor.

5.1 For this image, I exposed for the brightest part of the scene, allowing the sky to have deep rich colors while letting the surrounding elements appear as shadows.

Shutter speed

Shutter speed is the amount of time light entering from the lens is allowed to expose the image sensor. Obviously, if the shutter is open longer, more light can reach the sensor. The shutter speed can also affect the sharpness of your images. When using a longer focal-length lens, a faster shutter speed is required to counteract against camera shake, which can cause blurring. When taking photographs in low light, a slow shutter speed is often required, which can also cause blur from camera shake or fast-moving subjects.

The shutter speed can also be used to show motion. *Panning*, or moving the camera horizontally with a moving subject, while using a slower shutter speed can cause the background to blur but keeps the subject in focus. This is an effective way to portray motion in a still image. On the opposite end, using a fast shutter speed can freeze action, such as a splash of water caused by a surfer, which can also give the illusion of motion in a still photograph.

Shutter speeds are indicated in fractions of a second. Common shutter speeds (from slow to fast) are: 1 second, 1/2, 1/4, 1/8, 1/15, 1/30, 1/60, 1/125, 1/500, 1/1000, etc.

Increasing or decreasing shutter speed by one setting doubles or halves the exposure, respectively. The D90 also allows you to adjust the shutter speed in 1/3 stops. It may seem like math (okay, technically, it does involve math), but it's relatively easy to figure out. For example, if you take a picture with a 1/2-second shutter speed and it turns out too dark, logically you want to keep the shutter open longer to let in more light. To do this, you need to adjust the shutter speed to 1 second, which is the next full stop, letting in twice as much light.

5.2 For this image, I used a slow shutter speed to blur the background, resulting in the illusion of movement in the photo.

ISO

The ISO (International Organization for Standardization) setting is how sensitive your camera is to light. The higher the ISO number is, the less light you need to take a photograph, meaning the more sensitive the sensor is to light. For example, you might choose an ISO of 200 on a bright, sunny day when you're photographing outside because you have plenty of light. However, on a dark, cloudy day, you want to consider an ISO of 400 or higher to make sure your camera captures all the available light. This allows you to use a faster shutter speed should it be appropriate for the subject you're photographing.

It's helpful to know that each ISO setting is twice as sensitive to light as the previous setting. For example, at ISO 400, your camera is twice as sensitive to light as it is at ISO 200. This means it needs only half the light at ISO 400 that it needs at ISO 200 to achieve the same exposure.

The D90 allows you to adjust the ISO in 1/3-stop increments (100, 125, 160, 200, etc.), which enables you to fine-tune your ISO to reduce the noise inherent with higher ISO settings.

5.3 This image shows digital noise resulting from using a high ISO. The noise is more prevalent in the darker areas of the image.

Aperture

Aperture is the size of the opening in the lens that determines the amount of light that reaches the image sensor. The aperture is controlled by a metal diaphragm that operates in a similar fashion to the iris of your eye. Aperture is expressed as f-stop numbers, such as f/2.8, f/5.6, and f/8. Here are a couple of important things to know about aperture:

✦ **Smaller f-numbers equal wider apertures.** A small f-stop, such as f/2.8, opens the lens so more light reaches the sensor. If you have a wide aperture (opening), the amount of time the shutter needs to stay open to let light into the camera decreases.

✦ **Larger f-numbers equal narrower apertures.** A large f-stop, such as f/11, closes the lens so less light reaches the sensor. If you have a narrow aperture (opening), the amount of time the shutter needs to stay open to let light into the camera increases.

Deciding what aperture to use depends on what kind of photo you're going to take. If you need a fast shutter speed to freeze action and you don't want to raise the ISO, you can use a wide aperture to let more available light in to the sensor. Conversely, if the scene is very bright, you may want to use a small aperture to avoid overexposure.

Understanding Depth of Field

Depth of field is the distance range in a photograph in which all included portions of an image are at least acceptably sharp. It's heavily affected by aperture, subject distance, and focal length. When doing close-up photography, magnification also becomes a factor.

If you focus your lens on a certain point, everything that lies on the horizontal plane of that same distance is also in focus. This means everything in front of the point and everything behind it is technically not in focus. Because our eyes aren't acute enough to discern the minor blur that occurs directly in front of and directly behind the point of focus, it still appears sharp to us. This is known as the zone of acceptable sharpness, which we call depth of field.

This zone of acceptable sharpness is based on the circle of confusion. Simply put, the *circle of confusion* is the largest blurred circle that's perceived by the human eye as acceptably sharp.

Note *There are a few factors that go into determining the size of the circle of confusion, including visual acuity, viewing distance, and enlargement size.*

Circles of confusion are formed by light passing through the body of a lens. Changing the size of the circle of confusion is as easy as opening up or closing down your aperture. Therefore, when you open up the aperture, the circle of confusion is larger, resulting in a decreased depth of field and a softer, more blurred background (and foreground). When the aperture is closed down, the circle of

confusion is smaller, resulting in an increased depth of field and causing everything in the image to appear sharp.

Depth of field is referred to in two terms:

✦ **Shallow depth of field.** This results in an image where the subject is in sharp focus but the background has a soft blur. You've likely seen it frequently used in portraits. Using a wide aperture, such as f/2.8, results in a subject that's sharp with a softer background. Using a shallow depth of field is a great way to eliminate distracting elements in the background of an image.

✦ **Deep depth of field.** This results in an image that's reasonably sharp from the foreground to the background. Using a narrow aperture, such as f/11, is ideal to keep photographs of landscapes or groups in focus throughout.

Tip *To enlarge your depth of field, you want a large f-stop number; to shrink your depth of field, you want a small f-stop number.*

When working with depth of field, you must consider your distance from the subject. The farther you are from the subject you're focusing on, the greater the depth of field in your photograph. For example, if you stand in your front yard to take a photo of a tree a block away, it has a deep depth of field, with the tree, background, and foreground all in relatively sharp focus. If you stand in that same spot and take a picture of your dog who's standing just several feet away, your dog is in focus, but that tree a block away is just a blur of color. When focusing on a subject that's close to the lens, the depth of field is reduced. This explains why when you do macro photography, the depth of field is extremely shallow, even when you use relatively small apertures.

5.4 This image has a deep depth of field, putting most of the image in focus.

5.5 This image has a shallow depth of field, putting only the main subject in focus.

Rules of Composition

Although many of you are likely well-versed in concepts regarding composition, some of you may be coming in cold, so to speak. Thus, this section is intended as a refresher course and a general outline of some of the most commonly used rules of composition.

Photography, like any artistic discipline, has general rules. Although we call them rules, they are really nothing more than guidelines. Some photographers — notably, Ansel Adams, who was quoted as saying, "The so-called rules of photographic composition are, in my opinion, invalid, irrelevant and immaterial" — claim to have eschewed the rules of composition. However, when you look at Adams's photographs, they perfectly follow the rules in most cases.

Another famous photographer, Edward Weston, said, "Consulting the rules of composition before taking a photograph is like consulting the laws of gravity before going for a walk." Again, as with Adams, when you look at Weston's photographs, they tend to follow these very rules.

This isn't to say you need to follow all the rules every time you take a photograph. As I said, these are really just general guidelines that, when followed, can make your images more powerful and captivating.

However, when you're starting out in photography, you should pay attention to the rules of composition. Eventually, as you become accustomed to following the guidelines, they become second nature. That is, you no longer need to consult the rules of composition; you just inherently follow them.

Keep it simple

Simplicity is arguably the most important rule in creating a good image. You want the subject of your photograph to be immediately recognizable. When you have too many competing elements in your image, it can be hard for a viewer to decide what to focus on.

Sometimes, changing your perspective to the subject is all you need to do to remove a distracting element from your image. Try walking around and shooting the same subject from different angles.

5.6 There's no question as to what the subjects are in this photograph.

The Rule of Thirds

Most of the time, you're probably tempted to take the main subject of your photograph and stick it right in the middle of the frame. This makes sense, and it usually works pretty well for snapshots. However, to create more engaging and dynamic images, it often works better to put the main subject of the image a little off-center.

The Rule of Thirds is a compositional rule that has been in use for hundreds of years, and most famous artists throughout the centuries have followed it. With the Rule of Thirds, you divide the image into nine equal parts by using two equally spaced horizontal and vertical lines, kind of like a tic-tac-toe pattern. You want to center the main subject of the image at an intersection, as illustrated in figure 5.7. The subject doesn't necessarily have to be right on the intersection of the line but merely close enough to it to take advantage of the Rule of Thirds.

Another way to use the Rule of Thirds is to place the subject in the center of the frame but at the bottom or top third of the frame, as illustrated in figure 5.8. This part of the rule is especially useful when photographing landscapes. You can place the horizon on or near the top or bottom line; you almost never want to place it in the middle. Notice in figure 5.9 that the cliffs are covering the bottom third of the entire frame.

5.7 The seagull, which is the main subject of this photograph, is placed near the bottom of the frame according to the Rule of Thirds.

5.8 In this image, the subject is in the center of the frame but in the bottom third.

When using the Rule of Thirds, keep in mind the movement of the subject. If the subject is moving, you want to be sure to keep most of the frame in front of the subject to maintain the illusion that the subject has someplace to go within the frame. You can see the difference that framing makes in figures 5.10 and 5.11.

The Rule of Thirds is a very simple guideline, but it can work wonders in making your images more intriguing and visually appealing. To make the Rule of Thirds even easier to apply to your photography, the D90 has the option of showing a grid in the viewfinder. After you get used to visualizing the grid, you can start composing to the Rule of Thirds without even realizing it.

5.9 Using the Rule of Thirds in a landscape

5.10 Placing the surfers directly in the middle of the frame results in a decent picture.

5.11 Recomposing to place the surfers in the bottom-left part of the frame results in a much more dramatic image.

Leading lines and S-curves

Another good way to add drama to an image is to use a *leading line* to draw a viewer's eye through the picture. A leading line is an element in a composition that leads the eye toward the subject. A leading line can be a lot of different things, such as a road, a sidewalk, railroad tracks, buildings, or columns, to name a few.

In general, you want your leading line to go in a specific direction. Most commonly, a leading line leads the eye from one corner of the picture to another. A good rule of thumb to follow is to have your line go from the bottom-left corner and then lead toward the top-right corner.

You can also use leading lines that go from the bottom of the image to the top and vice versa. For the most part, leading lines heading in this direction lead to a *vanishing point*. A vanishing point is the point at which parallel lines appear to converge and disappear. Depending on the subject matter, a variety of directions for leading lines can work equally well.

Another good way to use a leading line is with an *S-curve*. An S-curve is exactly what it sounds like: It resembles the letter S. An S-curve can go from left to right or right to left. The S-curve draws a viewer's eye up through the image, usually starting from the bottom-left corner (although not always) and leading the eyes up through the image, ending at the top right corner. This brings the eye through the whole image, allowing the viewer to take it all in and possibly stopping to linger on interesting elements within the composition.

5.12 In this image, the leading lines of the ship's mast draw your eyes up through the photograph.

5.13 This image show a basic and very simple S-curve. The f-hole of the guitar (which is shaped like an S) draws your eye through the image from the bottom left to the top right.

Helpful hints

Along with the major rules of composition, there are all sorts of other useful guidelines. Here are just a few that I've found most helpful:

✦ **Frame the subject.** Use elements of the foreground to make a frame around the subject to keep a viewer's eye from wandering.

✦ **Avoid having the subject look directly out of the frame.** Having the subject look out of the photograph can be distracting to a viewer. For example, if your subject is on the left side of the composition, having the subject facing the right is better and vice versa.

✦ **Avoid mergers.** A *merger* is when an element from the background appears to be a part of the subject, such as the snapshot of Granny at the park that looks like she has a tree growing out of the top of her head.

✦ **Try not to cut through the joint of a limb.** When composing or cropping your picture, it's best not to end the frame on a joint, such as an elbow or a knee. This can be unsettling to a viewer.

✦ **Avoid having bright spots or unnecessary details near the edge.** Having anything bright or detailed near the edge of the frame draws a viewer's eye away from the subject and out of the image.

✦ **Avoid placing the horizon or strong horizontal or vertical lines in the center of the composition.** This cuts the image in half and makes it hard for a viewer to decide which half of the image is important.

✦ **Separate the subject from the background.** Make sure the background doesn't have colors or textures similar to the subject. If necessary, try shooting from different angles or use a shallow depth of field to achieve separation.

✦ **Fill the frame.** Try to make the subject the most dominant part of the image. Avoid having lots of empty space around the subject, unless it's essential to making the photograph work.

✦ **Use odd numbers.** When photographing multiple subjects, odd numbers seem to work best.

These are just a few of the hundreds of guidelines out there. Remember, these are not hard and fast rules — just simple pointers that can help you create stark and amazing images.

Lighting Essentials

To have your images appear exactly as you want them, you need to know a few things about light — how it reacts, its specific properties, and even how to control it to make it suit your needs. This section touches on some of the basic properties of light.

 For more on working with light, see Chapter 6.

Lighting is the essence of photography. Not only does it create an image, but it sets the tone and mood for a photograph. It can accentuate features and enhance the detail or it can soften the subject, creating a serene mood. Quality of light can be a misleading term; it not only means good quality light,

but it can also describe some of the unwanted attributes. In the broad scope of things, there are two basic qualities of light: hard and soft.

Hard light

Hard light comes from a single bright source and is very directional, such as photographing in the bright midday sunlight — the sun is your single bright source. The shadows are very distinct, and the image has high contrast and a wide tonal range. Using hard light can be effective when you want to highlight textures in your subject. Hard light is also very good at creating a dramatic portrait and is especially effective in black and white.

5.14 In this portrait of Lauren, I used hard light to create a dramatic mood.

Because hard light is directional and there's high contrast associated with its use, you want to be very careful with the position of the light source. The placement of the light affects where the shadows fall, and in high-contrast images, shadow placement can make or break an image.

Soft light

Soft light is very diffuse and comes from a broad source or is reflected onto the subject. The resulting images are very soft, with less noticeable differences between the shadows and the highlights. With a soft light image, the lighting seems to be coming from more than one direction, and it's often hard to pinpoint from which directions the light is coming. With soft light, the texture of objects is less apparent, and some of the detail is lost.

Soft light is very good for portraits and most everyday subjects. Soft light is flattering to most subjects, but it can sometimes lack the depth and drama that you may need for your image.

5.15 This soft light portrait of Heather was taken by using the evening sun as it filtered in from a window at the Texas State Capitol.

Working with Light

T he most important factor in photography is light; without it, your camera is rendered useless. You need light to make the exposure that results in an image. Whether the light is recorded to silver halide emulsion on a piece of film or to the CMOS sensor on your D90, you can't make a photograph without it.

Not only is light necessary to make an exposure, but it also has different qualities that can impact the outcome of your image. Light can be soft and diffuse or it can be hard and directional. Light can also have an impact on the color of your images; different light sources emit light at different temperatures, which changes the colorcast of the image.

When there's not enough light to capture the image you're after or if the available light isn't suitable for your needs, you can employ alternative sources of light, such as flash, to achieve the effect you're after.

The ability to control light is a crucial step toward being able to make images that look exactly how you want them to. In this chapter, I explain some of the different types of light and how to modify them to suit your needs.

Natural Light

Although it's by far the easiest type of light to find, natural light is sometimes the most difficult to work with. Because it comes from the sun, it's often unpredictable and can change from minute to minute. A lot of times, I hear people say, "Wow, it's such a nice, sunny day; what a perfect day to take pictures," but unfortunately, this isn't often the case. A bright day when the sun is high in the sky presents many obstacles. First, you have serious contrast issues on a sun-drenched day. Oftentimes, the digital sensor doesn't have the latitude to capture the whole scene effectively. For example, it's nearly impossible to capture detail in the shadows of your subject while keeping the highlights from blowing out or going completely white.

Fortunately, if you want to use natural light, it isn't necessary to stand in direct sunlight at noon. You can get desirable lighting effects when working with natural light in many ways. Here are a few examples:

✦ **Use fill flash.** You can use the flash as a secondary light source (not as your main light) to fill in the shadows and reduce contrast.

6.1 A food shot that uses natural light from a window

✦ **Try window lighting.** Believe it or not, one of the best ways to use natural light is to go indoors. Seating your model next to a window provides a beautiful soft light that's very flattering. A lot of professional food photographers use window light. It can be used to light almost any subject softly and evenly.

✦ **Find some shade.** The shade of a tree or the overhang of an awning or porch can block the bright sunlight while still giving you plenty of diffuse light with which to light your subject.

✦ **Take advantage of the clouds.** A cloudy day softens the light, allowing you to take portraits outside without worrying about harsh shadows and too much contrast. Even if it's only partly cloudy, you can wait for a cloud to pass over the sun before taking your shot.

✦ **Use a modifier.** Use a reflector to reduce the shadows or a diffusion panel to block the direct sun from your subject.

D90 Flash Basics

A major advantage of the Nikon D90 is the fact that it has a built-in flash for quick use in low-light situations. Even better is the fact that Nikon has additional flashes called Speedlights that are much more powerful and versatile than the smaller built-in flash.

Nikon Speedlights are *dedicated* flash units, meaning they're built specifically for use with the Nikon camera system and offer much more functionality than a nondedicated flash. A *nondedicated* flash is a flash made by a third-party manufacturer; the flashes usually don't offer fully automated flash features. There are, however, some non-Nikon flashes that use Nikon's i-TTL flash metering system. The i-TTL system allows the flash to operate automatically, usually resulting in a perfect exposure without your having to do any calculations.

If you're new to using an external Speedlight flash, exposure can seem confusing when you first attempt to use it. There are a lot of settings you need to know, and there are different formulas you can use to get the right exposure. Once you understand the numbers and where to plug them in, using the Speedlight becomes quite easy.

If you're using your Speedlight in the i-TTL mode, the calculations you would otherwise do manually are done for you, but it's always good to know how to achieve the same results if you don't have the technology to rely on and to understand how to work with the numbers. When you know these calculations, you can use any flash and get excellent results.

Three main components go into making a properly exposed flash photograph: Guide Number (GN), aperture, and distance. If one of these elements is changed, another one must be changed proportionally to keep the exposure consistent. For the most part, shutter

speed doesn't factor into the equation. The reason for this is that the flash being so bright completely overpowers the ambient light, effectively causing your shutter speed to be whatever the *flash duration* is. The flash duration is how long the flash is lit and can range from 1/880 at full power to 1/38,500 at the lowest power. Using a quick flash duration is how flash freezes objects. Shutter speed does come into play with the flash sync though. Sync speed is discussed later in this chapter. The only other time that shutter speed affects exposure is when using Slow Sync, or what's known as dragging the shutter to record ambient light. This topic is also discussed in further detail later in this chapter. The following sections cover each element and how to put them together.

Guide Number

The first component in the equation for determining proper flash exposure is the GN, which is a numeric value that represents the amount of light emitted by the flash. You can find the GN for your specific Speedlight in the owner's manual. The GN changes with the ISO sensitivity to which your camera is set; for example, the GN for a Speedlight at ISO 400 is greater than the GN for the same Speedlight when it's set to ISO 100 (because of the increased sensitivity of the sensor). The GN also differs depending on the zoom setting of the Speedlight. The owner's manual has a table that breaks down the GNs according to the flash output setting and the zoom range selected on the Speedlight.

Tip *If you plan to do a lot of manual flash exposures, I suggest making a copy of the GN table from the owner's manual and keeping it in your camera bag with the flash.*

Note *If you have access to a flash meter, you can determine the GN of your Speedlight at any setting by placing the meter 10 feet away and firing the flash. Next, take the aperture reading from the flash meter and multiply by ten. This is the correct GN for your flash.*

Aperture

The second component in the flash exposure equation is the aperture setting. As you already know, the wider the aperture, the more light that falls on the sensor. Using a wider aperture allows you to use a lower power setting (such as 1/4 when in Manual mode) on your flash, or if you're using the automatic i-TTL mode, the camera fires the flash by using less power.

Distance

The third component in the flash exposure equation is the distance from the light source to the subject. The closer the light is to your subject, the more light falls on it. Conversely, the farther away the light source is, the less illumination your subject receives. This is important because if you set your Speedlight to a certain output, you can still achieve a proper exposure by moving the Speedlight closer or farther away as needed.

Guide Number/Distance = Aperture

Here's where the GN, aperture, and distance all come together. The basic formula allows you to take the GN and divide it by the distance to determine the aperture at which you need to shoot. You can change this equation to find out what you want to know:

✦ **GN / D = A.** If you know the GN of the flash and the distance of the flash from the subject, you can determine the aperture to use to achieve the proper exposure. For example, if you know the GN is 100 and you know that the subject is 13 feet away, what aperture should you use? Divide 100 by 13 and you get approximately 7.7. Round that up, and f/8 is the proper aperture for this setting.

✦ **GN / A = D.** If you know the aperture you want to use and the GN of the flash, you can determine the distance to place your flash from the subject. Say you're shooting a portrait and you know the GN of the flash is 50, and you also know that you want to shoot at f/4. Divide 50 by 4 and you get 12.5. Place your subject 12.5 feet from the light source, and you'll have a good exposure.

✦ **A × D = GN.** If you already have the right exposure, you can take your aperture setting and multiply it by the distance of the flash from the subject to determine the approximate GN of the flash. This equation is a little less useful than the other two, but you can use it to determine the GN nonetheless.

Flash Exposure Modes

Flashes have different modes that determine how they receive the information on how to set the exposure. Be aware that depending on the Speedlight or flash you're using, some Flash modes may not be available.

i-TTL mode

The D90 determines the proper flash exposure automatically by using Nikon's proprietary i-TTL system. The camera gets most of the metering information from monitor pre-flashes emitted from the Speedlight. These pre-flashes are emitted almost simultaneously with the main flash, so it almost appears as if the flash has only fired once. The camera also uses data from the lens, such as distance information and f-stop values, to help determine the proper flash exposure.

Additionally, two separate types of i-TTL flash metering are available for the D90: Standard i-TTL flash and i-TTL Balanced Fill-Flash (BL). With Standard i-TTL flash, the camera determines the exposure for the subject only and doesn't take the background lighting into account. With i-TTL BL mode, the camera attempts to balance the light from the flash with the ambient light to produce a more natural-looking image.

When using the D90's built-in flash, the default mode is the i-TTL BL mode. To switch the flash to Standard i-TTL, the camera must be switched to Spot metering.

The Standard i-TTL and i-TTL BL Flash modes are available with Nikon's current Speedlight lineup, including the SB-900, SB-800, SB-600, SB-400, and the R1C1 Macro flash kit.

Manual mode

When you set your Speedlight (either the built-in or accessory flash) to full Manual mode, you must adjust the settings yourself. The best way to figure out the settings is by using a handheld flash meter or by using the GN/D = A formula previously discussed.

Auto mode

With Speedlights that offer the Auto mode (sometimes referred to as Non-TTL Auto Flash), such as the SB-900 and SB-800, you decide the exposure setting. These flashes usually have a sensor on the front of them that detects the light reflected back from the subject. When the flash determines enough light has been produced to make the exposure, it automatically stops the flash tube from emitting any more light.

When using this mode, you need to be aware of the limitations of the flash you're using. If the flash doesn't have a high GN or the subject is too far away, you may need to open the aperture. Conversely, if the flash is too powerful or the subject is very close, you may need to stop the aperture down a bit.

 When using Auto mode with a non-Nikon flash, be sure not to set the D90's shutter speed above the rated sync speed, which is 1/250 second. If you do, you'll have an incompletely exposed image.

Auto Aperture mode

Some flashes, such as the SB-900 and SB-800, also offer what's called an Auto Aperture mode. In this mode, you decide what aperture is best suited for the subject you're photographing and the flash determines how much light to add to the exposure.

Guide Number Distance Priority mode

In the Guide Number Distance Priority mode available with the SB-800 and SB-900, the flash controls the output according to aperture and subject distance. You manually enter the distance and f-stop value into the flash unit and then select the f-stop with the camera. The flash output remains the same if you change the aperture. You can use this mode when you know the distance from the camera to the subject.

 Changing the aperture or the distance to the subject after entering the setting on the flash can cause improper exposures.

Repeating Flash mode

When in Repeating Flash mode, the flash fires repeatedly like a strobe light during a single exposure. You must manually determine the proper flash output you need to light your subject by using the formula to get the correct aperture (GN/D = A) and then you decide the frequency (Hz) and the number of times you want the flash to fire. The slower the shutter speed, the more flashes you can capture. For this reason, I recommend only using this mode in low-light situations because the ambient light tends to overexpose the image. Use this mode to create a multiple-exposure-type image.

6.2 This image was shot by using repeating flash.

To determine the correct shutter speed, use this simple formula: shutter speed = number of flashes per frame/Hz. For example, if you want the flash to fire ten times with a frequency of 40 Hz (40 times per second), divide 10 by 40, which gives you .25, or 1/4 second.

Flash Sync Modes

Flash Sync modes control how the flash operates in conjunction with your D90. These modes work with both the built-in Speedlight and accessory Speedlights, such as the SB-900, SB-800, SB-600, etc. These modes allow you to choose when the flash fires, either at the beginning of the exposure or at the end, and they also allow you to keep the shutter open for longer periods, enabling you to capture more ambient light in low-light situations.

Sync speed

Before getting into the different Flash Sync modes, you need to understand *sync speed*. The sync speed is the fastest shutter speed that can be used while achieving a full flash exposure. This means that if you set your shutter speed at a speed faster than the rated sync speed of the camera, you don't get a full exposure and end up with a partially underexposed image. With the D90, you can't actually set the shutter speed above the rated sync speed of 1/250 (unless you're using Auto FP High-Speed Sync; more on that later) when using a dedicated flash because the camera won't let you; thus, there's no need to worry about having partially black images when using a Speedlight. But if you're using a studio strobe or a third-party flash, this is a concern you should consider.

Limited sync speeds exist because of the way shutters in modern cameras work. As you already know, the shutter controls the amount of time that light is allowed to reach the imaging sensor. All dSLR cameras have what's called a *focal plane shutter*. This term stems from the fact that the shutter is located directly in front of the focal plane, which is essentially on the sensor. The focal plane shutter has two shutter curtains that travel vertically in front of the sensor to control the time the light can enter through the lens. At slower shutter speeds, the front curtain covering the sensor moves away, exposing the sensor to light for a set amount of time. When the exposure has been made, the second curtain then moves in to block the light, thus ending the exposure.

To achieve a faster shutter speed, the second curtain of the shutter starts closing before the first curtain has exposed the sensor completely. This means the sensor is actually exposed by a slit that travels the length of the sensor. This allows your camera to have extremely fast shutter speeds but limits the flash sync speed because the entire sensor must be exposed to the flash at once to achieve a full exposure.

> **Note** The D90's built-in flash doesn't support Auto FP and can only sync up to 1/200.

Auto FP High-Speed Sync

Although the D90 has a top-rated sync speed of 1/250, Nikon has built in a convenient option in CSM e5 that allows you to use a Speedlight at shutter speeds faster than the rated sync speed. This is called Auto FP High-Speed Sync (the FP stands for focal plane, as in the shutter). Setting CSM e5 to Auto FP On allows you to shoot a compatible Speedlight (SB-900, SB-800, and SB-600) to a maximum of 1/4000. Earlier, I discussed that the sensor must be fully exposed to receive the full flash exposure, and that's limited to 1/250, so how on Earth does Auto FP flash work?

It's pretty simple actually: Instead of firing one single pop, the flash fires multiple times as the shutter curtain travels across the focal plane of the sensor (hence, the Auto FP). The only drawback is that your flash power, or GN, is diminished, so you may need to take this into consideration when doing manual flash calculations.

High-Speed Sync is a useful feature. It's mainly used when shooting in brightly lit scenes that use fill flash. An example would be shooting a portrait outdoors at high noon; of course, the light is very contrasty, and you want to use fill flash, but you also require a wide aperture to blur out the background. At the sync speed 1/250, ISO200, your aperture needs to be at f/16. If you open your aperture to f/4, you will then need a shutter speed of 1/4000. This is possible using Auto FP.

Front-Curtain Sync mode

Front-Curtain Sync is the default sync mode for your camera, whether you use the built-in flash, one of Nikon's dedicated Speedlights, or a third-party accessory flash. With Front-Curtain Sync, the flash fires as soon as the shutter's front curtain fully opens. This mode works well with most general flash applications.

One thing worth mentioning about Front-Curtain Sync is that although it works well when you use relatively fast shutter speeds, when the shutter is slowed down (also known as *dragging the shutter* when doing flash photography), especially when you photograph moving subjects, your images have an unnatural-looking blur in front of them. Ambient light recording the moving subject creates this.

When doing flash photography at slow speeds, your camera is actually recording two exposures: the flash exposure and the ambient light. When you use a fast shutter speed, the ambient light usually isn't bright enough to have an effect on the image. When you substantially slow down the shutter speed, it allows the ambient light to be recorded to the sensor, causing what's known as *ghosting*. Ghosting is a partial exposure that's usually fairly transparent-looking on the image.

6.3 A shot that uses Front-Curtain Sync with a shutter speed of 1 second. The flash freezes the hand during the beginning of the exposure, and the trail caused by the ambient exposure appears in the front, causing the hand to look like it's moving backward.

Ghosting causes a trail to appear in front of the subject because the flash freezes the initial movement of the subject. Because the subject is still moving, the ambient light records it as a blur that appears in front of the subject, creating the illusion that it's moving backward. To counteract this problem, you can use a Rear-Curtain Sync setting, which I explain later in this chapter.

Red-Eye Reduction mode

We've all seen red-eye in a picture at one time or another — that unholy red glare emanating from the subject's eyes that's caused by light reflecting off the retina. Fortunately, the D90 offers a Red-Eye Reduction Flash mode. When this mode is activated, the camera fires some pre-flashes (when using an accessory Speedlight) or turns on the AF-assist illuminator (when using the built-in flash), which cause the pupils of the subject's eyes to contract. This stops the light from the flash from reflecting off the retina and reduces or eliminates the red-eye effect. This mode is useful when taking portraits or snapshots of people or pets when there's little light available.

6.4 A picture taken with standard flash at night. Notice the dark background and the bright subject.

6.5 A picture taken in Slow Sync mode. Notice how the subject and background are more evenly exposed.

Slow Sync mode

Sometimes, when using a flash at night, especially when the background is very dark, the subject is lit but appears to be in a black hole. Slow Sync mode helps take care of this problem. In Slow Sync mode, the camera allows you to set a longer shutter speed (up to 30 seconds) to capture the ambient light of the background. Your subject and the background are lit, allowing you to achieve a more natural-looking photograph.

When using Slow Sync, be sure the subject stays still for the whole exposure to avoid ghosting. Ghosting is a blurring of the image caused by motion during long exposures. Of course, you can use ghosting creatively.

Note

Slow Sync can be used in conjunction with Red-Eye Reduction for night portraits.

Rear-Curtain Sync mode

When using Rear-Curtain Sync, the camera fires the flash just before the rear curtain of the shutter starts moving. This mode is useful when taking flash photographs of moving subjects. Rear-Curtain Sync allows you to more accurately portray the motion of the subject by causing a motion blur trail behind the subject rather than in front of it, as is the case with Front-Curtain Sync. Rear-Curtain Sync is used in conjunction with Slow Sync.

6.6 A picture taken in Rear-Curtain Sync mode.

Flash Exposure Compensation

When you photograph subjects using flash, whether you use an external Speedlight or your D90's built-in flash, there may be times when the flash causes your principal subject to appear too light or too dark. This usually occurs in difficult lighting situations, especially when you're using TTL metering, and your camera's meter can get fooled into thinking the subject needs more or less light than it actually does. This can happen when the background is very bright or very dark or when the subject is off in the distance or very small in the frame.

Flash Exposure Compensation (FEC) allows you to manually adjust the flash output while still retaining TTL readings so your flash exposure is at least in the ballpark. With the D90, you can vary the output of your built-in flash's TTL setting from −3 exposure value (EV) to +1 EV. This means if your flash exposure is too bright, you can adjust it down to 3 full stops under the original setting. Or if the image seems underexposed or too dark, you can adjust it to be brighter by 1 full stop. Additionally, the D90 allows you to fine-tune how much exposure compensation is applied by letting you set the FEC incrementally in either 1/3 or 1/2 stops of light.

Fill Flash

Fill flash is a handy flash technique that allows you to use your Speedlight as a secondary light source to fill in the shadows rather than as the main light source, hence the term *fill flash*. Fill flash is used mainly for outdoor photography when the sun is very bright, creating deep shadows and bright highlights that result in an image with very high contrast and a wide tonal range. Using fill flash allows you to reduce the contrast of the image by filling in the dark shadows, thus allowing you to see more detail in the image.

You may also want to use fill flash when your subject is backlit (lit from behind). When the subject is backlit, the camera's meter automatically tries to expose for the bright part of the image that's behind your subject. This results in a properly exposed background while your subject is underexposed and dark. However, if you use the spot meter to obtain the proper exposure on your subject, the background is overexposed and blown out. The ideal thing is to use fill flash to provide an amount of light on your subject that's equal to the ambient light of the background. This brings sufficient detail to both the subject and the background, resulting in a properly and evenly exposed image.

All of Nikon's dSLR cameras offer i-TTL BL (Nikon calls this Balanced Fill-Flash) — or, in laymen's terms, automatic fill flash — with both the built-in flash and the detachable SB-900, SB-800, SB-600, and SB-400 Speedlights. When using a Speedlight, the camera automatically sets the flash to do fill flash (as long as you're not in Spot mode). This is a very handy feature because it allows you to concentrate on composition and not worry about your flash settings. If you decide that you don't want to use the i-TTL BL

6.7 A picture of Emily taken without fill flash

option, you can set the camera's Metering mode to Spot, or if you're using an SB-900, SB-800, or SB-600, simply press the Speedlight's Mode button.

Of course, if you don't own an additional i-TTL dedicated Speedlight or you'd rather manually control your flash, you can still do fill flash. It's actually a pretty simple process that can vastly improve your images when you use it in the right situations.

To execute a manual fill flash, follow these steps:

1. **Use the camera's light meter to determine the proper exposure for the background or ambient light.** A typical exposure for a sunny day is 1/250 at f/16 with an ISO of 200. Be sure not to set the shutter speed higher than the rated sync speed of 1/250.

2. **Determine the flash exposure.** Using the GN/D = A formula, find the setting that you need to properly expose the subject with the flash.

6.8 A picture of Emily taken with fill flash

3. **Use FEC to reduce the flash output.** Dial your flash setting down 1/3 to 2/3 stops allows the flash exposure to be less noticeable while filling in the shadows or lighting your backlit subject. This makes your images look more natural, as if a flash didn't light them, which is the ultimate goal when attempting fill flash.

Note *The actual amount of FEC needed varies with the intensity of the ambient light source. Use your LCD to preview the image and then adjust the amount of FEC as needed.*

Bounce Flash

One of the easiest ways to improve your flash pictures, especially snapshots, is to use bounce flash. Bounce flash is a technique in which the light from the flash unit is bounced off the ceiling or off a wall onto the subject to diffuse the light, resulting in a more evenly lit image. To do this, your flash must have a head that swivels and tilts. Most flashes made within the last 10 years have this feature, but some may not.

When you attempt bounce flash, you want to get as much light from the flash onto your subject as you can. To do this, you need to first look at the placement of the subject and then adjust the angle of the flash head appropriately. Consider the height of the ceiling or the distance from the surface from which you intend to bounce the light to the subject.

Unfortunately, not all ceilings are useful for bouncing flash. For example, the ceiling in my studio is corrugated metal with iron crossbeams. If I attempted to bounce flash from a ceiling like that, it would make little or no difference to the image because the light won't reflect evenly and will scatter in all different directions.

6.9 A picture taken with straight flash

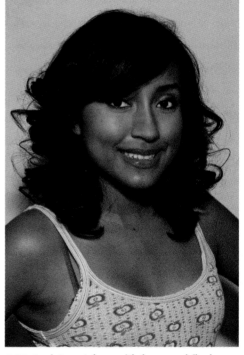

6.10 A picture taken with bounced flash

In a situation where the ceiling isn't useable, you can position the subject next to a wall, swivel the flash head in the direction of the wall, and then bounce the flash from there. To bounce the flash at the correct angle, remember the angle of incidence equals the angle of reflection.

You want to aim the flash head at such an angle that the flash isn't going to bounce in behind the subject so it's poorly lit. You want to be sure that the light is bounced so that it falls onto your subject. When the subject is very close to you, you need to have your flash head positioned at a more obtuse angle than when the subject is farther away. I recommend positioning the subject at least 10 feet away and setting the angle of the flash head at 45 degrees for a typical height ceiling of about 8 to 10 feet.

An important pitfall to be aware of when bouncing flash is that the reflected light picks up and transmits the color of the surface from which it's bounced. This means that if you bounce light off a red surface, your subject will have a reddish tint to it. The best approach is to avoid bouncing light off surfaces that are brightly colored and instead stick with bouncing light from a neutral-colored surface. White surfaces tend to work the best because they reflect more light and don't add any color. Neutral gray surfaces also work well, although you can lose a little light due to lessened reflectivity and the darker color.

Unfortunately, you can't do bounce flash with the D90's built-in flash; you need an external Speedlight, such as an SB-900, SB-800, SB-600, or SB-400.

Nikon Creative Lighting System Basics

Nikon introduced the Creative Lighting System (CLS) in 2004. In simple terms, it's a system designed to enable you to take Nikon Speedlights off the camera and attach them to stands. This allows you to position the Speedlights wherever you want and control the direction of light to make the subject appear exactly how you want. The Nikon CLS enables you to achieve creative lighting scenarios similar to what you would achieve with expensive and much larger studio strobes. You can do it wirelessly with the benefit of full i-TTL metering. To take advantage of the Nikon CLS, you need the D90 and at least one SB-900, SB-800, or SB-600 Speedlight. With the CLS, there's no more mucking about with huge power packs, heavy strobe heads on heavy-duty stands, or cables and wires running all over the place.

The Nikon CLS isn't a lighting system in and of itself but is composed of many different pieces you can add to your system as you see fit (or your budget allows). The first and foremost piece of the equation is your camera.

Understanding the Creative Lighting System

The Nikon CLS is basically a communication system that allows the camera, the commander, and the remote units to share information regarding exposure.

A *commander*, which is also called a master, is the flash that controls external Speedlights. *Remote units* are the external flash units that the commander controls remotely. Communications between the commander and the remotes are accomplished by using pulse modulation. *Pulse modulation* is a term that means the commanding Speedlight fires rapid bursts of light in a specific order. The pulses of light are used to convey information to the remote groups, which interpret the bursts of light as coded information.

Firing the commander tells the other Speedlights in the system when and at what power to fire. The D90's built-in flash can act as a commander. Using an SB-800 or SB-900 Speedlight or an SU-800 Commander as a master allows you to control three separate groups of remote flashes and gives you an extended range. Using the built-in Speedlight as a commander, you can only control two groups of external Speedlights and have a limited range on how far the camera can be from the remote flashes.

Here's essentially how CLS works:

✦ **The commander unit sends a series of monitor pre-flashes to the remote groups, which in turn fire a series of monitor pre-flashes to determine the exposure level.** The camera's i-TTL metering sensor reads the pre-flashes from all the remote groups and also takes a reading of the ambient light.

✦ **The camera tells the commander unit the proper exposure readings for each group of remote**

Speedlights. Just before the shutter is released, the commander, via pulse modulation, relays the information to each group of remote Speedlights.

✦ **The remotes fire at the output specified by the camera's i-TTL meter and then the shutter closes.**

All these calculations happen in a fraction of a second as soon as you press the Shutter Release button. It almost appears to the naked eye as if the flash just fires once. There's almost no waiting for the camera and the Speedlights to do the calculations.

Given the ease of use and the portability of the Nikon CLS, I highly recommend purchasing at least one (if not two) SB-900, SB-800, or SB-600 Speedlights to add to your setup. With this system, you can produce almost any type of lighting pattern you want. It can definitely get you on the road to creating more professional-looking images.

Cross-Reference *For a definitive and in-depth look into the Nikon CLS, read the* Nikon Creative Lighting System Digital Field Guide *(Wiley, 2007).*

Speedlights

Speedlights are Nikon's line of flashes. They are amazing accessories to add to your kit, and you can control most of them wirelessly. Currently, Nikon offers four shoe-mounted flashes — the SB-900, SB-800, SB-600, and SB-400 — along with two macro lighting ring flash setups — the R1 or R1C1 — that include two SB-R200 Speedlights. The R1C1 kit also includes the SU-800 Wireless Commander unit.

This section isn't meant to be a definitive guide to the Nikon Speedlight system but does provide a quick overview of some of the flashes Nikon has to offer and their major features.

Note *The SB-400 can't be used as a wireless remote.*

SB-900 Speedlight

The SB-900 Speedlight is Nikon's newest and most powerful Speedlight. This flash takes all the features of Nikon's previous flagship flash, the SB-800, and expands on them, adding more power, a greater range, and a more intuitive user interface. You can use the SB-900 as an on-camera flash, a commander flash that can control up to three groups of external Speedlights on four channels, or a remote flash that you control from the D90 built-in flash, another SB-900 or SB-800, or an SU-800 Wireless Commander. The SB-900 automatically detects whether it's attached to an FX- or DX-format camera, ensuring you get the maximum efficiency.

Another new feature the SB-900 offers is a choice of three lighting distribution options: Standard for normal photos, Center-weighted for portrait photography, and Even for evenly illuminating large groups or interior shots.

The SB-900 can also automatically identify the supplied color filters to ensure proper white balance when using the filters.

The SB-900 has a wider range of coverage than the SB-800, covering from 17–200mm in FX mode or 12–200mm in DX mode. With the built-in wide-angle flash diffuser, you can get coverage from 12–17mm in FX mode or 8–11mm in DX mode.

The SB-900 has a GN of 155 at ISO 200 at the 35mm and can be used to light subjects as far away as 70 feet.

The SB-900 offers a wide variety of Flash modes:

✦ i-TTL and i-TTL Balanced Fill-Flash (i-TTL BL)

✦ Auto Aperture Flash

✦ Non-TTL Auto Flash

✦ Distance Priority Manual Flash

✦ Manual Flash

✦ Repeating Flash

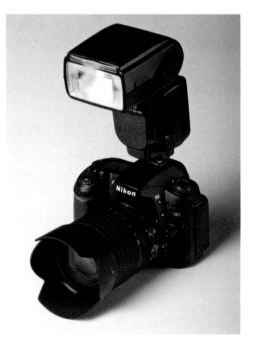

6.11 The SB-900 mounted on a D90

Flash Diffusers

One of the best things you can buy for your flash is a flash diffuser. This is possibly the most important accessory you can get after batteries. Flash diffusers, quite simply, diffuse the light coming from the flash. As you're probably aware, when using flash, the light can be harsh and unnatural. For this reason, photographers often use techniques, such as bounce flash, to improve the quality of light in their images. The SB-900 and SB-800 come with a diffuser as part of the package. The SB-600 doesn't come with a diffuser, but you can buy one relatively inexpensively. Sto-Fen makes an excellent and compact diffuser called the Omni-Bounce.

There are also diffusers for the built-in flash. There are many different types of these diffusers, but the one that I recommend is the Lumi-Quest soft screen. It works like a charm and folds up flat so you can stick it in your pocket when not using it.

I literally would not use the built-in flash without a flash diffuser. That's how much these things can improve your images. I can't stress this point enough. Get a flash diffuser!

This figure shows two shots taken just moments apart. The shot on the left was taken with straight flash. Notice the harsh shadows. The shot on the right was taken with the Lumi-Quest Soft Screen. The light is more evenly spread out, and the shadows are soft and diffused.

SB-800 Speedlight

The SB-800 can be used not only as a flash but also as a commander to control up to three groups of external Speedlights on four channels. You can also set the SB-800 to work as a remote flash for off-camera applications. The SB-800 has a built-in AF-assist Illuminator to assist in achieving focus in low light. The SB-800 has a powerful GN of 175 at ISO 200 35mm zoom setting and can be used to photograph subjects as far away as 66 feet.

The SB-800 offers the same Flash modes as the SB-900.

Image courtesy of Nikon
6.13 The SB-600

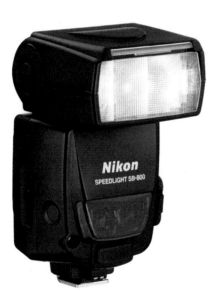

Image courtesy of Nikon
6.12 The SB-800

Like the SB-900 and SB-800, the SB-600 also has a built-in AF-assist Illuminator. However, the SB-600 can't be used as a commander to control off-camera flash units. The SB-600 has an impressive GN of 138 at ISO 200, which, although it gives about 1 stop less light than the SB-800, is more than enough for most subjects.

The SB-600 only has the two most important Flash modes:

✦ i-TTL/i-TTL BL

✦ Manual

SB-600 Speedlight

The SB-600 Speedlight is the SB-800's little brother. This flash has fewer features than its bigger sibling but has everything you need. You can use it on the camera as well as off-camera by setting it as a remote.

SB-400 Speedlight

The SB-400 is Nikon's entry-level Speedlight. It can only be used in the i-TTL/i-TTL BL mode. One neat feature is the horizontally tilting flash head that allows you to do bounce flash. Unfortunately, this only works

when the camera is in the horizontal position, unless you bounce off a wall when holding the camera vertically. For such a small flash, the SB-400 has a decent GN of 98 at ISO 200.

The SB-400 doesn't have an automatic zoom head like the bigger flashes. The SB-400 flash head is optimized for 28mm (you can use it at any zoom setting though).

> **Tip** If you plan on using the SB-400 Speedlight with a lens wider than 28mm, you may want to consider finding some sort of diffuser that works with the SB-400. I usually grab some tissue paper and rubber-band it loosely over the top of the flash head.

> **Caution** The SB-400 doesn't work wirelessly with the Nikon CLS. It only works when connected to the camera hot shoe or an off-camera hot-shoe cord.

Speedlights. It can control up to three groups of Speedlights on four different channels. The built-in flash on the D90 can control two groups on four channels, so depending on the type of photography, you may not need to use one of these on the D90 unless you have to have an extra group of flashes or you want to take advantage of the invisible infrared pre-flashes.

Image courtesy of Nikon
6.15 The SU-800

Image courtesy of Nikon
6.14 The SB-400

SU-800 Wireless Speedlight Commander

The SU-800 is a wireless Speedlight commander that uses infrared technology to communicate wirelessly with off-camera

R1/R1C1 Macro flash

The R1C1 kit comes with an SU-800 Wireless Commander, which is the only difference between it and the R1.

The R1 set consists of a ring that attaches to the lens and two SB-R200 Speedlights that attach to the ring. Ring lights are used in close-up and macro photography to provide a light that's direct or on-axis to the subject. This achieves a strong, even lighting, which can be difficult to do when the lens is close

Image courtesy of Nikon
6.16 The R1C1 (SU-800 and SB-R200s) mounted on the D200

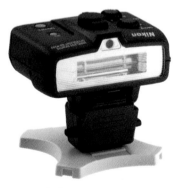

Image courtesy of Nikon
6.17 An SB-R200

to the subject. Unlike a regular ring flash, you can move the SB-R200 Speedlights around the ring to provide different lighting patterns.

Using the Built-In Speedlight

The D90's built-in Speedlight is a handy little flash that's great for taking casual snapshots. Although it lacks the versatility of the bigger external flashes, the built-in Speedlight is always there when you need it and requires no extra batteries because the camera's battery powers it. Activate it by pressing the Flash pop-up button on the top left of the camera (as you would hold it for shooting) near the built-in Speedlight.

The built-in Speedlight is set to i-TTL mode by default (i-TTL appears as TTL in the menu), although you can choose to set it to

Manual mode (you set the output). You can also set it to Repeating Flash (RPT) or Commander mode, which allows you to use it to control up to two separate groups of remote Speedlights.

You can also use it with all the sync modes your camera offers: Front-Curtain Sync, Rear-Curtain Sync, Slow Sync, and Red-Eye Reduction. To change the sync mode, press the Flash mode button located just below the Flash pop-up button. Rotating the Main Command dial while pressing the Flash mode button changes the mode. The selected mode appears in the LCD control panel.

You can also apply exposure compensation by pressing the Flash mode button and then rotating the Sub-command dial.

One of the best features of the built-in Speedlight is that you can use it to wirelessly control remote units by using the CLS. To take advantage of this feature, you need at least one SB-600, SB-800, SB-900, or SB-R200.

Follow these steps to use the built-in Speedlight in Commander mode:

1. **Press the Menu button and then use the Multi-selector to navigate to the Custom Setting menu.**

2. **Use the Multi-selector to highlight CSM e Bracketing/flash and then press the Multi-selector right to enter the CSM e menu.**

3. **Use the Multi-selector to highlight CSM e2 Flash cntrl for built-in flash and then press the Multi-selector right to view flash control options.**

4. **Press the Multi-selector up or down to choose Commander mode and then press the Multi-selector right to view settings.**

5. **Press the Multi-selector up or down to choose a Flash mode for the built-in flash.** You can choose M, TTL, or --. The last option (--) allows the flash to control the remotes without adding additional exposure.

6. **Press the Multi-selector right to highlight the exposure compensation setting.** Use the Multi-selector up or down to apply exposure compensation if desired. If the built-in flash is set to --, this option isn't available.

7. **Use the Multi-selector to set the mode for Group A.** You can choose TTL, AA, M, or --. Press the Mutli-selector right to highlight exposure compensation. Press the Multi-selector up or down to apply exposure compensation if desired. Repeat this process for Group B.

8. **Use the Multi-selector to highlight the Channel setting.** You can choose from channels 1 to 4. These channels can be changed if you're shooting in the same area as another photographer who's using CLS. If you're both on the same channel, you will trigger each other's Speedlights. If you use CLS alone, it makes no difference which channel you choose.

9. **Press the OK button.** If this button isn't pressed, no changes are applied.

When attempting to use wireless CLS, be sure that your remote Speedlights are set to the proper Groups and Channel. If the remotes aren't properly set, they won't fire.

Strobes and Monolights

Although the Nikon CLS allows you complete wireless control over lighting, it can be somewhat limited. The Speedlights are small, versatile, and portable, but they're limited in range, power, and options for accessories. Sometimes, there's no other option than to use a studio strobe, especially when lighting large subjects or when you need specific accessories to modify the light in a certain way. A studio strobe usually has a much higher GN than a shoe-mounted Speedlight, which means more power. Studio strobes run on AC power instead of batteries, which means faster recycle times between flashes. Also, many different accessories and light modifiers are available for studio strobes.

There are two different types of studio strobes: standard pack and monolights. Standard pack and head strobes have a separate power pack and flash heads that are controlled centrally from the power pack. Monolights are flash heads that have a power pack built in, and you adjust them individually at each head. Monolights tend to be lower in power than standard strobes, but they're more portable and less expensive.

One of the downsides to using studio strobes is that you lose the advantage of i-TTL flash metering. Studio strobes are generally fired by using a PC sync cord that runs from the camera to the strobe, which only tells the flash *when* to fire, not at what output level. You must calculate all the strobe settings. Of course, there are flash meters, which are designed to read the output of the strobe to give you a reading of the proper exposure. And you can always use the handy GN/D = A formula to determine the proper exposure. The D90 doesn't have a PC sync terminal, so you'd need to purchase an additional accessory that fits in the camera's hot shoe. Nikon makes an inexpensive device called the AS-15.

One of the plus sides of using studio strobes is the continuous modeling light. Because the strobes are only lit for a fraction of a second, studio strobes are equipped with a constant light source (called a *modeling light*) that allows you to see what effect the strobe is going to have on the subject, although the modeling light isn't necessarily consistent with the actual light output of the flash tube.

> **Note**
> *The SB-900, SB-800, SB-600, and SB-R200 and the built-in flash can be used with the camera's modeling light feature that uses a burst of low-power flashes to show where the shadows fall. However, this isn't a continuous light. The modeling light feature can be set in CSM e3, which allows the modeling light to be shown when the Depth of Field Preview button is pressed and a compatible Speedlight is attached or the built-in flash is up.*

Firing Your Studio Strobes Wirelessly

You can't use studio lighting setups completely wirelessly because you have to plug the lights in for power, and in the case of standard studio strobes, you have to not only plug in the power pack but also connect the flash heads to the power pack. For the most part, studio strobes are fired via a sync cord, which connects to the D90 via a hot-shoe sync device, such as the Nikon AS-15 or the Wein Safe-Sync. This is the easiest and most affordable way of firing your studio flashes. Most monolights have a built-in optical sensor that allows the flash to be triggered by another flash. Most standard studio strobe power packs can also be fitted with an optical sensor. This allows you some freedom from the wires that connect your camera to the main flash unit, as you can use the built-in flash in Manual mode set to a low power setting that's enough to trigger the strobe but not to add exposure.

More and more photographers these days use radio triggers. Radio triggers use a radio signal to fire the strobes when the shutter is released. Unlike the optical sensor, the radio trigger is not limited to seeing another flash to make it fire. Radio triggers can also fire from long distances and can even work from behind walls and around corners. Radio trigger units have two parts: the transmitter and the receiver. The transmitter is attached to the camera and tells the receiver, which is connected to the strobe, to fire when the Shutter Release button is pressed. Some newer radio units are transceivers, meaning they're able to function as a transmitter or a receiver (not at the same time, of course), but you still need at least two of them to operate.

Radio triggers work very well and free you from being directly attached to your lights, but they can be very expensive. There are a few different manufacturers, but the most well-known is Pocket Wizard. Pocket Wizard transceivers are fairly pricey, but they are built well and are extremely reliable. Recently, there has been a proliferation of radio transmitters and receivers on eBay that are priced very low. I can't attest to how well they work, but a lot of folks on the Internet seem to like them. At around $30 for a kit with one receiver and one transmitter, you won't be losing much if it doesn't work well.

When looking for a studio lighting setup, you have thousands of different options. There are a lot of reputable manufacturers offering a lot of different types of lights. Your only limit really is the amount of money you want to spend.

Standard studio strobes are the most powerful and most expensive option. With the standard strobes, you can usually attach up to six flash heads to the power pack, which provides a lot of lighting options. Of course, one power pack and two lights cost about $1000

to start, not including stands, lighting modifiers (covered later in this chapter), and other accessories. If you opt for studio strobes, reputable manufacturers include Speedotron, Dyna-lite, and Profoto.

A more economical approach is to use monolights. Most of the manufacturers that make standard strobes also make monolights. Although they're lower in power than strobes that are powered by a power pack, they are also far more portable because they're lighter and smaller in size. You can outfit monolights with the same light modifiers as the bigger strobe units. I recommend going this route when purchasing lights for a small or home studio setup. You can get a complete setup with two 200-watt-second (ws) monolights (that's 400 ws of combined power) with stands, umbrellas, and a carrying case for around $500; that's only a little more than you would pay for a 400 ws power pack alone.

When equipping your home or small studio with studio lighting, I recommend starting out with at least two strobes. With this setup, you can pretty easily light almost any subject. A three-light setup is ideal for most small home studios, with two lights for lighting the subject and one light for illuminating the background.

Those with a more limited budget can still achieve some excellent results by using a single strobe head, especially when going for moody low-key lighting. The late Dean Collins was a skilled photographer and a master at lighting who could light some amazing scenes with just one strobe. I highly encourage anyone who's interested in photographic lighting to view some of his instructional videos available for purchase at www.deancollins.com.

Flash Alternatives

There is a growing movement of amateur photographers who are using nondedicated hot-shoe flashes to light their subjects. This movement is based on getting the flash off the camera to create more professional-looking images (such as those you get when using studio lights) but is also centered on not spending a lot of money to achieve these results.

Basically, what these folks, called *Strobists,* are saying is that you don't need expensive studio lights or expensive dedicated flashes to achieve great images.

Small hot-shoe flashes are extremely portable and are powered by inexpensive AA batteries. You can find older-model flashes that don't have all the bells and whistles of the newer models at reasonable prices.

To get started with off-camera flash, you need a flash with two things: a PC sync terminal and a manual output power setting. If your flash doesn't have a PC sync terminal, you can buy a hot-shoe adapter that has one on it. This adapter slides onto the shoe of your flash and has a PC terminal on it that syncs with your flash.

The best flashes to use for this are the older Nikon Speedlights from the mid-1980s to the mid-90s: the SB-24, SB-25, SB-26, and SB-28. These flashes are available at a fraction of the cost of the newer i-TTL SB-800 or SB-600. Unfortunately, with a greater number of people using the Strobist technique, the prices have increased a bit.

Given the number of people now using small hot-shoe flashes off-camera, manufacturers are making accessories to attach these flashes to stands and other accessories to allow light modifiers to be added to them.

To learn more about the Strobist technique and find many tricks and tips, go to strobist. blogspot.com.

Continuous Lighting

Continuous lighting is just what it sounds like: a light source that's constant. It's by far the easiest type of lighting to work with. Unlike natural lighting, continuous lighting is consistent and predictable. Even when using a strobe with modeling lights, you sometimes have to estimate what the final lighting will look like. Continuous lighting is What You See Is What You Get. You can see the actual effects the lighting has on your subjects, and you can modify and change the lighting before you even press the Shutter Release button.

Continuous lights are an affordable alternative to using studio strobes. Because the light is constant and consistent, the learning curve is also less steep. With strobes, you need to experiment with the exposure or use a flash meter. With continuous lights, you can use the D90's Matrix meter to yield excellent results.

As with other lighting systems, there are a lot of continuous light options. Here are a few of the more common ones:

✦ **Incandescent.** Incandescent, or tungsten, lights are the most common type of lights. Thomas Edison invented this type of light: Your typical lightbulb is a tungsten lamp. With tungsten lamps, an electrical current runs through a tungsten filament, heating it and causing it to emit light. This type of continuous lighting is the source of the name hot lights.

✦ **Halogen.** Halogen lights, which are much brighter than typical tungsten lights, are actually very similar. They're considered a type of incandescent light. Halogen lights also employ a tungsten filament but include a halogen vapor in the gas inside the lamp. The color temperature of halogen lamps is higher than the color temperature of standard tungsten lamps.

✦ **Fluorescent.** Fluorescent lighting, which most of you are familiar with, is everywhere these days. It's in the majority of office buildings, stores, and even in your own house. In a fluorescent lamp,

electrical energy changes a small amount of mercury into a gas. The electrons collide with the mercury gas atoms, causing them to release photons, which, in turn, create the phosphor coating inside the lamp to glow. Because this reaction doesn't create much heat, fluorescent lamps are much cooler and more energy-efficient than tungsten and halogen lamps. These lights are commonly used on TV studio sets.

✦ **HMI.** HMI, or Hydrargyrum Medium-Arc Iodide, lamps are probably the most expensive type of continuous lighting. The motion picture industry uses this type because of its consistent color temperature and the fact that it runs cooler than a tungsten lamp with the same power rating. These lamps operate by releasing an arc of electricity in an atmosphere of mercury vapor and halogenides.

Incandescent and halogen

Although incandescent and halogen lights make it easier to see what you're photographing and cost less, there are quite a few drawbacks to using these lights for serious photography work. First, they're hot. When a model has to sit under lamps for any length of time, he or she will get hot and start to sweat. This is also a problem with food photography. It can cause your food to change

consistency or even to sweat; for example, cheese that has been refrigerated. On the other hand, it can help keep hot food looking fresh and hot.

Second, although incandescent lights appear to be very bright to you and your subject, they actually produce *less* light than a standard flash unit. For example, a 200-watt tungsten light and a 200-watt-second strobe use the same amount of electricity per second, so they should be equally bright, right? Wrong. Because the flash discharges all 200 watts of energy in a fraction of a second, the flash is actually much, much brighter. Why does this matter? Because when you need a fast shutter speed or a small aperture, the strobe can give you more light in a shorter time. An SB-600 gives you about 30 watt-seconds of light at full power. To get an equivalent amount of light at the maximum sync speed of 1/250 second from a tungsten light, you would need a 7500-watt lamp! Of course, if your subject is static, you don't need to use a fast shutter speed; in this case, you can use one 30-watt lightbulb for a 1-second exposure or a 60-watt lamp for a 1/2-second exposure.

Other disadvantages of using incandescent lights include:

✦ **Color temperature inconsistency.** The color temperature of the lamps changes as your household current varies and as the lamps get more and more use. The color temperature may be inconsistent from manufacturer to manufacturer and may even vary within the same types of bulbs.

✦ **Light modifiers are more expensive.** Because most continuous lights are hot, modifiers such as softboxes need to be made to withstand the heat; this makes them more expensive than the standard equipment intended to be used for strobes.

✦ **Short lamp life.** Incandescent lights tend to have a shorter life than flash tubes, so you'll have to replace them more often.

Although incandescent lights have quite a few disadvantages, they're by far the most affordable type of lights you can buy. Many photographers who are starting out use inexpensive work lights they can buy at any hardware store for less than $10. These lights use a standard lightbulb and often have a reflector to direct the light; they also come with a clamp you can use to attach them to a stand or anything else you have handy that might be stable.

Halogen work lamps, also readily available at any hardware store, offer a higher light output than a standard light, generally speaking. The downside is that they're very hot, and the larger lights can be a bit unwieldy. You may also have to come up with some creative ways to get the lights in the position you want them. Some halogen work lamps come complete with a tripod stand. If you can afford it, I'd recommend buying these; they're easier to set up and less of an aggravation in the long run. The single halogen work lamps that are usually designed to sit on a table or some other support are readily available for less than $20; the double halogen work lamps with two 500-watt lights and a 6-foot tripod stand are usually available for less than $40.

If you're really serious about lighting with hot lights, you may want to invest in a photographic hot-light kit. These kits are widely available from any photography or video store. They usually come with lights, light stands, and sometimes with light modifiers, such as umbrellas or softboxes, for diffusing the light for a softer look. The kits can be relatively inexpensive, with two lights, two stands, and two umbrellas for around $100. Or you can buy much more elaborate setups ranging in price up to $2000. I've searched the Internet for these kits and have found the best deals are on eBay.

Fluorescent

Fluorescent lights have a lot of advantages over incandescent lights; they run at much lower temperatures and use much less electricity than standard incandescent lights. Fluorescent lights are also a much softer light source than incandescent lights.

In the past, fluorescent lights weren't considered viable for photographic applications because they cast a sickly green light on the subject. Today, most fluorescent lamps for use in photography are color-corrected to match both daylight and incandescent lights. Also, given that white balance is adjustable in the camera or in Photoshop with RAW files, using fluorescents has become much easier because you don't have to worry about color-correcting filters and special films.

These days, because more people are using fluorescent lights, light modifiers are more readily available. They allow you to control the light to make it softer or harder and directional or diffused.

Fluorescent light kits are readily available through most photography stores and online. These kits are a little more expensive than the incandescent light kits — an average kit with two light stands, reflectors, and bulbs costs about $160. Fluorescent kits aren't usually equipped with umbrellas or softboxes because the light is already fairly soft. You can buy these kinds of accessories, and there are kits available that come with softboxes and umbrellas, although they cost significantly more.

Unfortunately, there aren't many low-cost alternatives to buying a fluorescent light kit. The only real option is to use the clamp light I mentioned in the section about incandescent light and fit it with a fluorescent bulb that has a standard bulb base on it. These types of fluorescent bulbs are readily available at any store that sells lightbulbs.

HMI

This type of continuous light is primarily used in the motion picture industry. HMI lamps burn extremely bright and are much more efficient than standard incandescent, halogen, or fluorescent lights. The light emitted is equal in color temperature to that of daylight.

Although I include them here for general information, these kits are usually too cost-prohibitive for use in average still-photography applications. A one-light kit with a 24-watt light can start at more than $1000. An 18,000-watt kit can cost more than $30,000!

Light Modifiers

Light modifiers do exactly what their name says they do: They modify light. When you set up a photographic shot, in essence you're building a scene by using light. For some images, you may want a hard light that's very directional; for others, a soft, diffused light works better. Light modifiers allow you to control the light so you can direct it where you need it, give it the quality the image calls for, and even add color or texture to the image.

Umbrellas

The most common type of light modifier is the umbrella. They're used to diffuse and soften the light emitted from the light source, whether it's continuous or strobe lighting. There are three types of umbrellas to choose from:

✦ **Standard.** The most common type of umbrella has a black outside, with the inside coated with a reflective material that's usually silver or gold in color. Standard umbrellas are designed so you point the light source into the umbrella and bounce the light onto the subject, resulting in a nondirectional soft light source.

✦ **Shoot-through.** Some umbrellas are manufactured out of a one-piece translucent silvery nylon that enables you to shoot through the umbrella like a softbox. You can also use shoot-through umbrellas to bounce the light as I previously mentioned.

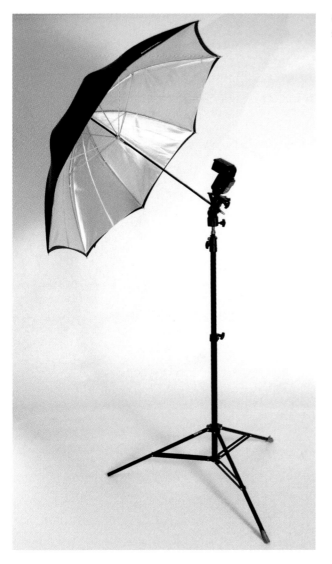

6.18 A Speedlight with a standard umbrella

✦ **Convertible.** This umbrella has a silver or gold lining on the inside and a removable black cover on the outside. You can use convertible umbrellas to bounce light or as a shoot-through when you remove the outside covering.

Photographic umbrellas come in various sizes, usually ranging from 27 inches all the way up to 12½ feet. The size you use depends on the size of the subject and the degree of coverage you want. For standard headshots, portraits, and small to medium products, umbrellas ranging from 27 inches to about

40 inches supply plenty of coverage. For full-length portraits and larger products, a 60- to 72-inch umbrella is generally recommended. If you're photographing groups of people or especially large products, you'll need to go beyond the 72-inch umbrella or you can use multiple smaller umbrellas.

The larger the umbrella is, the softer the light falling on the subject from the light source. It's also the case that the larger the umbrella is, the less light you have falling on your subject. Generally, the small to medium umbrellas lose about a stop and a half to 2 stops of light. Larger umbrellas generally lose 2 or more stops of light because the light is being spread out over a larger area.

Smaller umbrellas tend to have a much more directional light than larger umbrellas. With all umbrellas, the closer your umbrella is to the subject, the more diffuse the light is.

Choosing the right umbrella is a matter of personal preference. Features to keep in mind when choosing your umbrella include the type, size, and portability. You also want to consider how they work with your light source. For example, regular and convertible umbrellas return more light to the subject when light is bounced from them, which can be advantageous, especially if you're using a Speedlight, which has less power than a studio strobe. Also, the less energy the Speedlight has to output, the more battery power you save. On the other hand, shoot-through umbrellas lose more light through the back when bouncing, but they're generally more affordable than convertible umbrellas.

Softboxes

Softboxes, as with umbrellas, are used to diffuse and soften the light of a strobe or continuous light to create a more pleasing light source. Softboxes range in size from small, 6-inch boxes that you mount directly onto the flash head to large boxes that usually mount directly to a studio strobe.

The reason you may want to invest in a softbox rather than an umbrella is that it provides a more consistent and controllable light than an umbrella does. Softboxes are closed around the light source, thereby preventing unwanted light from bouncing back onto your subject. With the diffusion material, there's less of a chance of creating hotspots on your subject. A hotspot is an overly bright spot usually caused by bright or uneven lighting.

Softboxes are generally made for use with studio strobes and monolights, although special heat-resistant softboxes are made for use with hot lights. Softboxes attach to the light source with a device called a speedring. Speedrings are specific to the type of lights to which they're meant to attach. If you're using a standard hot-shoe flash as your light source, some companies, such as Chimera (www. chimeralighting.com), manufacture a type of speedring that mounts directly to the light stand and allows you to also attach one or more Speedlights to the light stand. You mount the speedring to the stand, attach the softbox to the speedring, attach the Speedlight with the flash head pointed into the softbox, and you're ready to go.

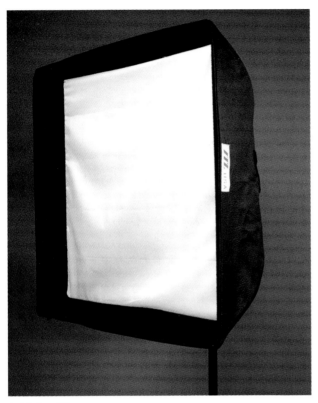

6.19 A softbox

Softboxes are available in a multitude of shapes and sizes, ranging from squares and rectangles to ovals and octagons. Most photographers use the standard square or rectangular softboxes. However, some prefer to use oval or octagonal softboxes because they mimic umbrellas and give a more pleasing round shape to the catchlights in the subject's eyes. This is mostly a matter of personal preference. I usually use a medium-sized, rectangular softbox.

As with umbrellas, the size of the softbox you need depends on the subject you're photographing. You can take most softboxes apart and fold them up, and most of them come with a storage bag that you can use to transport them.

Diffusion panels

A diffusion panel is basically a frame made out of PVC pipe with reflective nylon stretched over it. Diffusion panels function similarly to softboxes, but you have a little more control over the quality of the light.

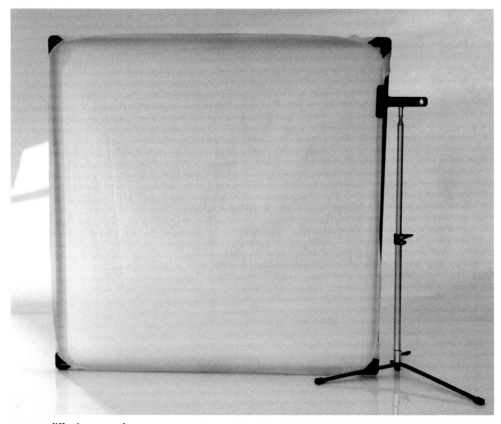

6.20 A diffusion panel

Diffusion panels are usually about 6 feet tall and have a base that allows them to stand without a light stand. You place the diffusion panel in front of the subject. You then place your light source behind the diffusion panel. You can move the light closer to the diffusion panel for more directional light or farther away for a softer, more even light. For a full-length portrait or a larger subject, you can place two or more lights behind the panel, achieving greater coverage with your lights.

You can use a diffusion panel as a reflector, bouncing the light from your light source onto the subject. You can purchase diffusion panels at most major camera stores at a fraction of the price of a good softbox. You can easily disassemble the PVC frame and pack it away into a small bag for storage or transport it to and from locations.

Tip *If you're feeling crafty, you can make a diffusion panel from items easily found in your local hardware and fabric stores. Numerous sites on the Internet offer advice on how to construct one.*

Other light modifiers

There are many different types of light modifiers. The main types — umbrellas, softboxes, and diffusion panels — serve to diffuse the light by effectively increasing the size of the light source, thereby reducing contrast. In addition to softboxes and such, other types of light modifiers, such as barn doors and snoots, are worth considering. They're also used to control the direction of the light to make it appear stronger or to focus it on a specific area of the subject. The following list includes some of the more common tools photographers use to direct the light from the light source:

✦ **Parabolic reflectors.** Most light sources come equipped with a parabolic reflector. They usually range from 6 to 10 inches in circumference, although you can buy larger ones. Without a reflector, the light from the bare bulb, whether it's a flash tube or an incandescent, scatters and lacks direction, resulting in the loss of useable light. The reflector focuses the light into a more specific area, actually increasing the amount of useable light by 1 or 2 stops. Parabolic reflectors are commonly used in conjunction with other light modifiers, including umbrellas, barn doors, and grids. When you use an umbrella, you always use a reflector to direct the light into the umbrella, which diffuses the light. Using only a reflector gives the light a very hard quality that results in a lot of contrast.

✦ **Barn doors.** Barn doors are used to control the direction of light and to block stray light from entering the lens, which can result in lens flare. Blocking the light is also known as *flagging*. Barn doors are normally attached to the reflector and come in two types — 4-leaf and 2-leaf. Barn doors consist of panels that are attached to hinges that allow you to open and close the doors to let light out or keep it in. Typically, barn doors are used when you want a hard light source to shine on a specific area of the subject but you don't want any stray light striking other parts of the subject or the camera lens.

✦ **Grids.** Grids, also known as grid spots or honeycombs, are used to create a light similar to a spotlight. A grid is a round disc with a honeycomb-shaped screen inside it. When the light shines through it, it's focused to a particular degree, giving you a tight circle of light with a distinct fall-off at the edges. There are different types of grids that control the spread of light. They run from a 5-degree grid to a 60-degree grid. The 5-degree grid has very small holes and is deep, so the light is focused down to a small, bright spot. The higher the degree of the grid spot, the more spread out the spot becomes. Grids fit inside of the reflector, just in front of the lamp or flash tube. They're great to use as hair lights and to add a spot of light on the background to help the subject stand out.

✦ **Snoots.** A snoot creates a spotlight-like effect similar to the grid. A snoot is shaped like a funnel, and it kind of works that way too, funneling light into a specific area of the scene. The snoot usually has a brighter spot effect than a grid does. The snoot fits directly over the flash head.

✦ **Reflector.** This type of reflector doesn't directly modify the light coming from the light source, but it's used to reflect light onto the subject. Reflectors are usually white or silver, although some can be gold. Professional reflectors are usually round or oval discs with wire frames that can be easily folded up to a smaller size. You can make your own reflector by using white foam board available at any art supply store and at some photography stores. You can use the board alone or cover it with silver or gold foil. In a pinch, almost anything white or silver, such as a lid from a Styrofoam cooler or even a white T-shirt, will work.

✦ **Gobos.** A gobo can be anything that goes between the light source and the subject or background, often to create a pattern or simulate a specific light source, such as a window. It's usually attached to a stand and placed a few feet in front of the light source. A common technique in film noir–type photography is to place venetian blinds between a light and the background to simulate sunlight shining through the blinds of the office window of a private eye. You can make gobos or purchase them from a photographic supply house.

D-Movie

The D90 is a groundbreaking camera for one simple fact: video. The D90 is the first dSLR in history to offer video. Canon wasn't far behind with the 5D mkII, but the D90 was the first. So, what does this mean for you? Quite simply, it means you can record video with your dSLR.

First and foremost, this statement must be made: The D90 is not a video camera. It's a still camera that just happens to record video by using the Live View feature. The D90 is one of Nikon's midrange dSLR cameras, and it's an excellent example of that. It has a 12-megapixel sensor, low noise at high ISO settings, and a fast continuous shutter speed. Everything you could want from a dSLR. Why am I bringing this up? There are some who aren't happy with the D90 video performance. These evaluations are being based on comparisons to dedicated video cameras. This is an unfair comparison, as the D90 was designed primarily to shoot still photographs, and it does an excellent job accomplishing that. You wouldn't compare a still grab from a video camera to a high-resolution still image from the D90, would you? Of course not. It's like comparing apples to oranges.

The D90's Video mode is, for all practical purposes, fully automatic. Once you switch to Video mode, the camera controls all the settings. Shutter speed and ISO can't be adjusted at all, and the aperture setting is locked in once Live View is activated. The only way to manually adjust the exposure is by applying exposure compensation. There are some ways to get around the total lack of control, which are covered as you move along through this chapter.

Some things the D90 can do that dedicated video cameras can't:

✦ **Interchangeable lenses.** You can use almost every Nikon lens ever made on the D90. While some video cameras will take Nikon lenses, you need an expensive adapter, and you lose some resolution and gain depth of field.

In This Chapter

About video

Tricks, tips, and workarounds

Video-editing software

✦ **Depth of field.** You can get a much more shallow depth of field than video when using a lens with a fast aperture, such as a 50mm f/1.4. Most video cameras have sensors that are much smaller than the sensor of the D90, which gives them a much deeper depth of field.

✦ **Cleaner images.** The D90's APS-C-sized sensor also allows the camera to record video with less noise at high sensitivities than most video cameras can.

So, although the D90 doesn't have all the capabilities of a dedicated video camera, there are things that the D90 can do better than video cameras.

About Video

Before getting into the nuts and bolts of the D90's Video mode, it's best to do a little exploration into the realm of video. Video capture functions much differently than still-photo capture. Of course, all photography is capturing light by using a sensor (or film), a lens, and a lightproof box (your camera). Video is just digitally capturing still images at a high frame rate and playing them back sequentially.

The D90 can shoot video in three resolutions that can be set in the Shooting menu under the Movie settings option. You can choose a small video size of 320 × 216 pixels, which is shot using a 3:2 aspect ratio. This is the same ratio at which still images are recorded. This resolution is very small and best suited for filming small clips that are sent through e-mail. The next size, 640 × 424, is also shot by using a 3:2 aspect ratio. This size is good for posting on the Internet without using up too much bandwidth. The best setting to use is the HD setting of 1280 × 720, which is a 16:9 or cinematic ratio. This setting gives

you the most resolution and can easily be watched on large HDTVs, offering a reasonable image quality.

Progressive versus interlaced

If you're familiar with HD, you've probably heard the terms *progressive* and *interlaced*. The terms are usually used in conjunction with the pixel resolution numbers of the HDTV or monitor (720p or 1080i, for example). To make things even more confusing, even the broadcast companies don't stick to one standard. Even your D90 has an HDMI output setting (found in the Setup menu) that lets you choose between progressive or interlaced resolutions.

So, what's the difference? It's actually quite simple. Interlaced video is displayed on your television by scanning in every other line that makes up the picture. First, the even lines are displayed and then the odd lines. This is done every 1/60 second. The way the human brain works allows this to appear as if it's being displayed all at once. This is how television has been displayed since the beginning. This method was used because the early cathode-ray tube televisions weren't fast enough to keep up with the information being sent through the signal.

Progressive scanning works by progressively displaying single lines of the image. The first line is displayed, then the second, the third, etc. As with interlaced technology, all this happens too fast for the human eye to detect the separate changes, so everything appears to happen all at once.

Both of these types of video display can be used for HD viewing. Progressive video resolution is most commonly displayed at 720p and interlaced at 1080i. So far, none of the current broadcasters in the United States are using 1080p. The reason 1080p isn't

commonly used is due to the high volume of information required to send a progressive signal of that resolution. Because only half of the image is being sent at a time, 1080i is actually only broadcasting at 540 lines per 1/60 of a second. So, although 1080i technically has a higher resolution, 720p has better image quality. Most of your standard HDTV programming is done in 1080i (mostly due to the smaller volume of information), but most sports are broadcast in 720p, which deals with fast motion better. Neither is really better than the other, as each has its own specific strengths and weaknesses.

Frame rate

As mentioned earlier, video capture is simply recording still photographs and linking them together, playing them back one after another in sequence. This allows the still images to appear as if they're moving. An important part of video capture is *frame rate*. This is the rate at which the still images are recorded and is almost always expressed in terms of *frames* per second or, more commonly, fps. Most video cameras capture video at 30 or 60 fps. 30 fps is generally considered the best rate for smooth-looking video that doesn't appear jerky. While 30 fps is the standard, many videographers prefer to use a camera that shoots at 24 fps or cameras that use what's known as *pulldown* to convert 30 fps to 24 fps.

Why all this fuss over a few more or less fps? Well, 24 fps is the standard that was set by filmmakers in the early years of moviemaking. Shooting at 24 fps gives videos a quality that's similar to cinema, and a lot of filmmakers find this aesthetic more pleasing than the standard 30 fps of video capture.

The Nikon D90 shoots video at 24 fps, giving you a cinematic feel from the start. Because the D90 uses a progressive image

sensor (all dSLR cameras do), you don't have the 24 fps pulldown that can cause artifacts in your movies.

Shutter

When shooting video with your D90, the camera isn't using the mechanical shutter that's used when making still exposures. The Video mode uses what's known as an *electronic shutter*. This electronic shutter isn't an actual physical shutter but is a feature of the sensor that tells the sensor when to activate to become sensitive to the photons of light striking it. When you press the Live View (Lv) button, the camera flips up the reflex mirror and the mechanical shutter opens, exposing the sensor to light. If the sensor was continuously exposed to light, it would become overexposed very quickly (depending on the available light). To allow Live View to operate by providing a live feed of properly exposed images, the sensor must be turned on and off very rapidly.

What's more, there are two ways for this electronic shutter to work: global or rolling. Typically, on digital video cameras with a CCD sensor, you find a global shutter. This means that the sensor is exposed all at once, similar to the way the sensor would be exposed by using the mechanical shutter. As you know, the D90 has a CMOS sensor. These types of sensors aren't normally equipped with global shutters but use a rolling shutter. For the same reason why CMOS sensors are great energy-saving sensors, the rolling shutter is used. A global shutter could be used but would require more transistors, resulting in a more expensive sensor, not to mention higher noise.

A rolling shutter operates by exposing each row of pixels progressively (similar to HDTV reception discussed earlier) from the top to

bottom. In effect, it rolls the exposure down the sensor row by row. Unfortunately, this rolling shutter has a few unwanted artifacts that are inherent in its operation. These artifacts are usually most noticeable when the camera is making quick panning movements or the subject is moving from one side of the frame to the other. There are three types of artifacts common to the rolling shutter:

✦ **Skew.** This is the most common artifact. Skew causes objects in the video to appear as if they're leaning (or *skewed*). This artifact only appears when the camera is quickly panned. This artifact is caused by the image being progressively scanned. As just discussed, the rolling shutter exposes each single frame from the top down. When the camera is moved sideways while the frame is being exposed, the top of the subject is exposed on one side of the frame, and the bottom of the subject is on the other side of the frame.

✦ **Jello.** This video problem is closely related to skew and occurs when the camera is panned quickly back and forth. First, the video skews to one side and then the other, causing it to look like it's made of Jello. It looks as if the subject is wobbly. This is the most common problem you will encounter when shooting video with the D90. Unfortunately, there's not much you can do about this problem. It's a symptom of the rolling shutter. Using a tripod can help to minimize it a bit.

✦ **Partial exposure.** This is caused by a brief flash of light, typically from a camera flash. As the shutter rolls down the frame, it's exposing for the ambient light. The brief flash duration causes part of the frame

7.1 An example of video skew. The top image shows a still shot taken from video while the camera was static. The bottom image shows a still shot taken when the camera was panning.

to be overexposed. This isn't a major problem, and you can expect to run across this problem at weddings or events where people are taking pictures with flash.

 Older fluorescent lights with low-frequency ballasts can cause video with a rolling shutter to flicker.

Setting up D-Movie

Using D-Movie is quite simple. Simply press the Live View (Lv) button on the back of the camera to activate Live View and then press OK to start recording. It's as simple as that. There are some important things to consider before you start recording:

✦ **Quality.** The Quality setting determines what size your videos are. Sizes and their uses are covered earlier in this chapter. You set the Quality by going to the Shooting menu, selecting the Movie settings option, select Quality, and then press OK. You have three choices: 1280 × 720 (16:9), 640 × 424 (3:2), or 320 × 216 (3:2).

✦ **Sound.** This option is also found in the Movie settings option. You can either record sound using the D90's built-in microphone or you can turn the sound recording off.

✦ **Picture Control.** Just like your still images, the D90 applies Picture Control settings to your movie. You can also create and use Custom Picture Controls that fit your specific application. For example, I created a Custom Picture Control called Raging Bull that uses the Monochrome Picture Control with added contrast and the yellow filter option. This gives me a black-and-white scene that's reminiscent of the Martin Scorsese film of the same name. Before you start recording your video, decide which Picture Control you want to use for your movie.

For more on Picture Controls, see Chapter 2. For more on the D90 menus, see Chapter 3.

Adding too much sharpening to a Picture Control can cause haloing in your movies.

✦ **Shooting mode.** Selecting a Shooting mode is one of the most important parts of D-Movie. This is how you select your lens aperture. The mode you select determines the aperture that you shoot with for the entire clip. This is important

for controlling depth of field. The Scene modes apply the same settings that they use for still photography, but they can be unpredictable. Because the shutter speed is controlled electronically, Shutter Priority mode isn't very useful either. Using Programmed Auto is just taking a major risk on your aperture setting. Basically, that leaves you with the two most useful Shooting modes: Aperture Priority and Manual. For all intents and purposes, these both operate exactly the same. Remember that the shutter is electronic and is completely controlled by the camera. The shutter speed that's displayed on the screen is for shooting stills in Live View and has no impact upon the movie. Basically, I recommend setting the camera to Manual mode when setting out to record video.

Once Live View is activated, the aperture setting is locked in and can't be changed until you exit Live View mode. You can rotate the Sub-command dial, and the aperture number changes on the Shooting Info Display on the LCD, but no changes to the aperture are actually made.

Note *When in Live View mode with a CPU lens, the aperture actually only stops down to about a minimum of f/8 to allow enough light for Live View to work.*

Recording

After you figure out all your settings and before you press the OK button to start recording, you want to get your shot in focus. You can do this by pressing the Shutter Release button halfway, as you normally would. When the AF point on the LCD is

green, you're focused and ready to go. Press the OK button to start filming. Once the camera is rolling, you have to do all the focusing manually. The camera pretty much runs things for you from then on. The only way to adjust the exposure while recording is to manually apply exposure compensation by pressing the Exposure Compensation button and then rotating the Main Command dial. You can dial in ±5 stops. The camera chooses the ISO settings for you. The rest is up to your imagination. You can make short clips of your kids running around that you can later e-mail to the grandparents or you can get creative with some software and produce a full-length feature film. You're the director.

> **Tip** *When applying exposure compensation or making any sort of change that requires you to rotate a command dial or even adjusting the aperture ring on a MF lens, remember that the microphone is on the camera and that noise is picked up. It may not sound loud at the time, but it will be extremely loud in your footage. The best bet is to get your settings right before filming starts to avoid this or turn the sound recording off.*

Tricks, Tips, and Workarounds

You probably bought a dSLR because you wanted flexibility and control that you just can't get with a compact digital camera. Now, you have a D90, but the Video mode wants to operate like a point-and-shoot camera. Is there a way to completely and manually control the D90's settings when using the D-Movie mode? The short answer is no, but there are some ways to work around the camera settings by tricking it into choosing the settings that you prefer:

✦ **AE-L.** You've probably noticed that as you're filming, the video goes from light to dark as the lighting changes depending on what the scene is. If you're filming in a high-contrast area, this can make your video look bad. The constant dimming and brightening of the video can be quite distracting. To stop your camera exposure from fluctuating, simply press the AE-L button. The best way to do this is to go to CSM f4, Assign AE-L/AF-L button, and set it to AE Lock (hold). This allows you to lock the exposure without holding the AE-L/AF-L button down. You'll want to find a relatively neutral area in the scene and meter it by pointing the camera at it. Press the AE-L button to lock the exposure and record the video without fluctuations in your exposure. Be sure to press the AE-L button again to unlock the exposure meter. Even if you exit Live View mode, the exposure remains locked until the camera is turned off or goes to sleep.

✦ **Go full Manual.** In my opinion, to take full advantage of the D90 video capabilities, you have to do something counterintuitive. Forsake all the newer lenses and get a non-CPU manual-focus lens. With a fully manual lens, you can adjust the aperture at anytime during recording as well as close down to the actual minimum f-stop of the lens to maximize depth of field. The lens I use for most of my D90 video work is a Nikkor-S 50mm f/1.4 AI from the 1960s. This lens is ultra-sharp and can give you an insanely shallow depth of field when wide open or a deep focus when stopped down. You can find these lenses used for about $100 to $150. This lens is also an amazing

portrait lens. Another good thing about using the older MF lenses for recording video is that these older lenses usually have a depth of field scale that can help you judge the focus range.

7.2 Nikkor-S 50mm f/1.4 AI

✦ **ISO.** Unfortunately, there are no selectable ISO settings when recording video. This makes it difficult to control the amount of noise that your videos show. Before I get started with this trick, I need to point out that this isn't exact science. This is just an estimation of the settings that the camera may or may not use. When shooting video, the camera doesn't actually use an ISO setting but adjusts the signal gain. This is very similar to adjusting the ISO sensitivity. Looking at the footage, it's apparent that in low light, the video appears noisier than video shot in bright light. This trick helps you to set the gain where you want it:

1. **Select your camera settings.** Set the Quality, Sound, and Picture Control if needed. Set the camera to Aperture Priority or Manual. If you're using an MF, non-CPU lens, set the Shooting mode to Manual.

2. **Set the scene.** Find the area or scene you're going to film. You need a constant light source, and the scene shouldn't have too much contrast or your exposures will be incorrect.

3. **Set the aperture.** This step determines the ISO range the camera chooses. See Table 7.1 for settings.

4. **Meter the scene.** This is important. Focus on an 18 percent gray card or a neutral object to take a meter reading. Don't do this step in Live View. Focus on the card or neutral object as if you were taking a picture normally.

5. **Lock the exposure.** Use the AE-L/AF-L button to lock the exposure. The button should be set to AE Lock (hold). You can set this in CSM f4.

6. **Activate Live View.** Press the Live View (Lv) button. You're now ready to record your video by using the ISO range that you specified by the aperture setting.

Table 7.1 gives an approximation of the ISO sensitivity and noise levels in the video as they would relate to noise in still images.

Table 7.1 Aperture and Approximate ISO Sensitivity in D-Movie	
Aperture	*ISO Range*
f/1.4 – 2.8	ISO 200–320
f/4 – 5.6	ISO 400–640
f/8 – 11	ISO 800–1200
f/16 – 32	ISO 1600+

Video-Editing Software

Because this is primarily a camera guide, I'm not going to go into all the different video-editing techniques. That is a subject for another book. Editing allows you to combine different footage to make your video into a story or you can simply cut out any extraneous footage. There are probably those of you who will jump right in and make elaborate videos, and some of you may just film short clips to send to friends over e-mail. There are many types of software that you can use to edit the D90 video footage that you record. This software ranges in price from $1300 for Apple Final Cut Studio 2 to free software, such as Avid Free DV. Personally, I use iMovie from Apple. It's fairly easy to learn. The reason I use this software is simply because it was already installed on my Mac when I bought it. There are many options, including the following:

✦ **Apple Final Cut Pro 6.** This program comes bundled inside of the Final Cut Studio 2 suite. This is the top-of-the-line video-editing software that professional videographers use to edit their footage. It supports almost all video formats, including the AVI files of the D90. This is a very intensive product that can do almost anything you can imagine.

✦ **Adobe Premiere CS4.** This is another high-end video-editing software package. With this software, you can edit multiple videos, add audio tracks, and apply color correction, among other options.

✦ **Adobe Premiere Elements.** This is a stripped-down, user-friendly version of Premiere meant for use by amateur filmmakers like you and me. This is supposed to be the best nonprofessional video-editing software available. You can add audio and narration, text, and titles. You can add special effects, transitions, and even picture-in-picture. Premiere Elements is very affordable at right around $120.

✦ **iMovie.** Mac users get this application bundled with the operating software. It's a very easy-to-use application that allows you to make cuts and paste together clips, add music from your iTunes, add special effects, make simple color corrections, and add titles and text. This is a Mac-only application.

✦ **Windows Movie Maker.** This is the PC version of Mac's iMovie. This program is rated fairly good by PC users and does most of the same things as iMovie.

✦ **Sony Vegas.** This video-editing software comes in a few different versions for users of all different levels. The top-of-the-line Vegas Pro is comparable to Final Cut or Premiere. The entry-level version is Vegas Movie Studio, which allows you to do all the standard editing. To take advantage of the D90 HD video capabilities, you'll need to get the step-up Vegas Movie Studio Platinum version, which allows you to export HD video.

Advanced Shooting Techniques

CHAPTER 8

This chapter covers some of the most common types of photography most people are likely to attempt. In the different sections, I offer different tips and techniques that I have learned both in college and in the field. Different photographers often have different techniques that work for them, so you may find that my methods may not be the easiest for you. One of the great things about photography — and digital photography in particular — is that fact that it's very easy to experiment. Use these techniques as building blocks to developing your own style and techniques.

Action and Sports Photography

Action and sports photography is just what it sounds like, although it doesn't necessarily mean your subject is engaging in some type of sport. It can be any activity that involves fast movement, such as your child riding his bike down the street or running across the beach. Shooting any type of action can be tricky to even seasoned pros because you need to be sure to shoot at a fast enough shutter speed to freeze the movement of your subject.

Although the D90's high frame rate of 4.5 fps comes in handy when shooting action and sports, often the best approach with shooting action is to get familiar with the movement of the subject, learn when the action is at its peak, and then take your shot rather than just firing off a bunch of frames in hopes that one comes out.

You can employ a number of techniques to decrease motion blur on your subject. The most commonly used technique is panning. *Panning* is following the moving subject with your camera lens. With this method, it's as if the subject isn't moving at all because your camera is moving with it. When done correctly, the subject should be in sharp focus while the motion blurs the background. This effect is great for showing the illusion of motion in a still photograph. While panning, you can sometimes use a slower shutter speed to exaggerate the effect of the background blur. Panning can be a very difficult technique to master and requires a lot of practice.

Tip

Consider using a monopod when trying the panning technique. Monopods help keep the camera steady while allowing the photographer more freedom of movement than a tripod.

Using flash for action/sports photography isn't always necessary or advisable. Sometimes, you're so far away from the action your flash won't be effective or you may be in a situation where flash isn't allowed. In these cases, just make sure you have a fast enough shutter speed to freeze the motion. You can either use a wider aperture or higher ISO setting to be sure you get the proper shutter speed.

8.1 I used Shutter Priority mode to be sure to have a shutter speed of 1/160 second that was slow enough to catch motion blur but fast enough to freeze the action. I used a slight pan to add some motion blur to the background.

Inspiration

When looking for action scenes to shoot, I tend to gravitate toward the more exciting and edgy events. You may find you favor more low-key action events, but regardless of what appeals to you, just keep your eyes open. Nearly everywhere you look, there's some kind of action taking place.

Go to the local parks and sporting events. Almost every weekend, there's a soccer tournament at the school across the street from my studio. I often go there just to practice getting action shots. Check your local newspapers for sporting events. Often, the local skateboard shops and bike shops have contests. I try to take pictures of people having fun doing what they love to do.

8.2 Using an extremely fast shutter speed of 1/4000 second to freeze the action, counteracts against camera shake when shooting with a 200mm lens with a 2X teleconverter.

Action and sports photography practice

8.3 BMX at the 9th Street dirt jumps in Austin, Texas

Table 8.1	
Taking Action and Sports Pictures	
Setup	**Practice Picture:** Figure 8.3 was taken at the 9th Street dirt jumps in downtown Austin, Texas. Being a BMX rider myself, I like to shoot my friends pulling tricks and having fun.
	On Your Own: Skate parks are a good place to find both BMX riders and skateboarders doing their thing. It's generally a good idea to ask permission before you start shooting.

Lighting	**Practice Picture:** I used an SB-900 Speedlight to illuminate the rider (Andy from Wisconsin), making him pop to separate him from the busy background. The Speedlight was off-camera (camera right) and triggered by the D90 built-in flash set to Commander mode.
	On Your Own: When shooting sports with a busy background, it's often helpful to use some flash. However, the existing light often is enough.
Lens	**Practice Picture:** I used a Nikkor 18–105mm kit lens zoomed to 18mm.
	On Your Own: Depending on how close you can get to your subject, you may want to use a telephoto lens in order to get closer to the action. If you can get right up to the action, using a wide-angle lens can also work.
Camera Settings	**Practice Picture:** My camera was set to Shutter Priority mode. I set the Flash mode to Slow Sync to create what's called a *shutter drag*. This means using a slow shutter speed when using flash, which gives the image a bit of blur while keeping the subject sharp. This technique can add an interesting dynamic to your image.
	On Your Own: When photographing action, setting your shutter speed is the key to capturing the image properly. Whether you want to stop motion by using a fast shutter speed or blur the background by using a slower shutter speed and panning with your subject, you want to be able to control the shutter speed in Shutter Priority mode.
Exposure	**Practice Picture:** 1/40 second at f/4.5, ISO 400. In this case, I used a slower shutter speed for a dramatic effect.
	On Your Own: Often using the fastest shutter speed you can to stop motion is best. If the light is dim, you may need to bump up your ISO in order to achieve a fast shutter speed.
Accessories	Using a monopod can help keep the camera steady while panning with the subjects.

Action and sports photography tips

✦ **Practice panning.** Panning can be a difficult technique to master, but practice makes perfect. The more time you spend practicing this, the better you (and your images) get.

✦ **Pay attention to your surroundings.** Often, when concentrating on getting *the* shot, you can forget that there are things going on around you. When photographing sporting events, be sure to remember that there may be balls flying around or athletes on the move. It's better to miss a shot than to get hurt in the process of trying to get the shot.

✦ **Know the sport.** In order to effectively capture a definitive shot, you need to be familiar with the sport, its rules, and the ebb and flow of the action. Being able to predict where the action will peak will get you better shots than hoping that you will luck into a shot.

Architectural Photography

Buildings and structures surround us, and many architects pour their hearts and souls into designing buildings that are interesting to the casual observer. This may be why architectural photography is so popular.

Despite the fact that buildings are such familiar, everyday sights, photographing them can be technically challenging and difficult — especially when you take pictures of large or extremely tall buildings. A number of different problems can arise, the main one being *perspective distortion*. Perspective distortion is when the closest part of the subject appears irregularly large and the farthest part of the subject appears abnormally small. Think about standing at the bottom of a skyscraper and looking straight up to the top.

Professional architectural photographers use view cameras with swings and tilts that allow them to adjust the film plane and lens to correct for the distortion. Nikon has three special-purpose lenses that are designed to deal with perspective control in a similar fashion to the view cameras by allowing the lens to shift and tilt. The lens most useful for architectural photography is the wide-angle PC-E Nikkor 24mm f/3.5D.

Some things to look for when attempting any type of architectural photography include:

✦ **Composition.** This is a very important part of architectural photography. The way you compose your images can cause the subject to be static and boring or dynamic and bold. Choose an interesting viewpoint. For example, shoot up at the building or, if you can, shoot down from another building across the street. Use the viewfinder grid display (CSM d2) to help with composing.

✦ **Repeating patterns.** One thing that can make for an interesting architectural shot is patterns that repeat themselves and appear to go on infinitely. Remember that architectural photography can sometimes be abstract; you don't necessarily need to include the structure.

✦ **Leading lines.** This is a fairly easy concept to take advantage of when doing architectural photography since most structures contain some elements of lines, be it support beams, walls, floors, or ceilings. Use leading lines to draw the eye through the image. Figure 8.4 is a good example of using leading lines in architectural photography.

Inspiration

Because buildings and architecture are all around us, there are limitless possibilities to shoot. Try looking for buildings with architectural features that you may enjoy, such as art deco, gothic, or modern. The building doesn't necessarily have to be in tip-top condition. Sometimes, photographing a building in a state of disrepair can give you an excellent image.

8.4 This is a photograph of the Palmer Events Center in Austin, Texas. Architectural photography doesn't necessarily mean photographing the entire building. Sometimes, isolating one part of the building can make a dynamic image. This also illustrates use of leading lines and repeating patterns.

Copyright and Permission

In most places, you don't need permission to photograph a building as long as it's a place to which the public has free access. If you're on private property, you should definitely request permission to photograph before you start. If you're inside a building, it's also generally a good idea to ask permission before photographing.

Due to recent tightening of security policies, a lot of photographers have been approached by security and/or police, so it's a good idea to check the local laws in the city where you're photographing to know what rights you have as a photographer.

For the most part, copyright laws allow photography of any building on permanent public display. Although the architect of the structure may own the copyright of the design, it usually doesn't carry over to photographs of the building. There are exceptions to this, so, again, check local laws, especially if you plan on selling your images.

Architectural photography practice

8.5 Texas State Capitol

Table 8.2
Taking Architectural Pictures

Setup	**Practice Picture:** For Figure 8.5, I photographed the Texas State Capitol, an Italian Renaissance Revival building built between 1882–1888 in downtown Austin, Texas.
	On Your Own: Buildings are literally everywhere, but that doesn't mean you have to photograph a huge skyscraper or giant structure. Even a small bungalow can make an interesting architectural photograph.
Lighting	**Practice Picture:** Because this picture was shot at night, the only lighting came from the lights on the building and the surrounding area. I chose to photograph this building at twilight because it faces north–south, and it's backlit most of the day on the north side where this photo was taken. Twilight is also a good time to get a saturated blue sky while having just enough light to capture your subject.

On Your Own: Night is a fantastic time to take architectural shots. Architects and landscape designers often use lighting to create an entirely different look to a building at night. When shooting during the day, be sure the sun is facing the side of the building you're photographing to ensure a good exposure. Shooting a backlit building can cause the sky to blow out when the building is properly exposed, or when the sky is properly exposed, the building appears too dark.

Lens

Practice Picture: For this photo, I used a Nikon 14mm f/2.8 prime lens. Because I was a good distance from the structure, I was able to avoid any perspective distortion on the building. I filled the foreground of the image with the underground rotunda to add some interest and to provide some leading lines pointing upward, drawing the eye to the building.

On Your Own: Generally, a wide-angle lens setting is used for architectural shots. When you can put some distance between you and the structure, you can zoom in a bit. A good wide-to-short telephoto lens like the Nikkor 17–55mm is a good choice to cover most architectural shots. If you plan on doing a lot of architectural shots, you may want to invest in a good ultrawide lens.

Camera Settings

Practice Picture: My camera was set to Aperture Priority with Matrix metering. I chose these settings because I knew I wanted a small aperture to increase my depth of field and to ensure a sharp image. I set the white balance to Auto, but I shot in RAW to be sure that I could adjust the WB settings if I needed to. I manually bracketed the shot 9 frames at 1/2-stop intervals to be sure that I got an exposure that was perfect, getting enough exposure for the shadow areas while not blowing out the highlight area where the sun was setting.

On Your Own: Oftentimes, when shooting static objects, such as buildings, you can set up your camera and use the built-in light meter to determine your settings and adjust them as you see fit. Be sure to take into consideration the light source, especially when photographing at night and adjust your WB as necessary.

Exposure

Practice Picture: ISO 200 at f/11 for 2 seconds.

On Your Own: Achieving a good depth of field is important in architectural photography, so using a rather small aperture is usually advisable. Keep your ISO low for the best image quality.

Accessories

I used a tripod to get this low-light evening shot. Even in fairly bright sunlight, using a small aperture can sometimes make for slow shutter speeds. A tripod keeps your images sharp. Using a tripod with a level in it can also help keep your horizons straight.

Architectural photography tips

✦ **Shoot from a distance.** When taking pictures of tall buildings and skyscrapers, try not to take your photograph too close to the base of the building. The perspective distortion can make the structure look abnormal.

✦ **Avoid backlighting.** If the building you're photographing is backlit, you'll lose detail in the structure and the background will appear too bright. Try to take your picture when the sun is shining on the part of the building you want to photograph.

✦ **Be aware of lens distortion.** Different lenses can introduce distortion. Wide-angle lenses often suffer from barrel distortion that can cause the straight lines of the structure that are near the edge of the frame to appear bowed out. Either avoid placing straight lines near the edge of the frame or be sure to correct for the distortion in post-processing.

Concert Photography

Concert photography can be a particularly difficult endeavor, but it's also extremely rewarding, especially if you're a music fan. Getting that quintessential shot of your favorite performer is the reason why many photographers do this type of photography. Unfortunately, to get the shot you want sometimes requires you to fight a crowd and risk getting drinks spilled on your camera. If you're like me, however, and enjoy getting into the fray, this is great fun.

> **Tip** *I strongly suggest that you invest in good earplugs if you plan to do much concert photography.*

Some photographers are staunchly against using flash at concerts, preferring to shoot with the available light. I like to use some flash at times, as I find that the stage lights can oversaturate the performer, resulting in loss of detail.

> **Note** *Some venues or performers don't allow flash photography at all. In this situation, just try to use the lowest ISO you can to keep noise at a minimum while still maintaining a fast enough shutter speed.*

8.6 Professional lighting can add depth and drama to concert shots.

For the most part, with concert photography, the lighting comes from the stage lights. If you're shooting at a larger venue or concert, the stage lighting is usually wonderful, and you can get amazing images by using low ISO

settings. The stage lighting engineers are paid to make the performers look good, and you're essentially piggybacking off their expertise. Of course, you are in charge of the composition. Sometimes, when photographing in places with less-than-perfect lighting, I crank up the ISO to 3200. With some previous cameras I've owned, this would have rendered the shots barely useable but not with the D90. At ISO 3200, images from the D90 are perfectly useable and amazingly low in noise. For these situations, I've started using the Auto ISO feature. I know that sometimes I need to set the ISO at 3200 for some shots but not all of them. I don't want to waste my time switching ISO settings all through the show, so I set the ISO sensitivity auto control to On/Maximum sensitivity 3200/Minimum shutter speed 1/250. You can set the Auto ISO in the Shooting menu under the ISO sensitivity settings option. Using a minimum shutter speed of 1/250 allows me to freeze the action of the band members so that they aren't blurry.

For lighting situations such as this, I use Spot metering to set the exposure for the performer because I'm not at all concerned about the background. As a matter of fact, it's preferable to lose detail in the background because it brings out the subject of the image much better.

Inspiration

A good way to get started with concert photography is to find out when a favorite band or performer is playing and bring your camera. Smaller clubs are usually better places to take good close-up photos simply because you are more likely to have closer access to the performers. Most local bands, performers, and regional touring acts don't mind having their photos taken. You can also offer to e-mail the performers some images to use on their Web sites. This is beneficial for both them and you, as lots of people will see your photos.

8.7 HR of the Bad Brains. I often like to shoot my concert images by using the black-and-white monochrome Picture Control. I chose to use this setting to emulate the early concert photography work of Glen E. Friedman. Friedman covered the burgeoning skateboarding and punk rock scene in the late 1970s and early 1980s. He shot mainly in black and white, capturing the frenetic energy and reckless abandon of the musicians of that era.

Concert photography practice

8.8 The Humpers at Red 7 in Austin, Texas

Table 8.3
Taking Concert Pictures

Setup	**Practice Picture:** For Figure 8.8, I was photographing the California punk band The Humpers playing at a local Austin club, Red 7.
	On Your Own: Smaller venues can offer the most intimate or in-your-face photo ops. Often, you can get closer to the stage and the band, giving your images an up-close and personal feel.
Lighting	**Practice Picture:** Because the stage lighting at the venue was dim at best, I used an SB-600 Speedlight to provide most of the lighting for the exposure. I used the built-in flash to wirelessly trigger the SB-600 while I held it in my hand over my head, directing the light onto the singer who was leaning out into the crowd. The built-in flash was set to Commander mode, while the SB-600, set to Group A, was fired in TTL mode with an FEC of −2 EV Rear-Curtain Sync.
	On Your Own: Concert lighting can be very tricky depending on the venue. Some venues have bright stage lights, while some can be very dim. Make a few test shots to determine if the lighting is bright enough. Sometimes, I like to mix it up, taking shots with and without flash.

Lens	**Practice Picture:** Nikon 17–55mm f/2.8 zoomed to 17mm. This is my go-to lens for almost everything when using a DX camera. It works well for smaller venues, allowing you a wide-angle view for close-up shots as well as a small amount of zoom for when you're farther away. The fast, constant f/2.8 aperture allows you to work with available light even when the lighting is quite dim.
	On Your Own: For small venues, a good wide-angle to medium tele-photo works well. For larger venues or concerts where you're farther away from the stage, you may need to use a longer telephoto lens, but your flash will be of little use. When photographing large concert events, I bring both a 17–55mm and an 80–200mm lens with a 2X teleconverter just in case I need some extra reach.
Camera Settings	**Practice Picture:** I used Aperture Priority mode to ensure that my lens was wide open to capture enough light.
	On Your Own: Aperture Priority mode is a good place to start to be sure that you have as much light reaching the sensor as possible. Using Spot metering is often a good choice, especially if the performers are on a dark stage with spotlights shining on them. This prevents the camera from try-ing to expose for the mostly dark areas behind the performers, which can cause your shutter speed to be too slow.
Exposure	**Practice Picture:** ISO 400 at f/2.8 for 1/8 second.
	On Your Own: Because the lighting is often dark at concert events, more often than not, you'll have to crank up the ISO. Before using the D90, I tried not to go up past 800 unless absolutely necessary. Now even at 3200, the images are pretty good. When shooting above 3200, choosing the Black & White option can help your images because much of the noise is chrominance noise (color). Most of the time, you'll find yourself shooting wide-open apertures. Using a fast shutter speed is recom-mended, although when using flash, you can bring the shutter speed down a bit, allowing the bright flash to freeze your subject while allowing some of the ambient light to fill in the shadow areas.
Accessories	An off-shoe camera cord such as Nikon's SC-27 can help to get your flash off your camera. This accessory gives you full TTL control of your flash and doesn't have the shutter lag that you can sometimes get when using the built-in flash as a commander. I often use the SC-27 when photographing bands so as to not have the built-in flash pop up. When the flash is popped up and you're in a pit full of rowdy people, you can risk breaking the built-in flash off.

Concert photography tips

✦ **Experiment.** Don't be afraid to try different settings and long exposures. Slow Sync flash enables you to capture much of the ambient light while freezing the subject with the short, bright flash.

✦ **Call the venue before you go.** Be sure to call the venue to ensure that you're allowed to bring your camera in.

✦ **Bring earplugs.** Protect your hearing. After spending countless hours in clubs without hearing protection, my hearing is less than perfect. You don't want to lose your hearing. Trust me.

✦ **Take your Speedlight off your camera.** If you're using one of the Nikon accessory flashes, such as the SB-800 or SB-600, invest in an off-camera through-the-lens (TTL) hot-shoe sync cord, such as the Nikon SC-29 TTL cord. You can also try using the built-in flash as a commander and take advantage of the wireless flash capabilities of your D90. When you're down in the crowd, your Speedlight is very vulnerable. The shoe mount isn't the sturdiest part of the flash. Not only is using the Speedlight off-camera safer, but you also gain more control of the light direction by holding it in your hand. This reinforces my suggestion to experiment — move the Speedlight around, hold it high, hold it low, or bounce it. This is digital, and it doesn't cost a thing to experiment.

Landscape and Nature Photography

With landscape photography, the intent is to represent a specific scene from a certain viewpoint. For the most part, animals and people aren't included in the composition, so the focus is solely on the view.

Landscape photography can incorporate any type of environment — desert scenes, mountains, lakes, forests, skylines, or just about any terrain. You can take landscape photos just about anywhere, and one good thing about them is that you can return to the same spot, even as little as a couple of hours later, and the scene will look different according to the position of the sun and the quality of the

light. You can also return to the same scene months later and find a completely different scene due to the change in seasons.

There are three distinct styles of landscape photography:

✦ **Representational.** This is a straight landscape: the What You See Is What You Get approach. This is not to say that this is a simple snapshot; it requires great attention to details, such as composition, lighting, and weather.

✦ **Impressionistic.** With this type of landscape photo, the image looks less real due to filters or special photographic techniques, such as long exposures. These techniques can give the image a mysterious or otherworldly quality.

8.9 In this shot, the reddish orange of the rocks contrasts nicely with the blue sky and water. Keep an eye for complementary colors when scouting locations for landscape photos.

✦ **Abstract.** With this type of land-scape photo, the image may or may not resemble the actual subject. The compositional elements of shape and form are more important than an actual representation of the scene.

One of the most important parts of capturing a good landscape image is knowing about *quality of light*. Simply defined, quality of light is the way the light interacts with the subject. There are many different terms to define the various qualities of light, such as soft or diffused light, hard light, etc., but

Table 8.4 *(continued)*

Lens	**Practice Picture:** Nikon 10.5mm f/2.8 fisheye. When shooting landscapes with a fisheye lens, careful attention should be paid to distortion. I placed the horizon smack dab in the middle of the frame to avoid the distortion that happens near the edges of the frame with fisheye lenses. **On Your Own:** The rule of thumb when shooting landscapes is the wider, the better. More often than not, you want to catch a large area in your photograph, although using a telephoto lens can pull an unreachable scene up close for you.
Camera Settings	**Practice Picture:** My camera was set to Aperture Priority because I wanted to use a small aperture to ensure everything in both the background and foreground was in focus. I used Matrix metering and Active D-Lighting set to Auto so I would capture all the colors of the sky without blowing out the highlights. **On Your Own:** For landscapes, you want to be in control of the aperture to keep a deep focus, so Aperture Priority works great. When photographing directly into the sun, Spot metering is preferable; but when the lighting is more even, Matrix metering works great. Of course, Landscape mode works well. The Landscape Picture Control boosts the color of the greens and blues for richer colors.
Exposure	**Practice Picture:** ISO 200 at f/11 for 1/400 second. **On Your Own:** As usual, use a low ISO for the best image quality. Use smaller apertures to increase depth of field. But be careful: Shutter speeds get longer due to the smaller f-stops when the light is low.
Accessories	A tripod can be a great help when those shutter speeds get really long. Using a tripod with a level can help you keep your horizons level. Using the viewfinder grid display (CSM d2) can also help. Using the Live View feature can really make composing your images much easier when using a tripod.

Landscape photography tips

✦ **Bring a tripod.** When you photograph landscapes, especially early in the morning or at sunset, the exposure time may be quite long. A tripod can help keep your landscapes in sharp focus.

✦ **Scout out locations.** Keep your eyes open; even when you're driving around, you may see something interesting.

✦ **Be prepared.** If you're out hiking looking for landscape shots, don't forget to bring the essentials, such as water and a couple of snacks. It's also a good idea to be familiar with the area you're in or at the very least bring a map.

Macro Photography

Macro photography is easily my favorite type of photography. Sometimes, you can take the most mundane object and give it a completely different perspective just by moving in close. Ordinary objects can become alien landscapes. Insects take on a new personality when you can see the strange details of their faces, especially their multifaceted eyes.

Technically, macro photography can be difficult. The closer you get to an object, the less depth of field you get, and it can be difficult to maintain focus. When your lens is less than an inch from the face of a bug, just breathing in is sometimes enough to lose focus on the area that you want to capture (or scare the bug off). For this reason, you usually want to use the smallest aperture you can (depending on the lighting situation) and still maintain focus. I say "usually" because a shallow depth of field can also be very useful in bringing attention to a specific detail.

8.11 When taking this macro shot of a dragonfly, I used a small aperture to get as much of the dragonfly in focus as possible. ISO 2000 at f/10 for 1/1000 second.

Caution *When shooting extremely close-up, the lens or lens hood may obscure the light from the built-in flash, resulting in a dark area on the bottom of the images. Sometimes, removing the lens hood fixes the problem; other times, you may have to use an off-camera flash.*

One of the best things about macro photography is that you aren't limited to shooting in one type of location. You can do this type of photography indoors or out. Even on a rainy day, you can find something in your house to photograph. It can be a piece of fruit, a trinket, a coin, or even your dog's nose (if the dog sits still for you).

Macro photography requires special lenses or filters to allow you to get closer to your subject. Most lens manufacturers offer lenses that are designed specifically for this purpose. These macro lenses give you a reproduction ratio of 1:1, which means that the image projected onto the sensor is exactly the same size as the physical subject. Some other lenses that can be used to do macro photography are actually telephoto lenses. Although you can't actually get close to the subject with a telephoto, the extra zoom gives you a close-up perspective. Telephoto lenses usually have a reproduction ratio of 1:4, or one-quarter size.

There are alternatives to dedicated macro lenses. One of the cheaper routes is to use an *extension tube*. An extension tube attaches between the lens and the camera body and gives your lens a closer focusing distance, allowing you to reduce the distance between the lens and your subject. Extension tubes are widely available and easy to use. They make both autofocus tubes and those that require you to focus manually. A drawback to using extension tubes is that they effectively reduce the aperture of the lens they're attached to, causing you to lose a bit of light. Extension tubes come in various lengths, and some of them can be stacked or used in conjunction with each other.

Another inexpensive alternative to macro lenses are *close-up filters*. A close-up filter is like a magnifying glass for your lens. It screws onto the end of your lens and allows you to get closer to your subject. There are a variety of different magnifications, and they can be *stacked* or screwed together to increase the magnification even more.

As with any filter, there are cheap ones and more expensive ones. Using cheap close-up filters can reduce the sharpness of your images because the quality of the glass isn't quite as good as the glass of the lens elements. This reduction in sharpness becomes more obvious when stacking filters. Buying the more expensive filters is still cheaper than buying a macro lens, and the quality of your images will definitely be better.

Reversing rings are adapters that have a lens mount on one side and filter threads on the other. The filter threads are screwed into the front of a normal lens like a filter, and you attach the lens mount to the camera body. The lens is then mounted to the camera backward. This allows you to closely focus on your subject. One thing to be careful of when using reversing rings is damaging the rear element of your lens; special care should be taken when using one of these. Not all lenses work well with reversing rings. The best lenses to use are fixed focal-length lenses that have aperture rings for adjusting the f-stop. Zoom lenses simply don't work well nor do lenses that have no aperture control.

A very good alternative to expensive autofocus macro lenses is to find an older manual-focus macro lens. These lenses can be found for much less money than AF lenses. You can also check into lenses from other camera companies. I have a lens made for older Pentax screw-mount (M42) camera bodies. I found an adapter on eBay that allows you to attach M42 lenses to Nikon F-mount cameras. The lens and adapter together cost me less than $50. The lens allows me to get a 4:1 magnification, which is 4X life size. I use the lens when I want to get super-magnification.

Inspiration

My favorite subjects for macro photography are insects. I go to parks and wander around, keeping my eyes open for strange bugs. Parks are also a great place to take macro pictures of flowers. Although flowers are easily the most common subjects for macro photography enthusiasts, by no means are they the only subjects you can take pictures of. Many normal, everyday objects can become interesting when viewed up close.

8.12 This is a close-up shot of a bicycle chain taken with the Micro-Nikkor 105mm f/2.8G VR.

Macro photography practice

8.13 Rolleiflex MiniDigi camera

Table 8.5
Taking Macro Pictures

Setup	**Practice Picture:** Figure 8.13 is a picture of my Rolleiflex MiniDigi camera. Although when photographed using a macro lens this looks like a full-size camera, in reality the camera is less than 3 inches tall.
	On Your Own: You can find plenty of interesting macro subjects; just look around. It's a good idea to always have your macro lens or close-up filters in your camera bag because you never know when you may run across an interesting subject for a macro shot.

Lighting	**Practice Picture:** This was shot at my house on my kitchen table by using a piece of white mat board for an impromptu backdrop. I set up an SB-800 to the right of the subject. The flash head was tilted to 45 degrees, and the bounce card was pulled out to kick some of the light down.
	On Your Own: When the lighting is dim, it's sometimes necessary to use an external flash. Even in bright light, a flash can help give your subject a little more light to help you maintain a very small aperture. When photographing your subject at a very close distance, the lens can obscure the built-in flash, causing a dark area near the bottom of the frame. It's best to use off-camera flash or a use dedicated macro flash system, such as the Nikon R1.
Lens	**Practice Picture:** Micro-Nikkor 105mm f/2.8G VR. This is one of Nikon's best lenses. If you're a macro photography buff, you'll love this lens. It also doubles as an excellent portrait lens.
	On Your Own: A good macro lens is invaluable to get sharp images. Using close-up filters or extension tubes can also be a more affordable option.
Camera Settings	**Practice Picture:** I used Aperture Priority mode to get the precise depth of field that I required. I wanted the whole front of the camera to be in focus, letting the rest fade out of focus. I set the Picture Control to Monochrome (MC) and gave it a sepia tone to give the image a nostalgic feeling.
	On Your Own: Aperture Priority works best to ensure that you can get the depth of field you desire. Using Auto white balance usually yields good results.
Exposure	**Practice Picture:** ISO 200 at f/5.6 for 1/60 second.
	On Your Own: Your exposure may vary depending on the lighting situation. Using a small f-stop is recommended for maximum depth of field, although a wide aperture can draw attention to a specific feature by making it the only thing in focus.
Accessories	A tripod can be a good tool to have when photographing macro subjects because focusing close up to a subject tends to exaggerate camera shake and the extremely shallow depth of field makes it easy to drift in and out of focus just by the simple motion of breathing. Using an ML-L3 can also reduce blur cause by camera shake when pressing the Shutter Release button.

Macro photography tips

✦ **Use the self-timer.** When using a tripod, use the self-timer to make sure the camera isn't shaking from pressing the Shutter Release button.

✦ **Use a low ISO.** Because macro and close-up photography focuses on details, use a low ISO to get the best resolution.

✦ **Use a remote shutter release.** If using a tripod, using a remote shutter release can also help reduce blur from camera shake.

Night Photography

Taking photographs at night brings a whole different set of challenges that aren't present when you take pictures during the day. The exposures become significantly longer, making it difficult to handhold your camera and get sharp images. Your first instinct may be to use the flash to add light to the scene, but as soon as you do this, the image loses its nighttime charm. It ends up looking like a photograph taken with a flash in the dark. In other words, it looks like a snapshot.

When taking photos at night, you want to strive to capture the glowing lights and the delicate interplay between light and dark. The best way to achieve this is to use a tripod and a longer exposure. This allows you to capture the image, keeping your subjects in sharp focus even with the long exposures that are often necessary.

Flash can be used effectively at night for portraits. You don't necessarily want to use it as your main light. Ideally, you want a good balance of flash and ambient light. To get this effect, set your flash to the Slow Sync or the Rear-Curtain Sync setting. This allows longer exposures, so the ambient light is sufficiently recorded while the flash adds a bright pop to freeze the subject for sharp focus.

8.14 This shot of Lynn was taken using Slow Sync flash to balance the lighting between the subject and the background for a more natural-looking image.

Inspiration

When I look for scenes to photograph at night, I try to think of subjects that have a lot of color that can be accented by the long exposures. City skylines, downtown areas, and other places with lots of neon or other brightly colored lights are very good subjects for this type of photography.

Fireworks

One type of night photography that's fun and a bit challenging at the same time is photographing fireworks.

When photographing fireworks, I find that using the Bulb setting in Manual mode using an aperture of about f/8–11 at ISO 200–400 works the best. The Bulb setting opens the shutter when the button is pressed. The shutter remains open as long as the Shutter Release button remains pressed. When the Shutter button is released, the shutter closes. To access the Bulb mode, set the camera to Manual exposure (M) and then rotate the Main Command dial past the slowest shutter speed of 30 seconds.

The first thing you want to do is figure out where the fireworks are going to bloom. Set your camera on the tripod and aim it in the right direction. For the most part, you're going to need a wide-angle to short telephoto lens to be sure to get everything in the frame; unless you're very far away, you shouldn't need to zoom in too much. Manually focus on a couple of bursts before shooting to get the focus down. Once you're in focus, leave it and shoot. When the firework is launched, press the Shutter Release button and then hold it down until the firework explodes. When the bloom is over, release the Shutter Release button to close the shutter and end the exposure.

When using the Bulb mode, your best bet is to get some sort of remote shutter release. These gadgets plug into the accessory terminal of the D90. This allows you to release the shutter without jiggling the camera, which can cause motion blur in your images, especially when using long shutter speeds. Nikon offers the MC-DC2 remote cord or the inexpensive ML-L3 wireless remote.

This fireworks shot was taken at f/8 for approximately 1 second using the Bulb setting of the D90.

Night photography practice

8.15 Toy Joy, Austin, Texas

Table 8.6
Taking Night Pictures

Setup	**Practice Picture:** Figure 8.15 is a picture of Toy Joy, an eclectic toy store located near the University of Texas campus in Austin.
	On Your Own: Buildings with lots of lights and neon make great night shots. The lights at night are often brightly colored, and long exposures can make them super-saturated.
Lighting	**Practice Picture:** For this shot, lighting is ambient.
	On Your Own: For the most part, ambient lighting is all you need. If there are some details in the foreground you want to bring out, you can use a low-powered flash pop to paint some light into the scene.
Lens	**Practice Picture:** Sigma 12–24mm f/4–5.6.
	On Your Own: Any lens will do for night photography. It just depends on your subject matter. Sometimes, a lens with a wider aperture can give a little bit more light, which allows for a faster shutter in case it's necessary to handhold your camera.

Camera Settings	**Practice Picture:** To get this shot, I used Manual mode. Because there are many different light sources in this shot, I recorded the image in RAW mode so I could adjust the white balance manually in post-processing until I got the effect that I liked the most. The camera white balance was set to Auto. I used Live View mode to compose the image.
	On Your Own: When photographing a scene with multiple light sources, it's best to shoot to RAW so you can adjust the white balance in post-processing to suit your particular taste.
Exposure	**Practice Picture:** ISO 100 (L 1.0) at f/25 for 25 seconds. For this particular image, I chose a small aperture to make the points of light in the image to appear as stars. The diffraction of the light from the aperture diaphragm causes this effect. The smaller the aperture, the longer the points of the star. I also wanted a small aperture so I could get a long shutter speed to allow the cars that were driving by to become invisible, leaving only the streaks of their headlights and taillights.
	On Your Own: For night shots, long exposures are the norm. Extremely long exposures can sometimes bring unexpected results. These results may not always be desired, so open your f-stop to get a faster shutter speed if you need it.
Accessories	A tripod was absolutely necessary to achieve this shot. When photographing at night, you should always have a tripod with you. I used an ML-L3 to release the shutter wirelessly.

Night photography tips

✦ **Bring a tripod.** Without a tripod, the long exposure times will cause your photos to be blurry.

✦ **Try using flash in Slow Sync mode.** If using flash is an absolute must, try using Slow Sync mode to capture some of the ambient light in the background.

✦ **Use the self-timer.** Pressing the Shutter Release button when the camera is on the tripod often causes the camera to shake enough to blur your image. Using the self-timer gives the camera and tripod enough time to steady so your images come out sharp.

Pet Photography

Photographing pets is something every pet owner likes to do (I've got hundreds if not thousands of pictures of my dog on my hard drive). The most difficult aspect about pet photography is getting the animal to sit or stand still. Whether you're creating an animal portrait or just taking some snapshots of your pet playing, patience is a good trait to have.

If your pet is fairly calm and well-trained, using a studio-type setting is entirely possible. If you've trained your pet to sit and wait for a treat, it can be easy to snap a formal portrait. Some pets, such as snakes or rodents, may be more difficult to pose. In these types of situations, it's good to have someone on hand to help you out.

Some of my most popular pictures are the ones I have taken of my dog just doing her normal dog things: sitting and waiting for a treat, yawning, or jumping around. The best photos of pets often are those that capture their personality, and this isn't necessarily achieved by sitting them in front of studio lights.

Inspiration

Animals and pets are an inspiration in and of themselves. If you don't have a pet yourself, you likely have friends or relatives who have one they would be happy to let you photograph. Go to the park and find people playing with their dogs. Lots of people have pets, so it shouldn't be hard to find one.

8.16 I used a wide aperture to achieve a shallow depth of field to bring attention to the fuzzy paws of Migs the Japanese Chin. The lens was a Nikkor 17–55mm f/2.8.

Pet photography practice

8.17 Henrietta in the studio

Table 8.6
Taking Pet Pictures

Setup	**Practice Picture:** For Figure 8.17, I had my Boston terrier, Henrietta, at my studio, so I decided to do some portraits of her. As I was snapping the shot, she opened up with a big yawn.
	On Your Own: Although standard shots are great, odd or unusual angles often make the most interesting shots. Don't be afraid to get dirty!
Lighting	**Practice Picture:** For this shot, I used an SB-800 fired wirelessly from the D90 by using the built-in flash. The SB-800 was mounted on a stand and fired through a medium softbox to provide even and diffused lighting. The Speedlight was placed to the right of the camera. The built-in flash was set to Commander mode, with the SB-800 to TTL. There was a silver reflector camera left to bounce some light in to the left side to fill in the shadows evenly.
	On Your Own: It's not always necessary or convenient to use an elaborate lighting setup. Using natural light can be the best for shooting pets. It allows you to concentrate on the composition without worrying about your lighting setup.
Lens	**Practice Picture:** Nikkor 17–55mm f/2.8 zoomed to 40mm.
	On Your Own: A good wide-angle to medium zoom is invaluable for pet photography. This type of lens allows you the freedom to try many different compositions, from wide-angle shots to close-ups.
Camera Settings	**Practice Picture:** I chose Aperture Priority for this shot to try to throw the background out of focus a bit. I used Matrix metering for this shot.
	On Your Own: Programmed Auto can work fine when photographing pets. It frees you from worrying about the exposure and allows you to concentrate on dealing with the animal.
Exposure	**Practice Picture:** ISO 200 at f/2.8 for 1/60 second.
	On Your Own: Your exposures may vary depending on the setting that your subject is in. Using a wide aperture can help blur out distracting background details. A fast shutter speed can also help to keep your subject sharp in case of any movement.

Pet photography tips

✦ **Be patient.** Animals aren't always the best subjects; they can be unpredictable and uncooperative. Have patience and shoot plenty of pictures. You never know what you're going to get.

✦ **Get low.** Because we're used to looking down at most animals, we tend to shoot down at them. Try getting down low and shooting from the animal's perspective. This can make your picture much more interesting.

✦ **Bring some treats.** Sometimes, animals can be coaxed to do things with a little bribe.

✦ **Use Red-Eye Reduction.** If you're going to use the flash, using Red-Eye Reduction is a must, although sometimes it doesn't completely remove the glare.

Portrait Photography

Portrait photography can be one of the easiest or one of the most challenging types of photography. Almost anyone with a camera can do it, yet it can be a complicated endeavor. Sometimes, simply pointing a camera at someone and snapping a picture can create an interesting portrait; other times, elaborate lighting setups may be needed to create a mood or to add drama to your subject.

A *portrait*, simply stated, is the likeness of a person — usually the subject's face — whether it's a drawing, a painting, or a photograph. A good portrait should go further than that. It should go beyond simply showing your subject's likeness and delve a bit deeper, hopefully revealing some of your subject's character or emotion.

You have lots of things to think about when you set out to do a portrait. The first thing to ponder (after you find your subject, of course) is the setting. The setting is the background and surroundings — the place where you shoot the photograph. You need to decide what kind of mood you want to evoke. For example, if you want to create a somber mood with a serious model, you may want to try a dark background. For something more festive, you may need a background with a bright color or multiple colors. Your subject may also have some ideas about how he or she wants the image to turn out. Keep an open mind and be ready to try some other ideas that you may not have considered.

There are many ways to evoke a certain mood or ambience in a portrait image. Lighting and background are the principal ways to achieve an effect, but there are other methods. Shooting the image in black and white can give your portrait an evocative feel. You can shoot your image so that the colors are more vivid, giving your photo a live, vibrant feeling, or you can tone the colors down for a more ethereal look.

8.18 For this studio portrait of Matt, we planned for a *film noir* look.

Studio considerations

Studio portraits are essentially indoor portraits, except that with studio portraits, the lighting and background are controlled to a much greater extent. The studio portrait is entirely dependent on the lighting and background to set the tone of the image.

The most important part of a studio setting is the lighting setup. Directionality and tone are a big part of studio lighting, and close attention must be paid to both. There are quite a few things to keep in mind when setting up for a studio portrait. A few things to consider:

✦ **What kind of tone are you looking for?** Do you want the portrait to be bright and playful or somber and moody? These elements must be considered, and the appropriate lighting and backgrounds must be set up.

✦ **Do you want to use props?** Sometimes, having a prop in the shot can add interest to an otherwise bland portrait.

✦ **What kind of background is best for your shot?** The background is crucial to the mood and/or setting of the shot. For example, when shooting a high-key portrait, you must have a white or brightly colored background. You can also use props in the background to evoke a feeling or specific place. One photographer I know went so far as to build walls, complete with windows, inside his studio. He then set up a couch, end tables, and lamps

to create a 1970s-style motel room for a series of photographs he was shooting for assignment.

✦ **What type of lighting will achieve your mood?** Which lighting pattern are you going to use? Do you need to light the background?

Studio portraits require the most thought and planning of all the different types of portraits. This type of photography also requires the most equipment; lights, stands, reflectors, backgrounds, and props are just a few of the things you may need. For example, for figure 8.19, I used a 200-watt-second strobe set up at camera right, bounced from a 36-inch umbrella for the main light. A reflector was used to add a little fill on the left.

> **Cross-Reference** *For more on lighting and accessories, see Chapter 4.*

Portrait lighting patterns

Professional photographers use different types of *lighting patterns*. These patterns are generally used to control where the shadow falls on the face of the subject. If the shadows aren't controlled while lighting your subject, your portrait can appear odd, with strange shadows in unwanted places. In addition to the lighting patterns, there are two main types of lighting — broad lighting and short lighting. *Broad lighting* occurs when your main light illuminates the side of the subject that faces toward you. *Short lighting* occurs when your main light illuminates the side of the subject that faces away from you. In portrait lighting, there are five main types of lighting patterns:

✦ **Shadowless.** This is when your main light and your fill light are at equal ratios. Generally, you will set up a light at 45 degrees on both sides of your model. This type of light can be very flattering, although it can lack moodiness and drama.

✦ **Butterfly or Hollywood glamour.** This type of lighting is mostly used in glamour photography. The name is derived from the butterfly shape of the shadow that the nose casts on the upper lip. You achieve this type of lighting by positioning the main light directly above and in front of your model.

✦ **Loop or Paramount.** This is the most commonly used lighting technique for portraits. Paramount Studios used this pattern so extensively in Hollywood's golden age that this lighting pattern became synonymous with the studio's name. This lighting pattern is achieved by placing the main light at a 15-degree angle to the face, making sure to keep the light high enough so that the shadow cast by the nose is at a downward angle and not horizontal.

8.19 Shadowless lighting

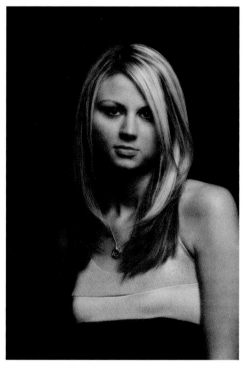

8.20 Butterfly lighting

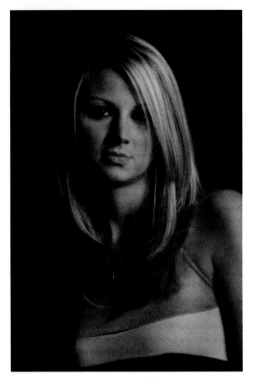

8.21 Loop or Paramount lighting

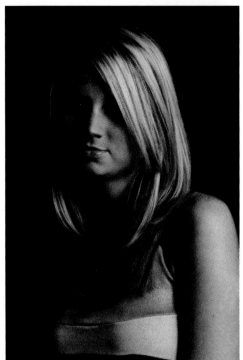

8.22 Rembrandt lighting

✦ **Rembrandt.** The famous painter Rembrandt van Rijn used this dramatic lighting pattern extensively. It's a moody dramatic pattern that benefits from using less fill light. The Rembrandt style is achieved by placing the light at a 45-degree angle, aimed a little bit down at the subject. Again, I emphasize using little or no fill light. This pattern is epitomized by a small triangle of light under one eye of the subject.

✦ **Split.** This is another dramatic pattern that benefits from little or no fill. You can do this by simply placing the main light at a 90-degree angle to the model.

8.23 Split lighting

Posing and composition considerations

As humans, we convey many of our expressions and emotions through body language, so it goes without saying that how the person is posed can make a huge impact on the general mood or feeling of the image.

Posing your model can be one of the most daunting tasks for a photographer. Oftentimes, in order to get the right pose, your model will have to be like a contortionist bending into awkward positions. One thing to remember

about posing is that your models or clients expect you to know what you're doing. You need to be confident and assertive. Acting timid or being afraid to ask your model to do what you need will get you nowhere in the portrait business. Remember, your clients rely on you to know what you're doing.

One of the easiest ways to get started with learning posing is to study poses from other photographers or artists. This is as simple as opening a fashion magazine or even looking on the Internet. I keep a folder on my desktop to which I frequently save a small copy of an image if I think it's an interesting pose. If I'm feeling particularly uninspired during a photo shoot, I can just open the folder to get some ideas and creative juices flowing. Some of my favorite poses don't even come from other photographers but from artists. Alberto Vargas and Gil Elvgren were two artists who painted pinup girls in the 1940s. Their work is iconic and fun. Check these guys out for some inspiration.

When posing your model, keep an eye on everything from stray hairs to clothing bunching up in weird ways and limbs jutting out in awkward fashions. Before you trip the shutter, take time to really look close at everything in the frame.

Also pay close attention to the hands. Hands can subliminally reveal a lot of information about how a person is feeling. You want to make a conscious effort to tell your model or client to relax his or her hands. When the hands are relaxed, the model looks and feels more relaxed. Clenched or tense hands can make your portraits look forced or make

the model look uncomfortable. Hands are an extension of the arms, and arms too can have an emotional impact on your image. For example, having your subject cross his or her arms can show strength and determination or even obstinacy depending on the facial expression.

Positioning the head is another major consideration when shooting portraits. When the head is straight up and down looking directly down the lens, it can convey strength or even hostility. Titling the head to the side a bit usually makes the image more relaxed, especially when the subject is smiling, as it helps to portray kindness and empathy in some cases.

Some general posing tips:

✦ **One foot behind.** One of the first things I do is have the person put one foot behind the other. This helps distribute the weight evenly and gives a more relaxed appearance. Having the subject lean back slightly is also helpful.

✦ **Come in at an angle.** You almost never want the subject to face straight ahead (unless you're a police photographer). Having him or her angled slightly away from the camera with one shoulder closer to the camera is a good idea.

✦ **Tilt the head.** Tilt the head a bit to avoid having the model look static, giving the portrait a casual feel. Of course, if the subject isn't casual, you probably don't want to do this. For example, with a CEO of a corporation, you would want to portray strength and character, so keeping the head straight would be ideal.

✦ **Watch the hands.** I can't stress this enough. Also try to keep the hands at an angle. Having the flat side of the back of the hand or the palm facing the camera can look odd. A 3/4 view or the side of the hand is preferable.

Some things to be aware of when composing a portrait:

✦ **Don't sever limbs.** Be sure not to frame the image in the middle of a knee joint or elbow. Don't cut off the toes or fingers. If the foot or hand is in the image, be sure to get it all in the frame.

✦ **Watch out for mergers.** Be aware of the background as well as the subject. Oftentimes, you can get so involved with looking at the model, you can forget about the rest of the photograph. You don't want your model to look like a tree is sprouting out of her head or a lamp has suddenly grown out of her shoulder.

✦ **Fill the frame.** Make your subject the overwhelming part of the image. Having too much background can distract from the subject of the image.

Indoor

When shooting portraits indoors, more often than not, there isn't enough light to make a correct exposure without using flash or some sort of other additional lighting. Although the built-in flash on the D90 sometimes works very well, especially outdoors, I find that when I try to use it for an indoor portrait, the person ends up looking like a deer caught in headlights. This type of lighting is very unnatural-looking and doesn't lend itself well for

8.24 For this indoor shot of my niece Evie, I placed her next to a window to get a bright but diffused light. This type of light is perfect for portraits.

portraiture. It works fine for snapshots, but your goal here is to get beyond taking snapshots and move up to making quality images.

The easiest way to achieve a more natural-looking portrait indoors is to move your subject close to a window. This gives you more light to work with, and the window acts as a diffuser, softening the light and giving your subject a vibrant glow.

Another easy way to get good portrait lighting indoors is to use an additional light source. A good source of additional lighting is one of the Nikon Speedlights. As with the built-in flash, photographing your subject with the Speedlight pointed straight at him or her is unadvisable. When using one of the shoe-mounted Speedlights, the best bet is to bounce the flash off the ceiling or a nearby wall to soften the flash. Ideally, use the flash off-camera, utilizing the wireless capabilities of the D90's built-in flash and Nikon CLS.

Outdoor

When you shoot portraits outdoors, the problems that you encounter are usually the exact opposite of the problems you have when you shoot indoors. The light tends to be too bright, causing the shadows on your subject to be too dark. This results in an image with too much contrast.

In order to combat this contrast problem, you can use your flash. I know that this sounds counterintuitive; you're probably thinking, "If I have too much light, why should I add more?" Using the flash in the bright sunlight fills in the dark shadows, resulting in a more evenly exposed image. This technique is known as *fill flash*.

8.25 For this outdoor portrait, I had Tasha posed underneath some trees. There was dappled sunlight coming through the trees, causing hot spots to appear, so I had an assistant block the sun with a diffusion panel. A diffusion panel can be an invaluable tool for outdoor portraits.

Another way to combat images that have too much contrast when you're shooting outdoors is to have someone hold a diffusion panel over your model or move your model into a shaded area, such as under a tree or a porch. This helps block the direct sunlight, providing you with a soft light for your portrait.

Cross-Reference *For more on fill flash, see Chapter 4. For more on diffusion panels, see Chapter 6.*

Portrait photography practice

8.26 Melissa with lens flare at Auditorium Shores in Austin, Texas

Table 8.7
Taking Portrait Pictures

Setup	**Practice Picture:** For Figure 8.26, model and friend Melissa came to me looking for some original and interesting shots for her portfolio.
	On Your Own: You can find inspiration in many different areas; don't be afraid to try some off-the-wall things. Portraits can portray many different moods, from somber to happy. Try to bring out some of your subject's personality.
Lighting	**Practice Picture:** For this shot, I broke some of the major rules of portrait photography. Not only was my model backlit, I was shooting directly into the sun. I shot into the sun specifically to introduce lens flare into the image. I had an assistant bounce some light onto her face by using a gold reflector to introduce some gold from the setting sun into her skin tone and to help compensate for the backlighting.
	On Your Own: There are a lot of different lighting techniques. Using reflectors and diffusion panels can really make a lot of difference both indoors and out.
Lens	**Practice Picture:** Micro-Nikkor 105mm f/2.8G VR. Although this is a macro lens, it's also one of Nikon's finest portrait lenses. It's super sharp, fast and has a pleasing bokeh.
	On Your Own: When shooting portraits, it's generally advisable to use a longer focal length to avoid the perspective distortion common with wide-angle lenses. Wide-angle lenses, especially when used close up, can cause the subject's features to appear distorted. For example, the nose can appear too large, while the ears will seem too small.
Camera Settings	**Practice Picture:** I used Aperture Priority mode for this shot. I set the aperture to f/2.8 and let the camera pick the shutter speed. I set the WB to Auto, but I shot in RAW so I could adjust the WB as needed. I used Matrix metering to ensure that the highlight from the sun in the corner wouldn't blow out. The vignette was added in post-processing.
	On Your Own: When shooting portraits, using Aperture Priority mode is the preferred setting. This gives you the option to control the depth of field. Be sure to set your white balance to the proper light source. When using external studio strobes, use Manual exposure. It's also a good idea to set a custom white balance to match the strobes.
Exposure	**Practice Picture:** ISO 200 at f/2.8 for 1/1000 second.
	On Your Own: Using a wide aperture is common to draw attention to the subject and blur out the background, but you generally want to be sure that your aperture is small enough to get your whole subject's face in focus. When using studio strobes, shooting at or near the sync speed of 1/200 second is recommended.
Accessories	Using a reflector can help bounce some light into shadow areas.

Portrait photography tips

✦ **Plan some poses.** Take a look at some photos on the Internet and find some poses that you like. Have these in mind when photographing your models.

✦ **Use a tripod.** Not only does the tripod help you get sharper images, but it also can make people feel more comfortable when you're not aiming the camera directly at them. The camera can be less intimidating when it's mounted to a stationary object and you can make direct eye contact with them.

✦ **Have some extra outfits.** Ask your model to bring a variety of clothes. This way, you can get some different looks during one shoot.

Still-Life and Product Photography

In still-life and product photography, lighting is the key to making the image work. You can set a tone by using creative lighting to convey the feeling of the subject. You can also use lighting to show texture, color, and form to turn a dull image into a great one. Becoming good at this type of photography can help you sell your items on eBay. When your product looks good, it's more likely to sell at a higher price.

When practicing for product shots or experimenting with a still life, the first task you need to undertake is finding something to photograph. It can be one object or a collection of objects. Remember: If you're shooting a collection, try to keep within a particular theme so the image has a feeling of continuity. Start by deciding which object you want to have as the main subject and then place the other objects around it, paying close attention to the balance of the composition.

The background is another important consideration when photographing products or still-life scenes. Having an uncluttered background that showcases your subject is often best, although you may want to show the particular item in a scene, such as photographing a piece of fruit on a cutting board with a knife in a kitchen.

Diffused lighting is essential in this type of photography. You don't want harsh shadows to make your image look like you shot it with a flash. The idea is to light it so it doesn't look as if it was lit.

Even with diffusion, the shadow areas need some filling in. You can do this by using a second light as fill or by using a fill card. A *fill card* is a piece of white foam board or poster board used to bounce some light from the main light back into the shadows, lightening them a bit. When using two or more lights, be sure that your fill light isn't too bright or it can cause you to have two shadows. Remember that the key to good lighting is to emulate the natural lighting of the sun.

Food photography is another type of product photography and can be extremely lucrative. It seems like here in Austin there are new restaurants popping up every day, and they all need food photos for their menus.

I find the best way to light food is window lighting. I bring a reflector along with me to add some fill, but I rarely use additional lighting unless I absolutely have to shoot in the evening. In the case where I need to use a Speedlight, I bounce the light off a wall to diffuse it.

One of the keys to successful food photography is to make the composition interesting. Simply photographing food sitting on a plate can be static and boring. Finding different angles and using selective focus help to add some interest to the image.

8.27 I shot this dish of homemade pesto goat cheese, shaved prosciutto, and roasted red bell peppers served with garlic bruschetta by using natural lighting from the window.

Inspiration

When searching for subjects for a still-life shot, try using some personal items. Some ideas are objects such as jewelry or watches, a collection of trinkets you bought on vacation, or even seashells you brought home from the beach. If you're interested in cooking, try photographing some dishes you've prepared. Fruits and vegetables are always good subjects, especially when they have vivid colors or interesting textures.

8.28 This is a shot of my Contax 193 Quartz 35mm camera with 50mm Zeiss lens. This shot was lit simply by tilting up the flash head of an on-camera SB-600 and bouncing the light from the ceiling.

Still-life and product photography practice

8.29 Gretsch G5120 with Orange amp

Table 8.8
Taking Still-life Pictures

Setup	**Practice Picture:** For Figure 8.29, I set out to take a picture of my newest guitar acquisition. A guitar's bright color makes it an interesting subject for a still life. I chose to photograph this on a black background in order to showcase the bright orange of the guitar body.
	On Your Own: Simple arrangements work best for still-life photos. Cramming too many objects into the composition can leave it looking cluttered. Keep it simple.

Lighting	**Practice Picture:** For this shot, I used a Smith-Victor 200ws moonlight fired into a large softbox placed in front of the guitar. A reflector was placed to the left to bounce a bit of light into the shadow areas. Additionally, an SB-800 set to SU-4 (optical remote) mode was set up at camera left perpendicular to the guitar and pointed at the guitar head stock to add some light. An SB-900 (SU-4 mode) with a snoot was placed directly behind the guitar and was aimed at the back of the head stock to provide some separation from the dark background.
	On Your Own: You don't need expensive studio strobes to achieve professional lighting results. You can use a continuous lighting setup or you can use some older Nikon Speedlights in Manual mode. See Chapter 6 for more on lighting.
Lens	**Practice Picture:** Nikkor 28–70mm f/2.8 zoomed to 70mm.
	On Your Own: A normal to medium focal length is recommended to reduce the perspective distortion that can occur when shooting close up. This is a common problem when using wide-angle lenses. For smaller objects, using a macro lens or a telephoto lens can work well.
Camera Settings	**Practice Picture:** Once again, as with most of my studio shots, I used Manual exposure. When shooting with strobes, I find it easiest to set the shutter speed and aperture that I want and adjust the lights to fit my chosen settings.
	On Your Own: Be sure to adjust your white balance settings to match your light source. Shooting in RAW can also help you fine-tune your white balance and exposure in post-processing.
Exposure	**Practice Picture:** ISO 200 at f/5.6 for 1/200 second. For this shot, I first set the shutter speed to 1/200 (the sync speed). I then set the aperture to f/5.6 so I would be sure to carry enough depth of field.
	On Your Own: Manual exposure is the best choice if using studio strobes, but if you're taking advantage of the Nikon CLS, you can just as easily shoot in one of the Exposure modes, such as Programmed Auto, Shutter Priority, or Aperture Priority.
Assessories	A tripod can help keep your images sharp, especially if shooting in available light.

Still-life and product photography tips

✦ **Keep it simple.** Don't try to pack too many objects in your composition. Having too many objects for the eye to focus on can lead to a confusing image.

✦ **Use items with bold colors and dynamic shapes.** Bright colors and shapes can be eye-catching and add interest to your composition.

✦ **Vary your light output.** When using more than one light on the subject, use one as a fill light with lower power to add a little depth to the subject by creating subtle shadows and varied tones.

Viewing, Downloading, and In-Camera Editing

♦ ♦ ♦ ♦

In This Chapter

Viewing your images

Downloading images

Using the Retouch menu options

♦ ♦ ♦ ♦

With the D90's large, bright, 3-inch 920,000-dot VGA LCD monitor, you can view your images and even use the in-camera editing features that allow you to save some time in post-processing and gives you the option to fine-tune your images for printing without ever having to download your images to a computer. Nikon has upgraded the Retouch menu with some exciting new options that weren't available on previous cameras, such as the straighten, distortion control, and fisheye options. With all these post-processing tools built right into the camera, it's entirely possible to do all your image adjustments (including RAW image processing) from start to finish, connect the camera to a PictBridge-enabled printer, and then print. This encompasses your entire workflow without even touching a computer!

Viewing Your Images

The Nikon D90 offers three ways to view your images while the memory card is still inserted in the camera. You can view the images directly on the LCD monitor on the camera, you can hook your camera up to a standard TV by using the Nikon EG-D2 audio/video cable that's included in the box, or you can connect the camera to an HDTV or HD monitor by using a separate cable that you can buy from your local electronics store.

When viewing images through an external device, such as an HDTV, the view is the same as would normally be displayed on the LCD monitor. The camera's buttons and dials function exactly the same:

✦ **Press the Playback button to view the most recent photo or video.** To play the video, press the OK button.

✦ **Press the Multi-selector left or right to scroll through the images.** Press right to view the images in the order they were taken; press left to view them in reverse order. Rotating the Main Command dial left or right also performs these same functions.

✦ **Press the Multi-selector up or down to view data.** By default, the camera displays shooting information that includes the brightness histogram, Metering mode, Shooting mode, shutter speed, ISO, focal length, exposure compensation (if any), WB color space, Picture Control, and Active D-Lighting settings (if any). The date/time, filename, and image quality are also displayed. You can display additional information such as highlights, RGB histograms, and more detailed data by setting the Display mode option in the Playback menu. If the optional GPS device was used, location and time details are also displayed on a separate page. Rotating the Sub-command dial left or right also allows you to view the camera data.

✦ **Press the Delete (trash can) button to erase an image or video from the memory card.** The camera asks for confirmation before permanently deleting the file.

✦ **Use the Protect button to prevent an image from being deleted.** The Protect button has a key icon on it. Press it once to protect the image; press it again to unprotect. Note that the image is erased when the card is formatted, but not if a Delete all is performed.

✦ **Use the Zoom Out button to view thumbnails.** Pressing this button from the default full-frame view gives you a 4-up view with one press, 9-up with two presses, and 72-up with three presses. Pressing the button a fourth time displays a calendar view that displays images taken on a certain day. Use the Multi-selector to choose the date. Press the Zoom In button the corresponding amount of times to return to the default display.

✦ **Use the Zoom In button to more closely inspect your images.** From the default preview setting, you can press this button eight times to zoom in. The sixth step shows the image at 100%, and the last two steps appear pixilated. Use the Multi-selector to move around to different areas of the image. When viewing portraits, the camera has a Face Detection mode that allows you to zoom in directly on the face by scrolling with the Sub-command dial. When the camera detects a face in the frame, a smiley face icon appears on the lower right of the image.

Before connecting the camera to your television, you need to set the Video mode. There are two types of video interface: PAL and NTSC. By default, the camera (if you bought it in North America) is set to NTSC. These modes control how the electronic signal is processed. In NTSC mode, 30 frames are transmitted each second, with each frame composed of 525 scan lines. PAL mode transmits 25 frames per second, with each frame composed of 625 scan lines. These two video modes are used in different parts of the world. Most of North and South America use NTSC, while Asia and Europe use the PAL system.

9.1 Face detection in Playback mode

To set the Video mode:

1. **Turn the camera on.**

2. **Press the Menu button.**

3. **Use the Multi-selector to highlight the Setup menu.**

4. **Use the Multi-selector to highlight Video mode and then press the OK button.**

5. **Use the Multi-selector to highlight NTSC (or PAL).**

6. **Press the OK button to save the settings.**

> **Cross-Reference** *For more on playing back images, see Chapter 3.*

To connect your camera to a standard TV:

1. **Turn the camera off.** This prevents damage to your camera's electronics from static electricity.

2. **Open the connector cover.** The connector cover is on the left side of the camera when the lens is facing away from you.

3. **Plug in the EG-D2 video cable.** The cable is available separately from Nikon. Plug the cable into the video-out port. This is the connection at the top.

4. **Connect the EG-D2 to the input jack of your television or VCR.**

5. **Set your TV to the video channel.** This may differ depending on your TV. See the owner's manual if you're unsure.

6. **Turn on the camera and then press the Playback button.**

Connecting your camera to an HDTV or monitor is the same as the steps to connect to a regular TV, with the exception that you must use a type C mini-pin HDMI cable, which you can purchase at a local electronics store.

Be sure to tune the HDTV to the HDMI channel. When connected to an HDTV, the camera LCD turns off and the image appears only on the HDTV screen. When connected to a standard TV, the LCD and TV both display the image.

Downloading Images

After you finish taking your pictures, you're probably going to want to download them to your computer for further image editing and tweaking or so you can post them to the Web or send them off to your friends and family.

Downloading your images is a fairly simple process, and there are a couple of different ways to do this. The most common way is to remove the memory card from the camera and insert it into a card reader that's connected to your computer. The other option is to use the USB cable supplied with the D90 to connect the camera directly to the computer. Either option works just as well as the other.

In the past, most Nikon dSLRs had an option that you could set the camera to appear on your computer as Mass Storage; in other words, when you plugged in your camera, it showed up the same as an external hard drive. For some reason, the D90 Nikon doesn't include this option. What this means is that to download any images directly from the camera, you may have to use the Nikon Transfer software that's included on a CD with the camera. I'm a Mac user, and with OS X, the camera doesn't show up when the camera is connected with a USB cable (it shows up in Nikon Transfer). I've been told that Windows automatically detects the camera with no problem. I tend to find this feature a bit tricky because I prefer to manually download my images to folders that I've already created to help speed up my workflow. However, the Nikon Transfer software is very easy to learn and works well. I encourage you to use Nikon Transfer if you don't have a card reader or prefer to plug your camera directly into the computer.

Using Nikon Transfer

If you use a Mac, before you download any images directly from the camera, you must first install Nikon Transfer to your computer. There is a CD included inside the box with your D90. In addition to Nikon Transfer on the CD, there's also Nikon's image-editing and viewing software: Nikon View. You can use Nikon View to do most basic editing of your photos, such as contrast adjustments and red-eye removal.

After installing Nikon Transfer, as soon as your D90 is connected to the computer and turned on, the application launches automatically. By default, Nikon Transfer is set up to create a new folder named Nikon Transfer, which is where your images are saved. Transfer also automatically creates a numbered subfolder each time new images are downloaded.

There are a number of different tabs in the Nikon Transfer main window that allow you to specify how Nikon Transfer deals with your files.

Source tab

The first tab is the Source tab. This allows you to set what type of media Nikon Transfer searches for. Clicking the Search For drop-down menu allows you to set the program to recognize when a camera is attached or a removable disk has been connected. Both of these options can also be set at the same time. Choosing the camera option allows the program to recognize only when a camera has been connected. When using an external card reader, you should choose the removable disk option.

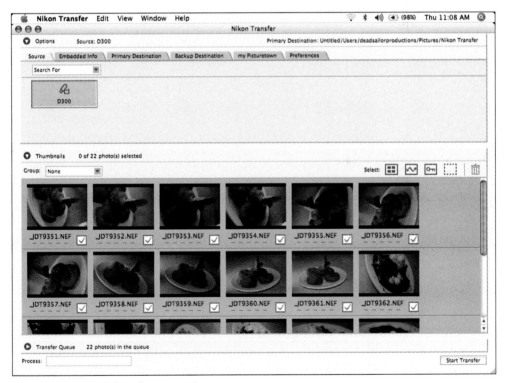

9.2 The Source tab in Nikon Transfer

Embedded Info tab

The Embedded Info tab allows you to attach text information to the EXIF (Exchangeable Image File) data of your image. EXIF data is embedded into your image file and has information such as the date and time, camera make and model, white balance settings, shutter speed and aperture, Exposure and Flash modes, and other information. The EXIF data can be read by using programs such as Adobe Bridge as well as other image-editing software. Some photo-sharing Web sites, such as Flickr, also allow you to view the EXIF data on images that are uploaded.

You can add all sorts of different information by using the Embedded Info feature, such as a description of the photo, a title, your name and address, copyright information, and the location that the image was taken. You can also save a number of presets for saving different information.

9.3 The Embedded Info editing screen

Primary Destination tab

The Primary Destination tab allows you to choose where your images are downloaded. You can browse your hard drive to choose a specific destination or you can leave the default. There is also an option that allows you to customize the folder-naming sequence that Nikon Transfer employs.

9.4 The Primary Destination tab in Nikon Transfer

Backup Destination tab

The Backup Destination tab allows you to automatically back up your images when transferring them. Backing up your images to an external hard drive is a good idea in case of a computer or hard drive failure. This feature works in much the same way as the Primary Destination tab.

9.5 The Backup Destination tab in Nikon Transfer

Preferences tab

The Preferences tab allows you to customize how the program works and what it does with the files after transferring them. You can choose from a number of different options:

✦ Launch automatically when device is attached

✦ Disconnect automatically after transfer

✦ Shut down computer automatically after transfer

✦ Quit Nikon Transfer automatically after transfer

✦ Synchronize camera date and time to computer when camera is connected

✦ Transfer new photos only

✦ Delete original files after transfer

✦ Open destination folder with another application after transfer

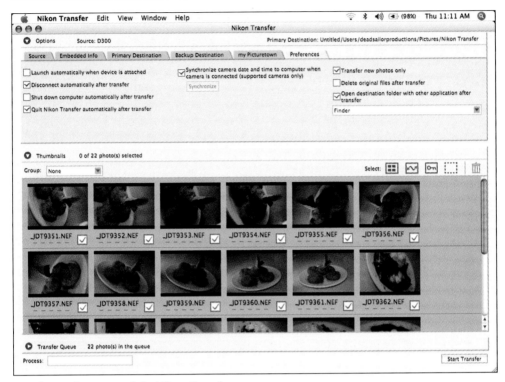

9.6 The Preferences tab in Nikon Transfer

Transferring your images

Once you set everything the way you want it, transferring your images is a very simple process. All the images on the memory card are displayed as thumbnails in the Nikon Transfer window. Below each thumbnail is the image's filename and a box that can be checked or unchecked. Simply click the check box to select the image. When the check mark appears in the box, the image is set to be transferred. If the check box is empty, the image won't be copied. After you select all the images you want to transfer, simply click the Start Transfer button located on the bottom right-hand side of the window. The images are then copied to the specified destination.

Using the Retouch Menu Options

The Nikon D90 has a very handy Retouch menu. These in-camera editing options make it simple for you to print straight from the camera without downloading images to your computer or using any image-editing software.

One great feature of using the Retouch menu is that the camera saves the retouched image as a copy so you don't lose the original image. This can be beneficial if you decide that you would rather edit the photo on your computer or if you simply aren't happy with the outcome. There are two ways to access the Retouch menu.

The first and quickest method:

1. **Press the Play button to enter Playback mode.** Your most recently taken image appears on the LCD screen.

2. **Use the Multi-selector to review your images.**

3. **When you see an image you want to retouch, press the OK button to display the Retouch menu options.**

4. **Use the Multi-selector to highlight the retouch option you want to use.** Depending on the retouch option you choose, you may have to select additional settings.

5. **Make the necessary adjustments.**

6. **Press the OK button to save.**

> **Note** When the image review displays a video, pressing the OK button causes the video to play.

The second method:

1. **Press the Menu button to view menu options.**

2. **Use the Multi-selector to scroll down to the Retouch menu.** It's the fifth menu down and appears as an icon with a paintbrush.

3. **Press the Multi-selector right and then press the Multi-selector up or down to highlight the retouch option you want to use.** Depending on the retouch option you select, you may have to select additional settings. After you select your option(s), thumbnails appear.

4. **Use the Multi-selector to select the image to retouch and then press the OK button.**

5. **Make the necessary adjustments.**

6. **Press the OK button to save.**

> **Note** Some Retouch menu options may not be available depending on the setting used when the image was taken.

There are a few options you can select when using the Retouch menu. The options vary from cropping your image to adjusting the color balance to taking red-eye out of your pictures.

RETOUCH MENU

- D-Lighting
- Red-eye correction
- Trim
- Monochrome
- Filter effects
- Color balance
- Small picture
- Image overlay

RETOUCH MENU

- Color balance
- Small picture
- Image overlay
- NEF (RAW) processing
- Quick retouch
- Straighten
- Distortion control
- Fisheye

9.7 The Retouch menu

D-Lighting

D-Lighting allows you to adjust the image by brightening the shadows. This isn't the same as Active D-Lighting. D-Lighting uses a curves adjustment to help bring out details in the shadow areas of an image. This option is for use with backlit subjects or images that may be slightly underexposed.

When the D-Lighting option is chosen from the Retouch menu, you can use the Multi-selector to choose a thumbnail and the Zoom In button to get a closer look at the image. When you press the OK button to choose the image you want to retouch, two thumbnails are displayed: One is the original image, and the other is the image with D-Lighting applied.

9.8 The D-Lighting option

You can press the Multi-selector up or down to select the amount of D-Lighting: Low, Normal, or High. The results can be viewed in real time and compared with the original before saving. Press the OK button to save; the Playback button to cancel; and the Zoom In button to view the full-frame image.

Red-eye correction

This option enables the camera to automatically correct for the red-eye effect that can sometimes be caused by using the flash for pictures of people. This option is only available on photos taken with flash. When choosing images to retouch from the Playback menu by pressing the OK button during preview, this option is grayed out and can't be selected if the camera detects that a flash wasn't used. When attempting to choose an image directly from the Retouch menu, a message is displayed stating that this image can't be used.

Once the image has been selected, press the OK button; the camera then automatically corrects the red-eye and saves a copy of the image to your SD card.

If an image is selected that flash was used on but there's no red-eye present, the camera displays a message stating that red-eye isn't detected in the image and that no retouching can be done.

Trim

This option allows you to crop your image to remove distracting elements or to allow you to crop closer to the subject. You can also use the Zoom In and Zoom Out buttons to adjust the size of the crop. This allows you to crop closer in or farther out depending on your needs.

Use the Multi-selector to move the crop around the image so you can center the crop on the part of the image that you think is most important.

When you're happy with the crop you've selected, press the OK button to save a copy of your cropped image or press the Playback button to return to the main menu without saving.

 Caution *After cropping, no additional edits can be made to the image, so be sure that this is the last step in your processing,*

9.9 Using the Trim option

Monochrome

This option allows you to make a copy of your color image in a monochrome format. There are three options:

✦ **Black-and-white.** This changes your image to shades of black, white, and gray.

✦ **Sepia.** This gives your image the look of a black-and-white photo that has been sepia-toned. Sepia-toning is a traditional photographic process that gives the photo a reddish-brown tint.

✦ **Cyanotype.** This option gives your photos a blue or cyan tint. Cyanotypes are a form of processing film-based photographic images.

When using Sepia or Cyanotype, you can press the Multi-selector up and down to adjust the lightness or darkness of the effect. Press the OK button to save a copy of the image or press the Playback button to cancel without saving.

9.10 An image converted to black and white

9.11 An image converted to sepia

9.12 An image converted to cyanotype

Filter effects

The Filter effects option allows you to simulate the effects of using certain filters over your lens to subtly modify the colors of your image. There are six filter effects available:

✦ **Skylight.** A skylight filter is used to absorb some of the UV rays emitted by the sun. The UV rays can give your image a slightly bluish tint. Using the skylight filter effect causes your image to be less blue.

✦ **Warm filter.** A warming filter adds a little orange to your image to give it a warmer hue. This filter effect can sometimes be useful when using flash because flash can sometimes cause your images to feel a little too cool.

✦ **Red intensifier.** This adds a red colorcast to your image. You can press the Multi-selector up and down to lighten or darken the effect.

✦ **Green intensifier.** This adds a green colorcast to your image. You can press the Multi-selector up and down to lighten or darken the effect.

✦ **Blue intensifier.** This adds a blue colorcast to your image. You can press the Multi-selector up and down to lighten or darken the effect.

✦ **Cross screen.** This effect simulates the use of a star filter. A star filter creates a star-shaped pattern on the bright highlights in your image. If your image doesn't have any bright highlights, the effect won't be apparent. Once an image is selected for the cross screen filter, you are shown a submenu with a few options that you can adjust. You can choose the number of

points on the stars: 4, 6, or 8. You can also choose the amount; there are three settings, which give you more or less stars. You can choose three angle settings, which control the angle at which the star is tilted. You also have three settings that control the length of the points on the stars.

After choosing the desired filter effect, press the OK button to save a copy of your image with the effect added.

tint to your image. You can use this effect to neutralize an existing color tint or to add a color tint for artistic purposes.

Press the Multi-selector up to increase the amount of green, down to increase the amount of magenta, left to add blue, and right to add amber.

A color chart and color histograms are displayed along with an image preview so you can see how the color balance affects your image. When you're satisfied with your image, press the OK button to save a copy.

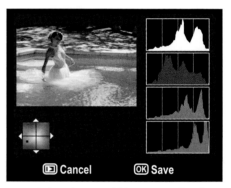

9.14 Color chart and histograms for the color balance option

Small picture

This is a handy little option that allows you to make a copy of your images that are a smaller size. These smaller pictures are more suitable for e-mailing to friends and family.

The first thing you need to do when creating a small picture is to select the Choose size option from the Small picture submenu. You have three sizes to choose from: 640 × 480, 320 × 240, or 160 × 120. After you decide what size you want your small pictures to be, go to the Select picture option. When the Select picture option is chosen, the LCD

9.13 Cross screen filter

Color balance

You can use the color balance option to create a copy of an image on which you have adjusted the color balance. Using this option, you can use the Multi-selector to add a color

shows thumbnails for all the images in the current folder. To scroll through your images, press the Multi-selector left or right. To select or deselect an image, press the Multi-selector up or down. You can select as many images as you have on your memory card. When all the images that you want to make a small copy of are selected, press the OK button to make the copies.

Image overlay

This option allows you to combine two RAW images and then save them as one. This menu option can only be accessed by entering the Retouch menu via the Menu button (the longer route); you can't access this option by pressing the OK button when in Playback mode.

> **Note** To use this option, you must have at least two RAW images saved to your memory card. This option isn't available for use with JPEG.

To use this option:

1. **Press the Menu button to view the menu options.**

2. **Use the Multi-selector to scroll down to the Retouch menu and then press the Multi-selector right to enter the Retouch menu.**

3. **Press the Multi-selector up or down to highlight Image overlay.**

4. **Press the Multi-selector right.** This displays the Image overlay menu.

5. **Press the OK button to view RAW image thumbnails.**

6. **Use the Multi-selector to high-light the first RAW image to be used in the overlay and then press the OK button to select it.**

7. **Adjust the exposure of Image 1 by pressing the Multi-selector up or down and then press the OK button when the image is adjusted to your liking.**

8. **Press the Multi-selector right to switch to Image 2.**

9. **Press the OK button to view RAW image thumbnails.**

10. **Use the Multi-selector to high-light the second RAW image to be used in the overlay and then press the OK button to select it.**

11. **Adjust the exposure of Image 2 by pressing the Multi-selector up or down and then press the OK button when the image is adjusted to your liking.**

12. **Press the Multi-selector right to highlight the Preview window.**

13. **Press the Multi-selector up or down to highlight Overlay to pre-view the image or use the Multi-selector to highlight Save to save the image without previewing.**

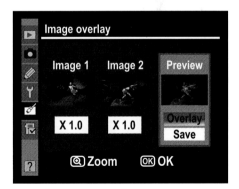

9.15 The Image overlay screen

NEF processing

This option allows you to do some basic editing to images saved in the RAW format without downloading them to a computer or using image-editing software. This option is limited in its function but allows you to fine-tune your image more precisely when printing straight from the camera or memory card.

You can save a copy of your image in JPEG format. You can choose the image quality and size that the copy is saved as, adjust the white balance settings, fine-tune the exposure compensation, and select a Picture Control to be applied.

To apply RAW processing:

1. **Enter the NEF (RAW) processing menu through the Retouch menu and then press the OK button to view thumbnails of the image stored on your card.** Only images saved in the RAW format are displayed.

2. **Press the Multi-selector left and right to scroll through the thumbnails and then press the OK button to select the highlighted image.** This displays a dialog screen with the image adjustment submenu located to the right of the image you've selected.

3. **Press the Multi-selector up or down to highlight the adjustment you want to make.** You can set image quality, image size, white balance, exposure compensation, and optimize image settings. The last option, EXE, sets the changes

and then saves a copy of the image in the JPEG format at the size and quality that you have selected. The camera default saves the image as a Large, Fine JPEG. You can also use the Zoom In button to view a full-screen preview.

4. **When you have made your adjustments, use the Multi-selector to highlight EXE and then press the OK button to save the changes or press the Playback button to cancel without saving.**

> **Cross-Reference** *For more on image size, image quality, white balance, and exposure compensation, see Chapter 2.*

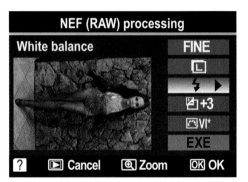

9.16 The NEF (RAW) processing menu screen

Quick retouch

The Quick retouch option is the easiest option. The camera automatically adjusts the contrast and saturation, making your image brighter and more colorful — perfect for printing straight from the camera or memory card. In the event that your image is dark or backlit, the camera also automatically applies D-Lighting to help bring out details in the shadow areas of your picture.

After your image has been selected for quick retouch, you have the option to choose how much of the effect is applied. You can choose from High, Normal, or Low. The LCD monitor displays a side-by-side comparison of the original image and the retouched image to give you a better idea of what the effect looks like.

After you decide how much of the effect you want, press the OK button to save a copy of the retouched image or you can press the Playback button to cancel without making any changes to your picture.

Straighten

This is a fairly simple tool that allows you to straighten any images that you may have inadvertently shot at a bit of an angle. Select the image that you want to straighten and then press the Multi-selector right to tilt the image to the right or press the Multi-selector left to tilt the image to the left. The image is overlaid with a grid to assist you with the process. Press the OK button to save the changes or press the Playback button to cancel.

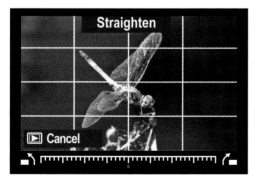

9.17 The Straighten tool

Distortion control

As discussed in Chapter 4, some lenses are plagued by distortion. Wide-angle lenses (or settings on a zoom lens) suffer from what's called barrel distortion where the edges of the image seem to bulge out (like a barrel). Telephoto lenses suffer from the opposite effect. The edges seem to be sucked in. This is what's known as pincushion distortion.

Previously, in order to fix this lens distortion, you would need to fix the photo in an image editor, such as Photoshop, Capture NX2, or DxO Optics. Fortunately, this option is now included on-camera with the D90. Although not as precise as an image editor for minor fixes, this option works pretty well.

There are two settings you can use with this menu option: Auto or Manual. The Auto setting automatically adjusts for the distortion but allows you to fine-tune it a little to your taste by pressing the Multi-selector left or right. This option can only be used with certain lenses. Most D- and G-type lenses are supported, with the exception of the fisheye and PC lenses. If the lens isn't supported, you can't select the image when choosing the Auto option.

The Manual option can be used with any lens. Press the Multi-selector right to reduce barrel distortion or left to counteract the effect of pincushion distortion.

Fisheye

This option applies a filter that simulates the spherical distortion that's the distinctive feature of the fisheye lens. Personally, I don't think the representation comes off very well, and I'd recommend staying away from this feature.

Side-by-side comparison

This option allows you to view a side-by-side comparison of the retouched image and the original copy of the image. This option can only be accessed by selecting an image that has been retouched.

To use this option:

1. **Press the Play button and then use the Multi-selector to choose the retouched image to view.**

2. **Press the OK button to display the Retouch menu.**

3. **Use the Multi-selector to highlight side-by-side comparison and then press the OK button.**

4. **Use the Multi-selector to highlight either the original or retouched image.** You can then use the Zoom In button to view closer.

5. **Press the Play button to exit the side-by-side comparison and return to Playback mode.**

Appendixes

Accessories

A number of accessories and additional equipment are available for the Nikon D90. They range from batteries and flashes to tripods and camera bags, and they can enhance your shooting experience by providing you with options that aren't available with the camera alone.

MB-D80 Battery Grip

The MB-D80 is arguably one of the greatest accessories you can buy for the D90. It's available only from Nikon and attaches to the bottom of your D90 with a bolt that screws into the camera's ¼-inch tripod socket (there's an additional tripod socket on the bottom of the MB-D80). Not only does this grip offer you an extended shooting life by allowing you to fit additional batteries to your camera, but it also offers the ease and convenience of a vertical Shutter Release button, Main Command and Sub-command dials, and an AE-L/AF-L button. This means that if you hold your camera in the vertical position, you can use the Shutter Release button on the MB-D80 to fire the camera and adjust settings without having to hold your camera awkwardly, with your elbow up in the air, to press the camera's Shutter Release button.

The MB-D80 also gives the camera some added weight and more real estate for gripping the camera. If you have large hands, you'll appreciate the added grip. This grip can also help to balance out the D90 when an especially large lens like the Nikkor 17–55mm f/2.8 is attached, which can make the camera a bit front-heavy.

The MB-D80 allows you to power your camera with two EN-EL3e batteries, effectively doubling your shooting time without having to switch out batteries. EN-EL3e batteries are recommended to get the peak performance out of your camera. With the included adapter, you can also power your camera with six AA-sized batteries, although AA batteries get you fewer shots than the standard EN-EL3e batteries.

In This Appendix

MB-D80 battery grip

ML-L3 wireless remote control

MC-DC2 remote cord

GP-1 GPS unit

Tripods

Camera bags and cases

If you're planning on using AA batteries as a backup or even as your main power source, I'd suggest investing in a set of rechargeable Ni-Mh (nickel–metal hydride) batteries. If you don't plan on using rechargeable batteries, lithium batteries are your best choice for longer battery life. Standard alkaline and nickel-manganese aren't recommended because they have a fairly short life, and these types of batteries should only be used in a pinch.

When using AA batteries to power your D90, you may notice an increased frame rate when shooting in Continuous High Shooting mode. The frame rate drops as the AA batteries lose their charge. Nikon doesn't provide information on the exact frame rate available when using AA batteries, but depending on the battery and the charge, it's estimated to be between 5–7 frames per second (fps).

Image courtesy of Nikon
A.1 The D90 with the MB-D80 battery grip

ML-L3 Wireless Remote Control

This relatively inexpensive and handy little device is used to wirelessly trigger the D90's Shutter Release by using the infrared sensor located on the front of the camera. To use this feature, set the camera's Drive mode to Remote (you can choose from Quick Response Remote or Delayed Remote). Point the remote at the camera and then press the button.

This remote is great for triggering the camera when you want to do self-portraits or if you want to get in the picture when doing a

group portrait. This remote is also very useful to use to reduce camera shake when doing long exposures with the camera mounted on a tripod.

 Note *The Bulb setting is unavailable when the camera is set to one of the remote Drive modes.*

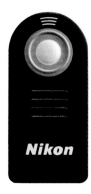

Image courtesy of Nikon
A.2 The ML-L3 wireless remote control

MC-DC2 Remote Cord

This remote cord allows you to trigger the Shutter Release button. This accessory plugs into the camera via the accessory terminal located on the side of the camera body.

This remote can be used in similar situations as the ML-L3 wireless remote, with the added bonus of a locking button that allows you to use the Bulb mode for an exposure longer than 30 seconds. This can be useful in extremely dark situations or when attempting astrophotography.

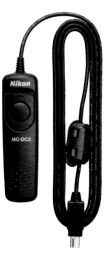

Image courtesy of Nikon
A.3 The MC-DC2 remote cord

GP-1 GPS Unit

This GPS unit mounts to your camera's hot shoe or to the camera strap by using the supplied adapter and connects to the camera via the accessory terminal on the side of the camera. This device allows you to automatically geotag your images with the latitude and longitude your image was taken at. Using View NX version 1.2, you can match up your images with maps.

Tripods

One of the most important accessories that a photographer can have is a tripod. It allows you to get sharper images by eliminating the shake caused by handholding the camera in low-light situations. It can also allow you to use a lower ISO, thereby reducing the camera noise and resulting in an image with better resolution.

Image courtesy of Nikon
A.4 The D90 with the GP-1

There are literally hundreds of types of tripods available, ranging in size from less than 6 inches all the way to 6 feet or more. In general, the heavier the tripod is, the steadier it keeps the camera. The D90 isn't a very heavy camera, so you may be able to get away with purchasing a relatively lightweight tripod (just don't buy one that's *too* light). When using the D90 with the MB-D80 battery grip or an especially heavy lens, such as the Nikkor 70–200mm f/2.8 VR, you may need to purchase a more heavy-duty tripod; otherwise, the weight of the camera can cause the tripod to shake, offering no improvement over shooting without a tripod.

There are many different features available on tripods, but the standard ones include:

✦ **Height.** This is an important feature. The tripod should be the right height for the specific application for which you're using it. If you're shooting landscapes most of the time and are 6 feet tall, using a 4-foot-tall tripod forces you to bend over to look into the viewfinder to compose your images. This is probably not optimal.

✦ **Head.** Tripods have several different types of heads. The most common type of head is the *pan/tilt* head. This type allows you to rotate, or *pan*, with a moving subject and also allows you to tilt the camera for angled or vertical shots. The other common type of head is the *ball* head. It's the most versatile and can quickly tilt and rotate into nearly any position. Some of the more expensive tripods don't come equipped with a head, allowing you to buy a head of your choosing so you can customize your tripod to your shooting style.

✦ **Plate.** The plate attaches the camera to the tripod. The D90 has a threaded socket on the bottom. Tripods have a type of bolt that screws into these sockets, and this bolt is on the plate. Most decent tripods have what's called a *quick release* plate. You can remove a quick-release plate from the tripod, attach it to the camera, and then reattach it to the tripod with a locking mechanism. If you're going to be putting the camera on and taking the camera off the tripod frequently, this is the most time-efficient type of plate to use. The other type of plate, which is on some inexpensive tripods, is the standard type of plate. It attaches directly to the head of the tripod. It still has the screw bolt that attaches the camera to the plate, but it's much more time-consuming to use if you plan to put the camera on and take the camera off a lot.

✦ **Locking mechanisms.** There are a couple different types of locking mechanisms found on today's tripods. The two most common are the twist-lock and the lever-lock. The twist-lock functions by twisting a collar that allows the leg to telescope. The lever-lock functions by simply flipping a lever up to release the telescoping leg and then flip the lever down again to lock the leg up. Personally, I prefer the lever-lock types for the ease and quickness with which they operate. The only drawback to the lever-lock is that it occasionally loosens and needs to be tightened with a special tool that's usually included with the tripod.

Tripods have legs made from different types of materials. Each tripod has its own features that make it useful for specific purposes. Some types of materials include:

✦ **Wood.** Wooden tripods aren't seen very much anymore. These were the tripods of choice for photographers from the past who used large, heavy, box-like view cameras or field cameras. These wood tripods are often heavy, but they support quite a bit of weight and are also good at dampening vibrations, which can cause camera shake.

✦ **Aluminum.** Most of the tripods on the market today are made from aluminum. Aluminum is a lightweight and durable material that's fairly low in cost. This is the most cost-effective type of tripod, although depending on the feature set of the tripod, some can get pretty expensive.

✦ **Carbon fiber.** This is a great material. These are made from layers of cross-plied carbon fiber. Carbon fiber is significantly (20–30%) lighter than aluminum and dampens vibrations much better than wooden tripods do. Tripods with carbon-fiber legs are some of the most expensive ones, but they are very durable and are perfect for when you're hiking because of their low weight.

✦ **Exotic materials.** Some tripod manufacturers, such as Giotto's and Gitzo, use materials such as basalt, which comes from molten lava, to make their tripod legs. The basalt is crushed, melted, and then drawn into fibers similar to carbon fiber.

Magnesium tripods are also available. Magnesium tripod legs are similar to aluminum but are a bit stiffer and lighter than aluminum legs. These tripods are usually the most expensive types of tripods.

When to use a tripod

Many situations are ideal for using a tripod, and the most obvious is when it's dark or when lighting is poor. However, using a tripod even when there's ample light can help keep your image sharp. Here are just a few situations when you may want to use a tripod:

✦ **When the light is low.** Your camera needs a longer shutter speed to get the proper exposure if there isn't much available light. And when the shutter speed gets longer, you need steadier hands to get sharp exposures. Attaching your camera to a tripod eliminates camera shake.

✦ **When the camera is zoomed in.** When you're using a long focal-length lens, any shaking from your hands is more exaggerated due to the higher magnification of the scene. Your images can be blurry, even in moderate light.

✦ **When shooting landscapes.** Shooting landscapes, especially when you're using the Landscape mode, requires a smaller aperture to obtain maximum depth of field to ensure that the whole scene is in focus. When the camera is using

a smaller aperture, the shutter speed can be long enough to suffer from camera shake, even when the day is bright.

✦ **When shooting close up.** When the camera is very close to a subject, camera shake can also be magnified. When you're shooting close-ups or macro shots, it may also be preferable to use a smaller aperture to increase depth of field, thus lengthening the shutter speed.

Which tripod is right for you?

Considering that so many different types of tripods exist, choosing one can be daunting. Many different features and functions are available in a tripod; here are some things to think about when you're considering which one to purchase:

✦ **Price.** Tripods can range in price from as little as $5 to as much as $500 or more. Obviously, the more a tripod costs, the more features and stability it's going to have. Look closely at your needs when deciding what price level to focus on.

✦ **Features.** There are dozens of features available in any given tripod. Some tripods have a quick-release plate, some have a ball head, some are small, and some are large. Again, base your decision on your specific needs.

Monopods

An option you may want to consider is a *monopod* instead of a tripod. A monopod connects to the camera the same way a tripod does, but it only has one leg. Monopods are excellent for shooting sports and action with long lenses because they allow you the freedom to move along while providing the support to keep your camera steady.

✦ **Weight.** This can be a very important factor when you're deciding which tripod to purchase. If you're going to use the tripod mostly in your home, a heavy tripod may not be a problem. On the other hand, if you plan on hiking, a 7-pound tripod can be an encumbrance after a while. Some manufacturers make tripods that are made out of carbon fiber. While these tripods are very stable, they're also extremely lightweight. However, carbon fiber tripods are also very expensive.

Recently, there have been a few different types of special-purpose tripods being offered. These types of tripods are often referred to as claw types. These tripods can grip onto different surfaces and are pretty handy when you're in an odd situation. One manufacturer of these is the Joby Gorillapod.

Camera Bags and Cases

Another important accessory to consider is the bag or carrying case you choose for your camera. These can provide protection not only from the elements but also from impact. Camera bags and cases exist for any kind of use you can imagine, from simple cases to prevent scratches to elaborate camera bags that can hold everything you may need for a week's vacation. Some of the bag and case types available include:

✦ **Hard cases.** These are some of the best cases you can get. Pelican makes the best ones; they're watertight, crushproof, and dustproof. They're unconditionally guaranteed forever. If you're hard on your cameras or do a lot of outdoor activities, you can't go wrong with these.

Image courtesy of Joby
A.5 The Gorillapod in use

✦ **Shoulder bags.** These are the standard camera bags you can find at any camera shop. They come in a multitude of sizes to fit almost any amount of equipment you can carry. I have a couple of different shoulder bags: the Naneu Pro Tango and the Correspondent C400. Both fit quite a bit of equipment, including two camera bodies and a slew of lenses and flashes. The Tango bag also holds a 15-inch computer. Other reputable makers include Tamrac, Domke, and Lowepro. Look them up on the Internet to peruse the various styles and sizes.

✦ **Backpacks.** Some camera cases are made to be worn on your back, just like a standard backpack. These also come in different sizes and styles, and some accommodate a laptop. The type of camera backpack I use when traveling is a Naneu Pro Alpha. It's designed to look like a military pack, thus thieves don't know you're carrying camera equipment. When traveling, I usually pack it up with two Nikon digital single-lens reflex (dSLR) camera bodies, a wide-angle zoom, a standard zoom, a long telephoto, two or three prime lenses, two Speedlights, a reflector disc, a 12-inch Apple PowerBook, and all the plugs, batteries, and other accessories that go along with my gear. Lowepro and Tamrac also make some very excellent backpacks.

✦ **Messenger bags.** Recently, more camera bag manufacturers have started to offer messenger bags, which resemble the types of bags that a bike messenger uses. They have one strap that goes over your shoulder and across your chest. The bag sits on your back like a backpack. The good thing about these bags is that you can just grab it and pull it around to the front for easy access to your gear. I also have one of these for when I'm traveling light. My messenger bag is the Echo made by Naneu Pro.

✦ **Holster-type bags.** The holster-type camera bag is a bare-bones camera holder. It's made to carry one camera with a lens attached and a few accessories, such as batteries and flash cards. In my opinion, the best holster-type bag is the Lowepro Toploader. Lowepro makes several types of holsters to accommodate different cameras and lens combinations. For example, it makes bags to fit a standard dSLR with a standard zoom lens and makes a bigger bag to fit larger dSLRs (such as the D90 with MB-D80 grip) with a large telephoto zoom lens (such as a 70–200mm lens). These bags are great when you're traveling with a small amount of equipment on a day trip.

Glossary

Active D-Lighting A camera setting that preserves highlight and shadow details in a high-contrast scene with a wide dynamic range.

AE (Autoexposure) A general-purpose Shooting mode where the camera selects the aperture and/or shutter speed according to the camera's built-in light meter. See also *Aperture Priority* and *Shutter Priority*.

AE/AF (Autoexposure/Autofocus) Lock A camera control that lets you lock the current metered exposure and/or autofocus setting prior to taking a photo. This allows you to meter an off-center subject and then recompose the shot while retaining the proper exposure for the subject. The function of this button can be altered in the Custom Setting menu (CSM f7).

AF-assist illuminator An LED light that's emitted in low-light or low-contrast situations. The AF-assist illuminator provides enough light for the camera's AF to work in low light.

ambient lighting Lighting that naturally exists in a scene.

angle of view The area of a scene that a lens can capture, which is determined by the focal length of the lens. Lenses with a shorter focal length have a wider angle of view than lenses with a longer focal length.

aperture The designation for each step in the aperture is called the f-stop. The smaller the f-stop (or f/number), the larger the actual opening of the aperture, and the higher-numbered f-stops designate smaller apertures, letting in less light. The f/number is the ratio of the focal length to the aperture diameter.

Aperture Priority A camera setting where you choose the aperture and the camera automatically adjusts the shutter speed according to the camera's metered readings. Aperture Priority is often used by a photographer to control depth of field.

aspect ratio The proportions of an image as printed, displayed on a monitor, or captured by a digital camera.

autofocus The capability of a camera to determine the proper focus of the subject automatically.

backlighting A lighting effect produced when the main light source is located behind the subject. Backlighting can be used to create a silhouette effect or to illuminate translucent objects. See also *frontlighting* and *sidelighting*.

barrel distortion An aberration in a lens in which the lines at the edges and sides of the image are bowed outward. This distortion is usually found in shorter focal-length (wide-angle) lenses.

bounce flash Pointing the flash head in an upward position or toward a wall so that it bounces off another surface before reaching the subject, which softens the light reaching the subject. This often eliminates shadows and provides smoother light for portraits.

bracketing A photographic technique in which you vary the exposure over three or more frames. By doing this, you ensure a proper exposure in difficult lighting situations where your camera's meter can be fooled.

broad lighting When your main light is illuminating the side of the subject that's facing toward you.

camera shake Camera movement, usually at slower shutter speeds, which produces a blurred image.

catchlight Highlights that appear in the subject's eyes.

center-weighted meter A light-measuring device that emphasizes the area in the middle of the frame when you're calculating the correct exposure for an image.

colored gel filters Colored translucent filters that are placed over a flash head or light to change the color of the light emitted on the subject. Colored gels can be used to create a colored hue of an image. Gels are often used to change the color of a background when shooting portraits or still lifes by placing the gel over the flash head and then firing the flash at the background.

compression Reducing the size of a file by digital encoding, which uses fewer bits of information to represent the original subject. Some compression types, such as JPEG, actually discard some image information, while others, such as RAW, preserve all the details in the original.

Continuous Autofocus (AF-C) A camera setting that allows the camera to continually focus on a moving subject.

contrast The range between the lightest and darkest tones in an image. In a high-contrast image, the shades fall at the extremes of the range between white and black. In a low-contrast image, the tones are closer together.

dedicated flash An electronic flash unit, such as the Nikon SB-900, SB-800, SB-600, or SB-400, designed to work with the auto-exposure features of a specific camera.

depth of field (DOF) The portion of a scene from foreground to background that appears sharp in the image.

diffuse lighting A soft, low-contrast lighting.

D-Lighting A function within the camera that can fix the underexposure that often happens to images that are backlit or in deep shadow. This is accomplished by adjusting the levels of the image after it's been captured. Not to be confused with Active D-Lighting.

D-Movie Nikon's term for using the Video mode of the D90.

DX Nikon's designation for digital single-lens reflexes (dSLRs) that use a small APS-C–sized (23.6mm × 15.8mm) sensor.

equivalent focal length A DX-format digital camera's focal length, which is translated into the corresponding values for 35mm film or the FX format.

exposure The amount of light allowed to reach the film or sensor, which is determined by the intensity of the light, the amount admitted by the aperture of the lens, and the length of time determined by the shutter speed.

exposure compensation A technique for adjusting the exposure indicated by a photographic exposure meter, in consideration of factors that may cause the indicated exposure to result in a less-than-optimal image.

exposure mode Camera settings that let you take photos in Automatic mode, Shutter Priority mode, Aperture Priority mode, and Manual mode. In Aperture Priority mode, the shutter speed is automatically set according to the chosen aperture (f-stop) setting. In Shutter Priority mode, the aperture is automatically set according to the chosen shutter speed. In Manual mode, both aperture and shutter speeds are set by the photographer, bypassing the camera's metered reading. In Automatic mode, the camera selects the aperture and shutter speed. The D90 also offers Scene modes, which are automatic modes that adjust the settings to predetermined parameters, such as a wide aperture for the Portrait.

fill flash A lighting technique where the Speedlight provides enough light to illuminate the subject to eliminate shadows. Using a flash for outdoor portraits often brightens the subject in conditions where the camera meters light from a broader scene.

fill lighting The lighting used to illuminate shadows. Reflectors or additional incandescent lighting or electronic flash can be used to brighten shadows. One common technique outdoors is to use the camera's flash as a fill.

flash An external light source that produces an almost instant flash of light to illuminate a scene. Also known as electronic flash.

Flash Exposure Compensation (FEC) Adjusting the flash output by +1/−3 stops in 1/3-stop increments when using the built-in flash or ±3 stops when using a Speedlight. If images are too dark (underexposed), you can use FEC to increase the flash output. If images are too bright (overexposed), you can use FEC to reduce the flash output.

flash modes Modes that enable you to control the output of the flash by using different parameters. Some of these modes include Red-Eye Reduction and Slow Sync.

flash output level The output level of the flash as determined by one of the Flash modes used.

Front-Curtain Sync Front-Curtain Sync causes the flash to fire at the beginning of this period when the shutter is completely open in the instant that the first curtain of the focal plane shutter finishes its movement across the film or sensor plane. This is the default setting. See also *Rear-Curtain Sync*.

frontlighting The illumination coming from the direction of the camera. See also *backlighting* and *sidelighting*.

F-stop See *aperture*.

full-frame sensor A digital camera's imaging sensor that's the same size as a frame of 35mm film (24mm × 36mm).

FX Nikon's designation for dSLRs that use a sensor that's equal in size to a frame of 35mm film.

histogram A graphic representation of the range of tones in an image.

hot shoe The slot located on the top of the camera where the flash connects. The hot shoe is considered hot because it has electronic contacts that allow communication between the flash and the camera.

ISO sensitivity The ISO (International Organization for Standardization) setting on the camera indicates the light sensitivity. Film cameras need to be set to the film ISO speed being used (such as ISO 100, 200, or 400 film), whereas a digital camera's ISO setting can be set to any available setting. In digital cameras, lower ISO settings provide better quality images with less image noise; however, a lower ISO setting requires more exposure time.

JPEG (Joint Photographic Experts Group) This is an image format that compresses the image data from the camera to achieve a smaller file size. The compression algorithm discards some of the detail when closing the image. The degree of compression can be adjusted, allowing a selectable tradeoff between storage size and image quality. JPEG is the most common image format used by digital cameras and other photographic image-capture devices.

Kelvin A unit of measurement of color temperature based on a theoretical black body that glows a specific color when heated to a certain temperature. The sun is approximately 5500 K.

lag time The length of time between when the Shutter Release button is pressed and the shutter is actually released; the lag time on the D90 is so short, it's almost imperceptible. Compact digital cameras are notorious for having long lag times, which can cause you to miss important shots.

leading line An element in a composition that leads a viewer's eye toward the subject.

lens flare An effect caused by stray light reflecting off the many glass elements of a lens. Lens shades typically prevent lens glare, but sometimes, you can choose to use it creatively by purposely introducing flare into your image.

lighting ratio The proportion between the amount of light falling on the subject from the main light and the secondary light, such as 2:1 — a ratio in which one light is twice as bright as the other.

macro lens A lens with the capability to focus at a very close range, enabling extreme close-up photographs.

manual exposure Bypassing the camera's internal light meter settings in favor of setting the shutter and aperture manually. Manual exposure is beneficial in difficult lighting situations where the camera's meter doesn't provide correct results. When you switch to manual settings, you may need to review a series of photos on the digital camera's LCD to determine the correct exposure.

Matrix metering The Matrix meter (Nikon exclusive) reads the brightness and contrast throughout the entire frame and matches those readings against a database of images (over 30,000 in most Nikon cameras) to determine the best metering pattern to be used to calculate the exposure.

metering Measuring the amount of light by using a light meter.

NEF (Nikon Electronic File) The name of Nikon's RAW file format.

noise Pixels with randomly distributed color values in a digital image. Noise in digital photographs tends to be more pronounced with low-light conditions and long exposures, particularly when you set your camera to a higher ISO setting.

Noise Reduction (NR) A technology used to decrease the amount of random information in a digital image, often caused by long exposures and high ISO settings.

pincushion distortion A lens aberration in which the lines at the edges and sides of the image are bowed inward. It is usually found in longer focal-length (telephoto) lenses.

Programmed Auto (P) A camera setting where shutter speed and aperture are set automatically.

RAW An image file format that contains the unprocessed camera data as it was captured. Using this format allows you to change image parameters, such as white balance saturation and sharpening. Although you can process RAW files in-camera the preferable method requires special software, such as Adobe Camera Raw (available in Photoshop), Adobe Lightroom, or Nikon's Capture NX or View NX.

Rear-Curtain Sync Rear-Curtain Sync causes the flash to fire at the end of the exposure an instant before the second, or rear, curtain of the focal plane shutter begins to move. With slow shutter speeds, this feature can create a blur effect from the ambient light, showing as patterns that follow a moving subject, with the subject shown sharply frozen at the end of the blur trail. This setting is usually used in conjunction with longer shutter speeds. See also *Front-Curtain Sync*.

red-eye An effect from flash photography that appears to make a person's eyes glow red or an animal's yellow or green caused by light bouncing from the retina of the eye. It is most noticeable in dimly lit situations (when the irises are wide open) as well as when the electronic flash is close to the lens and, therefore, prone to reflect the light directly back.

Red-Eye Reduction A Flash mode controlled by a camera setting that's used to prevent the subject's eyes from appearing red in color. The Speedlight fires multiple flashes just before the shutter is opened, with the intention of causing the subject's iris to contract, therefore reflecting less light from the retina to the camera.

self-timer A mechanism that delays the opening of the shutter for several seconds after the Shutter Release button has been pressed.

short lighting When your main light is illuminating the side of the subject that's facing away from you.

shutter A mechanism that allows light to pass to the sensor for a specified amount of time.

Shutter Priority In this camera mode, you set the desired shutter speed and the camera automatically sets the aperture for you. It's best used when you're shooting action shots to freeze the subject's motion by using fast shutter speeds.

shutter speed The length of time the shutter is open to allow light to fall onto the imaging sensor. The shutter speed is measured in seconds or, more commonly, fractions of seconds.

sidelighting Lighting that comes directly from the left or the right of the subject. See also *frontlighting* and *backlighting*.

Single Autofocus (AF-S) A focus setting that locks the focus on the subject when the Shutter Release button is half-pressed. This allows you to focus on the subject and then recompose the image without losing focus as long as the Shutter Release button is half-pressed.

Slow Sync A Flash mode that allows the camera's shutter to stay open for a longer time to allow the ambient light to be recorded. The background receives more exposure, which gives the image a more natural appearance.

Speedlight A Nikon-specific term for its accessory flashes.

spot meter A metering system in which the exposure is based on a small area of the image; usually, the spot is linked to the AF point.

TTL (Through-the-Lens) A metering system where the light is measured directly though the lens.

vanishing point The point at which parallel lines converge and seem to disappear.

Vibration Reduction (VR) A function of the camera in which the lens elements are shifted to reduce the effects of camera shake.

white balance A setting used to compensate for the differences in color temperature from different light sources. For example, a typical tungsten lightbulb is very yellow-orange, so the camera adds blue to the image to ensure that the light looks like standard white light.

Index

Continued

Continued

Guides to go.

Colorful, portable *Digital Field Guides* are packed with essential tips and techniques about your camera equipment, iPod, or notebook. They go where you go; more than books—they're *gear*. Each $19.99.

978-0-470-16853-0 978-0-470-38087-1 978-0-470-17148-6

978-0-470-38627-9 978-0-470-17461-6 978-0-470-04527-5

Also available

Nikon D300 Digital Field Guide • 978-0-470-26092-0
Canon EOS 40D Digital Field Guide • 978-0-470-26044-9
Canon EOS Digital Rebel XTi/400D Digital Field Guide • 978-0-470-11007-2
Nikon D80 Digital Field Guide • 978-0-470-12051-4
Sony Alpha DSLR-A700 Digital Field Guide • 978-0-470-27031-8.

Available wherever books are sold.

⊗WILEY
Now you know.